Secure *the Shadow*

Secure *the* *Shadow*

Death and Photography in America

Jay Ruby

The MIT Press
Cambridge, Massachusetts
London, England

This book was set in Adobe Garamond by Graphic Composi-
tion, Inc. and was printed and bound in the United States of
America.

Library of Congress Cataloging-in-Publication Data

Ruby, Jay.
 Secure the shadow : death and photography in America /
Jay Ruby.
 p. cm.
 Includes bibliographical references and index.
 ISBN 0-262-18164-9
 1. Postmortem photography—United States—
History—19th century. 2. Postmortem photography—
United States—History—20th century. I. Title.
TR681.D43R83 1995
779′.2′0973—dc20 94-23118
 CIP

Death loves to be represented. . . . The image can retain some of the obscure, repressed meanings that the written word filters out. Hence its power to move us so deeply.

Philippe Ariès (1985, p. 11)

Death pervades the landscape of photography, for cameras are weapons that steal life and magical machines that defy death. They can preserve the past, promise the future, and transpose yesterday into tomorrow. Death and photography seem to have a basic relationship; but it is illusionary, for the camera does not depict death, it only shows how someone else saw it.

Judith Goldman (1976, p. 129)

[The photograph] embalms time, rescuing it from its proper condition.

André Bazin (1967, p. 14)

Contents

three

Memorial Photography 113

four

Conclusion: A Social Analysis of Death-Related Photographs 159

Acknowledgments

This book took a *long* time to write—over 10 years of research. Consequently, I have spoken to a lot of people and borrowed ideas and images from many of them. My debt cannot be repaid merely by mentioning their names, but at least it's a start. The idea to study death and photography came from a long-term research project in Juniata County, Pennsylvania. It is to the people of that place that I am the most grateful, particularly Marion Mertz, Michael Mertz, Karl Guss, John Henry, Walter Rex, Harold Hartman, David Shellenberger, and Paul Smith. Heinz and Bridget Henisch provided me with a constant and essential supply of encouragement. Faye Ginsburg, Chris Musello, and Deborah Smith all gave close readings of the manuscript and had many helpful suggestions. My wife, Janis Essner Ruby, listened, encouraged, read copy, and in an infinite number of ways made the book possible. I wish to particularly acknowledge Roger Conover from the MIT Press as someone who encouraged me at just the right time.

Among the people who have generously shared their knowledge with me and allowed me to cite their work, I want to especially cite: Phoebe Lloyd, Floyd and Marion Rinhart, Richard Stannard, Chris Musello, Judith Stillion, Merry Foresta, Mike Weaver, Jonathan Whitfield, Linda Layne, Karen Lamoree, James Tibensky, David Gradwohl, Rebecca Alpert, Howard C. Raether, Aaron Katcher, Dian Rabson, Charles Isaacs, Ruth Weidner, Tom Weprich, Laurel Gabel, Alison Devine Nordstrom, and Serge Lasko.

The following persons were kind enough to grant me permission to reproduce their images: Wm. B. Becker, H. and B. Henisch, Paul Smith, Irwin Weinfeld, Donna Van Der Zee, James Tibensky, John Wheeler, Rell G. Francis, Shirley Sue Swaab, S. F. Spira, and John Dilks. I would also like to acknowledge Ann Landers and the Aaron Priest agency for Erma Bombeck for granting permission to quote from their columns.

The following institutions and their representatives assisted me in my research and granted permission to reproduce their images: Rachael Shulman, David Wooter, and William Johnson from the International Museum of Photography at the George Eastman House, and Deborah Smith and Carolyn Block from the Strong Museum, both in Rochester, New York; the Rochester Public Library; Magnum Photos, New York; Louis A. Warren Lincoln Library and Museum, Fort Wayne, Indiana; Ashmolean Museum, Oxford; Musée d'Art et d'Histoire, Geneva; Man Ray Trust, Mauritshuis, The Hague; Philadelphia Museum of Art; the British Museum, London; The Museums of Stony Brook, Long Island, New York; Stanford Museum of Art; Smith College Museum of Art,

Northampton, Massachusetts; Kennedy Gallery, New York; Museum of Art, Raleigh, North Carolina; the Royal Photography Society; the University of Louisville Archives; Nebraska State Historical Society, Lincoln; the Colorado Historical Society; the Princeton University Art Museum, Princeton, New Jersey; Winterthur Museum, Wilmington, Delaware; and the Pennsylvania State University, William Darrah Collection, University Park.

Photographic Services at Pennsylvania State University and Bella Friesel provided me with copy negatives and prints of excellent quality.

And finally, financial assistance for the research was provided by the National Endowment for the Arts, Wenner Gren Foundation for Anthropological Research, and Temple University grant-in-aid for obtaining prints and permissions.

Secure *the* *Shadow*

Introduction: Seeing Death

Secure the Shadow is an exploration of the photographic representation of death in the United States from 1840 to the present. It focuses on the ways in which people have taken and used photographs of deceased loved ones and their funerals to mitigate the finality of death. "Secure the Shadow, Ere the Substance Fade, / Let Nature imitate what Nature made" (Newhall 1982, p. 32) is one of photography's earliest advertising cliches, predating George Eastman's "you push the button, we do the rest" by half a century. The sentiment provides an apt title for a book that examines photographic images of the dying, death, and funerals, and how they are used to mourn and memorialize.

Photography's amazing popularity over the last century and a half is undoubtedly due to its capacity to help us remember people, places, and events. It provides a witness—one thought to be unimpeachable and permanent. Life is commemorated through photographs. Why not death? A logical question, perhaps, but one that makes many twentieth-century Americans uncomfortable. Sometimes thought to be a bizarre Victorian custom, photographing corpses has been and continues to be an important, if not common, occurrence in American life. It is a photographic activity, like the erotica produced in middle-class homes by married couples, that many privately practice but seldom circulate outside the trusted circle of close friends and relatives. Along with photographic tombstones, funeral cards, and other images of death, these photographs represent one way in which Americans have attempted to secure their shadows.

This book employs photographs, newspaper accounts and advertisements, letters, photographers' account books, and interviews as evidence of how photography and death became historically intertwined in the nineteenth century. It traces the twentieth-century struggle between America's public denial of death and a deeply felt private need to use pictures of those we love to grieve their loss. Americans take and use photographs of our dead relatives and friends in spite of and not because of society's expectation about the propriety of these images. Comparisons are made between photographs and other pictorial media. Interpretations are founded upon the discovery of patterns in the appearance of the images and a reconstruction of the conditions of their production and utilization. The book was written in a manner that is, I hope, comprehensible, and even useful, for social scientists, historians of photography, and health care professionals who work with death and mourning. Anyone unfamiliar with photographic terms like daguerreotype or carte de visite will find the terms explained in the appendix.

Chapter one is an exploration of mourning and posthumous paintings, the immediate precursors to corpse photography. These forms of painting established the social and pictorial conventions that photography emulated in the nineteenth century. Chapter two is a chronological analytic description of postmortem and funeral photography. Chapter three deals with photographs as objects of memorialization. It explores photographic tombstones and funeral cards. The concluding chapter is a social analysis of the geographical and cultural distribution and uses of these images and the motivation for their use.

A Reflexive Interlude

My interest in death and photography has been nurtured by a somewhat perverse pleasure in dealing with things generally avoided, ignored, or undervalued by more traditional scholars. Orthodoxy in scholarship, as in life, limits our horizons. On a more profound level, I am convinced that an examination of this topic provides an important perspective on Americans' cultural expectations and attitudes toward photography, death, funerals, and mourning. The reward of combining death and photography in one study is that the synthesis offers something that an examination of each alone lacks.

People in the United States have a history of devaluing "the significance of death[;] it has been disguised, suppressed and denied in a way unprecedented in the history of human culture" (Stannard 1974, p. 44). Scholars interested in the pictorial representation of death and the social customs surrounding it find their work regarded as morbid or strange. "Expressions of grief have been considered embarrassing, even in bad taste, for many decades. Interest in death has been thought morbid or, at least, maudlin" (Stitt 1980, p. 7). Two photohistorians known for writing successful books on photography have had their manuscript on a pictorial study of the social customs of death rejected several times by publishers who thought it too depressing to sell well. According to Phoebe Lloyd (personal communication, March 4, 1981), the labeling of a nineteenth-century folk painting as posthumous will lower its market value and salability. A colleague's wife is uncomfortable at the thought of coming to my home because I have all "those pictures of dead babies." My proposal to mount an exhibition on this subject was rejected by several curators as being too "difficult" for the public.[1]

This book is an outgrowth of a general research interest in the ethnography of visual communication and the social history of pictorial representation (Ruby 1981; Ruby and Worth 1981). In the process of examining the sociocultural functions of photography in the rural community of Juniata County, Pennsylva-

nia, I discovered a number of twentieth-century postmortem photographs taken by Paul Smith, a professional studio photographer who practiced his trade in Port Royal, Pa. from 1925 to 1968. Because the goal of my research was to understand images within their contexts of production and use, I contacted the son of a funeral director whose name appeared on Smith's negative envelopes to inquire whether he could help me understand why people hire a professional to photograph their dead relatives and what they might do with these pictures. Our discussion was most enlightening. He told me that postmortem and funeral photography was common in Juniata County. When I pursued the questions with other local funeral directors and professional photographers, I discovered what was then to me an amazing amount of activity. To my knowledge, members of my family have never taken corpse or funeral photographs. So I accepted the received wisdom of the time from people like Michael Lesy (1973) that the practice was virtually nonexistent—a bizarre Victorian custom now confined to a few ethnic enclaves. I was wrong.

As I pursued my inquiry, I discovered a wide range of responses to this variety of photographic activity. No one was neutral. They either strongly disapproved or felt that it was an important thing to do. I could not even correlate the responses with profession. Some funeral directors were profoundly disgusted at the thought. They had little to say to me and actively discouraged their clients from taking pictures, whereas others had taken postmortem photographs of their own children. Some bereavement counselors told me categorically that taking funeral photos was a certain sign of pathological grief. I thus felt compelled to explore the subject in a more systematic way. I began to include questions about death photography in the interviews I was already conducting in Juniata County. I compiled an archive of death-related images and other relevant materials from flea markets, other collectors, and dealers. I sent out questionnaires to cultural institutions with significant photographic collections, and I questioned a number of professional photographers and funeral directors about the practice. Soon I had a sizable collection of images and information. I had sufficient evidence to state that death-related photography was very much a part of the picture-taking habits of contemporary Americans (Ruby 1984, 1987/8, 1991b). The material collected in this fashion constitutes the core of the book.

I became further intrigued when I discovered that I had misread one of Paul Smith's photographs. It might be useful to examine this postmortem photograph as a means of introducing the approach employed in this book to the study of how people construct and use meaning with photographic images. Figure 1 was taken by Paul Smith in Port Royal, Pa., in the 1930s. When I first examined the picture I did not know the deceased or anyone associated with him. I assumed that the photograph would have been placed in a frame or folder for the

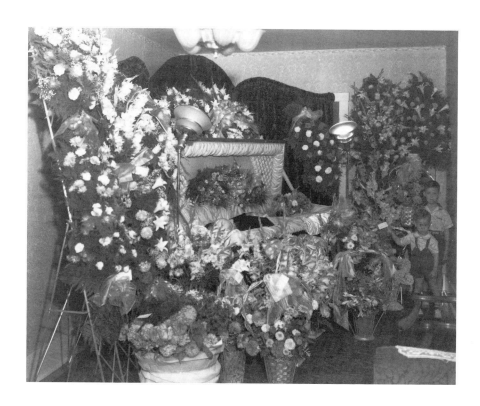

1
*Postmortem photograph of
C. C. Milliken with grand-
children. Paul Smith Studio,
Port Royal, Pa., August 24,
1939. Gelatin silver print,
8 × 10 inches. Courtesy, Cen-
ter for Visual Communication,
Mifflintown, Pa.*

customer and that the young boys on the right edge of the picture were acci-
dently in the frame and would have been cropped out with an oval or vignette
mat. In the process of interviewing one of the funeral directors in the county, I
discovered that the deceased in this picture had been a funeral director, in fact,
had owned the funeral home of the man I was interviewing. Moreover, the
adopted daughter of the deceased was currently the cleaning lady for the funeral
director. I spoke to her about the image. The children in the picture were hers.
She placed them there to be photographed with their grandfather for the last
time. The picture was commissioned by the widow and hung in a place of honor
above the widow's fireplace until her own death many years later. The daughter
also had a print. It was among her most treasured family images. When asked
why she thought that some people find these pictures morbid or offensive she
expressed the opinion that those people were simply not as used to death as she
was, being the daughter of a funeral director.

 While subsequent research has not borne out her idea, it did provide me
with a thesis to examine. Being able to discuss the photograph with one of the

intended users allowed me to correct my erroneous but logical error. The incident is a clear example of why the study of images alone, as objects whose meaning is intrinsic to them, is a mistaken method if you are interested in the ways in which people assign meaning to pictures. The conditions of production and consumption must be understood before the image's possible meanings can be examined. The point of the approach taken in this book is not to try to understand how and why the photographs are significant to scholars who study the history of photography but rather to discern how they were regarded by the people who made and used them. While this book is not the place to continue the argument in the detail it deserves, it is necessary to understand the position which illuminates what follows.

A Social Approach to Photography

The approach taken in this book provides a particular perspective on cultural expectations and attitudes toward photography.[2] It is an alternative to the dominant attitude which argues that photography is best understood as a form of fine art. While some photographs are designed to be regarded as art, most are not and therefore suffer when so scrutinized. Art historians argue that the vast majority of photographs are not worth seeing, let alone studying. Social historians suggest that any photograph, provided there is some contextual information accompanying it, can reveal something interesting about the people who made and used it. The photographs explored in this study are not valuable because they are rare, unusual, or "important art," but because they are useful in an exploration of attitudes toward death in America. Some images may strike viewers as moving, artistic, and compelling. Other photos, particularly the more recent ones, will undoubtedly appear to be banal, even visually boring (e.g., cf. figures 17 and 119).[3] Readers are asked to set aside their assumptions about what constitutes an "important" or "a visually compelling" image, and look at the photographs in this book in terms of the sociocultural importance they had for their producers and users.

Until recently, the scholarly study of photography was dominated by the search for significant works by important artists and the discovery of the naive products of vernacular practioners. Recent work by Hales (1984), Henisch and Henisch (1994), and many others, including myself (Ruby 1981, 1985, 1988), offer an option—a social history of photography.[4] From this perspective, the image itself becomes less compelling and less capable of independently revealing meaning. An interest in the photograph as a text complete in itself is replaced with a focus on the social processes of construction and subsequent use(s). The

intention of the maker, the conditions of reception, and the needs and capacities of the viewer assume more importance than the formal features of the picture. As socially constructed artifacts, photographs are regarded as objects of material culture that reveal something about the culture depicted as well as the culture of the picture taker. Given this approach it is logical that this study employed the methods of anthropology, social history, and ethnography rather than mainstream art history (see Ruby and Worth 1981, for an elaboration of this idea).

But what about the pleasure of the image? There can be no doubt that some of the photographs in this book are wonderful to look at, particularly those from the nineteenth century. Must we ignore the very real beauty of these pictures in our search for the cultural? I think not. There is no reason why historical photographs cannot fulfill and illuminate our contemporary expectations. Images are polysemic, i.e., they can have a variety of potential meanings. The nineteenth-century photographs used in this book were produced with a particular intention. We can try to understand the images from that vantage point and thereby hypothesize about the possible original meaning(s). We can also react to the photographs from the perspective of the late twentieth century and arrive at an altogether different meaning(s). So long as we are aware of the potential differences between our "revisionist" interpretations and the original intentions, we will not confuse the meanings we make to satisfy the needs of the present with the intentions of the past.

This book seeks to further a sociocultural approach to understanding photographs by attempting, when possible, to reconstruct the social contexts in which the images were produced and used. *Secure the Shadow* is a broadly conceived examination of death as a photographic subject among people living in the United States from 1840 to the present. This country is vast and socially very complex. Exactly how many different cultures there are in the United States is a matter of such debate that some social scientists doubt the utility of the concept when attempting to understand this society. One should beware of any statement about something called "American culture." Speculation is an important means to stimulate thinking, but couched in the third-person passive voice of authority it can create a false sense of certainty. To counter the grand and sweeping statements of earlier work, we need to remind ourselves of the limits of our knowledge and the tentativeness of all research conclusions. If I seem somewhat timid about drawing conclusions in this study, it is probably an overreaction to too many studies that are overly "generous" in their generalizations about culture and photography.

The information I collected is biased toward the northeastern United States. Some data were collected during ethnographic field work in rural Pennsylvania; most were not. While the data may be insufficient to support any con-

tention that the patterns described in the book apply to most people in the United States, it is my strongly felt hunch that they do. The historical and contemporary photographic practices described in this study were constructed mainly by inference and indirect evidence, and occasionally from primary data gained in ethnographic field research. In other words, this book constitutes an educated guess. While the guess is based on more than 10 years of work and thousands of hours of research in which thousands of images were examined, it must remain more of a hypothesis than anything else. I hope that readers will actively engage with what I have written.

Looking at Death

Means of preserving memories of the dead have developed. A study of the use of photographs by mourners is badly needed.

Humphreys (1981, p. 272)

Photographs commemorating death can be seen as one example of the myriad artifacts humans have created and used in the accommodation of death. Because the object created, i.e., the photograph, resembles the person lost through death, it serves as a substitute and a reminder of the loss for the individual mourner and for society. It would seem that photographs afford those in the business of adjusting to the loss of someone they cared for a chance to both remember and accept that which is final. While photographs of death have never figured in any elaborate social ritual, they provide the mourner with a private reminder of that which cannot be changed.

Attitudes toward death in American society have had a complex history. In the nineteenth century it was a common topic of polite discussion. Mourning was a normal part of the public life of most adults. Widowhood was a primary, lifelong social role for many women. Cemeteries were designed to be used as recreational sites. And then it all changed. From the beginning of the twentieth century until the 1970s, death became a forbidden subject among the "Americanized" middle class. The slightest sign of distress at the death of a family member was regarded as pathological.

Recently, some progress has been made in reintegrating death into the lives of people living in the United States. Certainly the popularity of Jessica Mitford's (1963) and Elisabeth Kübler-Ross's works (1969) signal a shift in popular attitude. Grief counseling has become more common and accessible. Death education is offered with greater frequency in the public schools. And the work of people like Ariès has legitimized death as an acceptable topic for research and discussion (1974a, 1974b, 1976, 1981, 1985).

This shift in our ability to deal publicly with death is sufficiently common as to provoke reactionary responses to the new openness by people like Anatole Broyard who, in a *New York Times* article reviewing books on death, suggested that:

> *In the 70s and 80s, there has been a wave of books telling us how to die. . . . For a while in this century dying was such a forbidden subject. . . . Now we may be carrying the pornography to the other extreme, to morbid exhibitionism and "the thrill of death." Kübler-Ross "believes that even mutilated or disfigured bodies should be viewed so that there will be no mystery, no ambiguity." David Handlin believes that "a good death is an indispensable end to a good life." According to Lisl Goodman "we are less afraid of death than of the incompleteness of our lives at the moment of death. . . ." she suggests an esthetic approach to living.*
>
> (Broyard 1981)

In spite of the increase in popular and scholarly work and the shift in public attitudes, the place of photography in our dealings with death has been virtually ignored by art historians, by those concerned with the material culture of death, and even by professionals in the field of grief counseling. Studies of images of death such as those of Ariès (1985), Lloyd (1980), Pigler (1956), and Llewellyn (1991) do not mention the practice. The absence of a discussion of death-related photography in the standard histories of photography, e.g., Newhall's (1982)[5] and Rosenblum's (1989), can partially be explained by the art-historical paradigm that has dominated the study of photography. If one is trying to construct a history based on the important works of significant artists, a postmortem or funeral photograph taken by a studio photographer hardly fits into this sort of grand scheme.[6]

When I began this study, I naively assumed that I would find a considerable literature on the role of photographs in psychotherapy and that within that literature some specific attention would be paid to death-related images and grief. What I discovered was a puzzling lacuna in the literature. The anecdotal information I was able to gather suggests that "many therapists use photographs as a central part of all therapy" (Judith Stillion, personal communication, November 15, 1991). Stillion, a psychologist, offered the following examples:

> *A therapist I know asks mothers regularly to bring in pictures of their children or themselves at particular times in their lives as a way of helping to illuminate the values and hardships of that time. This often helps clients to re-live the circumstances of a particular period and can result in re-gaining or at-*

taining objectivity concerning their actions and decisions of that period. When clients re-live the period with the help of photographs, they frequently can let go of feelings of guilt and regret over actions taken or not taken during that particular time.

Given the apparently obvious connection between photography and memory on the one hand, and memory and grief on the other, photographs of a dead loved one would seem a natural therapeutic tool when a patient is having difficulty dealing with his or her grief. Indeed, one psychiatrist, Vamik Volkan, has written about his uses of photographic images when dealing with clients suffering from pathological grief (1970, 1971, 1972, 1975). Lewis (1983) and other therapists specializing in bereavement counseling for the parents of stillborn children (Johnson, Johnson, Cunningham, and Weinfeld 1985) have "reinvented" postmortem photography and openly advocate it as a standard practice. Yet the rest of the profession is strangely silent about the role of photographs in the management of grief. I have been told by several clinicians that patients often voluntarily bring in photographs of the deceased and they are often useful in focusing the patient's attention on the object of their grief. If they do act as such a catalyst, it seems strange that these objects and their potential utility lack a significant or extensive literature.

Since *Photoanalysis,* a popular book written by Akeret in 1973, a number of therapists have experimented in a general way with photographs in their practice and a field called "PhotoTherapy" has developed (Weiser 1993). The emphasis seems to be on studying family snapshots to shed light upon the dynamics of family interaction and on having patients take self-portraits as a means of enhancing their self-esteem. None of the PhotoTherapy literature discusses postmortem and funeral photographs, nor is there mention of memorial photos in the work of grief. The only direct reference I can find is an offhand remark in an article, "Using Photographs in the Termination Phase," by Marvin Wikler (1977), a social caseworker, in which he states that "clients can, for example, bring in pictures of a deceased relative or divorced spouse, to facilitate discussions of the relationship between the client and the 'unavailable' family member" (p. 319). Stillion suggests that "because the practice [i.e., the use of photographs in all kinds of therapy] is so integrated into their work, they do not think to study the effects of using them in grief situations or any other problem situations" (personal communication, September 15, 1991).

The most widely known books about death photographs are Michael Lesy's *Wisconsin Death Trip* (1973) and the African-American studio photographer James Van Der Zee's *Harlem Book of the Dead* (1978).[7] Van der Zee's photographs have been presented as folk art—the work of a naive genius—an

African-American Grandma Moses, if you will, thus inadvertently perpetuating the false notion that postmortem photography is confined to certain ethnicities (see figure 52). Van der Zee's photographs are marvelous eccentricities but without some cultural and historical contextualizing, they are ghettoized as folk art anomalies, not part of a 150-year-old tradition of photographing the dead. It is possible to celebrate the creative genius of Van der Zee and at the same time recognize that he did not invent the custom.

In *Wisconsin Death Trip,* Lesy uses postmortem photographs taken in a rural Wisconsin community to demonstrate a pathology he sees in nineteenth-century rural American life. The book is a collage of artfully arranged and manipulated photographs from one local professional photographer, newspaper stories, obituaries, literary excerpts, and records from a state mental institution in Black River Falls, Wisconsin.

During the 1970s *Wisconsin Death Trip* was the talk of the literary and scholarly world. Some saw it as an inventive portrait of the suffering and degeneracy of rural America during the depressions of the 1890s (Gass 1973), whereas others, like Judith Guttman (1973), questioned Lesy's methods and conclusion. Critic Liz Harris found the book to be of dubious value. "At best, *Wisconsin Death Trip* provided tiny peepholes into the past, which the curious but not too squeamish could gaze through and ponder. At worst, it reduced rich lives to psychobabble and robbed death of its most potent and meaningful contexts: intimacy and personal history" (Harris 1987). Lesy's "small towns are pathological" thesis provoked small-town resident Dave Wood (1976) to publish a book-length rebuttal entitled *Wisconsin Life Trip.*

More recently, an ophthalmologist and collector, Stanley Burns, published *Sleeping Beauties: Memorial Photography in America* (1990), based mainly on his private collection. The book commodifies and aestheticizes memorial photographs. They are commodified as art objects in that they are constantly referred to as "rare" with "unusual" qualities. They are aestheticized through the design of the book (one image to a page with the written information about the images in a separate section so as to not interfere with the aesthetic appreciation by the viewer of the photograph as art). The book makes contradictory claims for the images. On the one hand, we are repeatedly told that the images are "rare," "unique," "one of a kind," and at the same time they are presented as representing something typical or common. These assertions are never supported with evidence and seldom with citations. These statements appear to represent an attempt to transform the photographs into historical-cultural documents. For example, the caption for Burns's figure 32 reads: "Photographs of the dead in coffins were typical of the mid-nineteenth century." Of the 38 figures in the book from this period, only seven show a coffin.

With all its shortcomings, *Sleeping Beauties* does represent a step away from the ethnocentric and unsupported thesis of Michael Lesy's *Wisconsin Death Trip*. Some of the images in *Sleeping Beauties* are striking. Many of the statements made about their place in American society may be supportable. The book could have been a credible attempt at producing a social history of death-related photography. However, the overblown statements about the "rarity" of the images (frequently the sole criterion by which one collects images) and their "typicality" coupled with fanciful figure titles and misleading dates greatly diminish its value.

None of the work to date dealing with death and photography will help us to understand the social context in which the images were produced and used nor do they aid our understanding of their social function. Lesy's and Burns's points of view do not allow us to deal with the possibility that the behavior may be normative and even therapeutic for the mourners. These authors have not adequately contextualized the images they used within the 300-year-old tradition in America of posthumous images, memorial and memorializing pictures executed in a variety of media. They have instead organized the images to suit and promote their own intellectual and aesthetic theses. Moreover, they do not appear to be aware of the degree to which their own transformations may not represent the intentions of the original makers or users. While their theses are not without interest or merit, they will not help us to understand the cultural constructions of meaning which transpired when the images were produced and used. Rather than condemn photographers of death as pathological or ghettoize the images as vernacular art, why not try to understand their social purpose?

I Heard the News Today, Oh Boy

> *Vicissitudes of our century have been summed up in a few exemplary photographs that have proved epoch-making; the unruly crowd pouring into the square during the "ten days that shook the world";* Robert Capa's dying miliciano; *the marines planting the flag on Iwo Jima;* the Vietnamese prisoner being executed with a shot in the temple; Che Guevara's tortured body on the plank in the barracks. *Each of these images has become a myth and has condensed numerous speeches. It has surpassed the individual circumstance that produced it; it no longer speaks of that single character or of these characters, but expresses concepts. It is universal, but at the same time it refers to other images that preceded it or that, in imitation, have followed it.*
>
> (Eco 1986, p. 216; emphasis added)

Photographs of people dying and dead and their funerals with grief-stricken mourners are seen daily in newspapers, magazines, and on television. Deaths that are deemed sufficiently newsworthy as to appear in the media expand, extend, and comment upon the earlier tradition of representing death in paintings and other pictorial forms (see chapter one for a discussion of paintings of the dead). The pictures constitute a socially shared American image of death—a common experience that appears to transcend gender, ethnic, regional, and class differences.[8] Long before most Americans ever see the actual body of a dead person, they see photographic and electronic representations of death—a few are actual, most make-believe. Our earliest encounters with death are mediated and dramatized by others—media producers—who are strangers except that they introduce us to one of life's profound mysteries—death.[9] Our culture's censors have decided that exposing us to the act of procreation or birth is not healthy. However, dismemberment, death by torture, suicide, mass murders, to name only a few, are acceptable viewing events. "While natural death became more and more smothered in prudery, violent death has played an ever growing part in the fantasies offered to mass audiences—detective stories, thrillers, Westerns, war stories, spy stories, science fiction and eventually horror comics" (Gorer 1965, p. 197).

If the frequency of experience is the determining factor in creating cultural attitudes, then "fictionalized" violent death is the template against which we measure all representations of death. It may be that death is real to us only when it looks like media-created fantasies.

Our culture is permeated by images and accounts of death, but they are only fictions, works of the imagination, counterfeits. The real thing is carefully hidden. Photographs are cropped; new footage is edited. What finally appears is only a flicker, out of context, reduced to a rectangle of light or printer's ink. Every Hollywood movie, television drama, and executioner's song, no matter how explicit, is only a fabrication, mantled with art, artifice, and commercial interruption. Death's fictions are everywhere available, shrink-wrapped like chicken legs and hamburger meat, but death itself is rarely revealed, only the mirror image of our fear, dread, and fascination with it. Eighty years ago, people died at home and their friends prepared their bodies for burial. In England and America, cemeteries were designed as parks where families strolled for refreshment, landscapes dotted with graves, where the living might contemplate the dead. Today, instead of gazing at death, we watch violence; instead of the long look at the steady state, we switch back and forth from one violent Epiphany to the other. Ordinary and inevitable death, death as an actual part of life, has become so rare that when it occurs among us it reverberates like a handclap in a empty auditorium.

(Lesy 1987, pp. 3–4)

Beginning with the advent of the "illustrated press" in the mid-nineteenth century (e.g., *London Illustrated Press* and *Harper's Weekly*), the pictorial representation of death, particularly during wartime, became a common feature of reportage.[10] Among the earliest and best known photographs of war dead in America is Alexander Gardner's *Home of the Rebel Sharpshooter, Gettysburg, Pennsylvania, 1863* (figure 2). It is not possible to reconstruct the impact this particular image had upon people in the 1860s or even to conjecture about how many people might have seen the picture. But among those who did see the image, there is no written evidence that anyone doubted its veracity. That faith in its verisimilitude no longer exists. William Frassanito (1975) has demonstrated that Gardner and his colleagues organized "reality." He moved the dead soldier and his weapons into a more compositionally pleasing position and used the same body for at least two different photographs. Apparently, Gardner believed the photograph would be more effective if it were composed in this manner. Some have argued that the falsification of photographs during the Civil War was necessary for a greater good: "The photograph readily became the vehicle for moral truth. If expression of this truth required mistitling an image, misinterpreting it, or even interfering physically with what was being photographed to achieve a more effective image, it was entirely justifiable" (Stapp 1988, p. 27).[11]

Civil War photographers brought the public face to face with what was assumed to be the grim realities of the war. There appeared to be a gritty realism lacking in earlier forms of pictorial representation. One result of these images was the establishment of the photograph as an unimpeachable witness and cornerstone of journalistic claims to objectivity. Journalists now strove to be "photographically" accurate in their reporting (Schiller 1981). Most Civil War photographs were transformed into lithographs or engravings by artists who took interpretative liberties with the photographic image. Some photos were published or displayed in exhibitions at Matthew Brady's New York gallery.[12] As this October 20, 1862, *New York Times* editorial suggests, they had a strong impact.[13]

Mr. Brady has done something to bring home to us the terrible reality and earnestness of war. If he has not brought bodies and laid them in our dooryards and along the streets, he has done something very like it. At the door of his gallery hangs a little placard, "The Dead of Antietam." Crowds of people are constantly going up the stairs; follow them and you find them bending over photographic views of that fearful battle-field, taken immediately after the action. Of all objects of horror one would think the battle-field should stand preeminent, that it should bear away the palm of repulsiveness. But on the contrary, there is a terrible fascination about it that draws one near these pic-

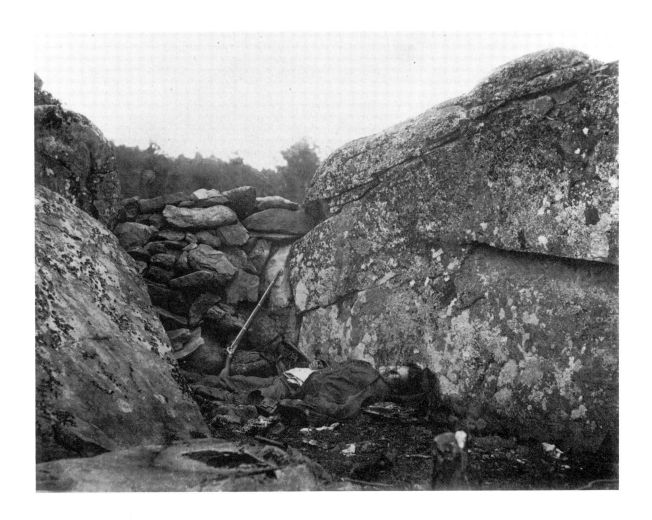

2
Home of the Rebel
Sharpshooter, Gettysburg,
Pennsylvania, 1863. *Alexan-*
der Gardner, 1863. Albumen
print, 6⅞ × 8⅞ inches. Cour-
tesy, International Museum of
Photography at George East-
man House, Rochester, N.Y.

*tures, and makes him loathe to leave them. You will see hushed, reverent
groups standing around these weird copies of carnage, bending down to look
in the pale faces of the dead, chained by the strange spell that dwells in dead
men's eyes. It seems somewhat singular that the same sun that looked down on
the faces of the slain blistering them, blotting out from the bodies all sem-
blance to humanity, and hastening corruption should have thus caught their
features upon canvas and given them perpetuity for ever. But so it is.*

Since the American Civil War, Americans' perceptions of the appearance
of death have been greatly molded by war photographs. "It is photography that
brings war home" (Moeller 1989, p. xii). What may be less obvious is that this
awareness has been arranged, filtered, perhaps controlled by our culturally con-
structed expectations. From World War I onward, the United States government
officially censored war photographs, often prohibiting photographs of dead
American soldiers, while promoting images of the enemy dead. Freedom of the
press is not a privilege photographers enjoy during wartime. With the exception
of some Vietnam War photos, what is known photographically about the wars
Americans fought during the twentieth century are those images officialdom
regard as furthering the United States government's policies. Whatever fantasies
exist about journalistic objectivity go out the window during wartime. This fil-
tering process was made abundantly clear during the war against Iraq, when total
censorship was imposed. We seldom saw any dead from either side even though
it is reported that the United States military killed many thousands of Iraqi
soldiers and civilians.

While the images of death we see in the news appear grimly natural, our
expectations about how death is supposed to look are aesthetically, not experien-
tially, derived. Conventions of representation drawn from television, theatre,
movies, and paintings have influenced how death is displayed in these photo-
graphs and, perhaps, how we think it will look in "real life." Funeral directors
construct "sets" to orchestrate our feelings about the dead. Soldiers in World
War II, "like the civilians at home, tended to see the war as a movie. It didn't
seem like men getting killed, more like a picture, like a moving picture"
(Steinbeck 1958, pp. 155–156). Stapp (1988) argues that these conventions are
necessary if photographs are to be effective. "As shown in the Antietam and Get-
tysburg photographs, the images seem to have been invested with sentiments
akin to those expressed in the other popular media of the time, probably because
the most potent photographic images would not otherwise be acceptable or
comprehendible to the American public. In the historical-cultural context of
the period, moreover, these sentiments were equated with meaning: they were
expressive of moral content, they were uplifting" (p. 31).

Metaphorically speaking, documentary and news photographers have been *rearranging corpses* ever since Alexander Gardner used the same dead soldier in two geographically separate photographs. Death as "reported" in news photographs is organized for our viewing pleasure. "Since before the American Civil War, scenes have been rearranged or created for the camera. Bodies have been positioned for the photographic eye, deaths faked" (Fralin 1985, p. 9). Since death is the last act of a person's life, it is supposed to be meaningful and dramatic, particularly if one dies on a battlefield. To die in a war for no apparent reason and without drama is unthinkable for it implies that the deceased's life was wasted.

The irony is that war photographs are sometimes judged believable only when they adhere to these conventions. "The effective war photographs of the past century, for example, play on certain conventional images of battle. War photography improvises on stereotypes of death and wounding. . . . During World War I, for instance, photographs of the wounded recalled religious paintings of the Renaissance; by World War II, pictures of the dead resembled an Alfred Hitchcock thriller" (Moeller 1989, p. 18).

The aesthetic transformation of death can be viewed positively if we believe, as some do, that war photographs have had a beneficial effect. It is a "lying-for-the-greater-good" argument.

> *Beginning with the first published halftones of a major conflict—during the Spanish-American War—photography helped to effect a subtle shift in the perception of war. Over time, a greater explicitness in the photography of combat prompted a greater sensitivity to American casualties, a greater reluctance to engage in certain kinds of exceptionally bloody warfare. . . . Visual portrayals of death and destruction began to outweigh the rhetorical arguments in favor of the wars. Although other elements were also significant, there is at least an indirect causal link between the increasingly graphic portrayal of dead Americans and, for example, the growing hesitancy of the government and the military to engage in the dramatic frontal assaults, casualties be dammed, that were so much a part of the Civil War. . . . By midway through World War II, officials were unwilling to brave—more than was necessary—the public's reaction to photographs of slaughtered soldiers.*
>
> *America's increased sensitivity to its own casualties, however, did not cause a concomitant sensitivity to enemy casualties. Until Vietnam, photographs that exposed disfiguring forms of warfare turned against the enemy, such as flamethrowers and napalm, caused little concerted outcry. Indeed, it could be argued that the American penchant for bloodthirsty images is sated by the extraordinarily explicit photographs of the dead enemy that have ap-*

peared in print—especially those of non-Caucasians: Chinese, Japanese, Koreans, and Vietnamese.

(Moeller 1989, pp. 6–7)

On the other hand, John Berger argues that artistically successful war photographs and any other photographs depicting shocking scenes of human suffering and death tend to desensitize us.

> *The reader who has been arrested by the photograph may tend to feel this discontinuity of the depicted moment of agony from other moments as his own personal moral inadequacy. And as soon as this happens even his sense of shock is dispersed: his own moral inadequacy may now shock him as much as the crimes being committed in the war. Either he shrugs off this sense of inadequacy as being only too familiar, or else he thinks of performing a kind of penance of which the purest example would be a contribution to OXFAM or UNICEF. . . . The issue of the war which has caused that moment is effectively depoliticized. The picture becomes evidence of the general human condition. It accuses nobody and everybody.*

(Berger 1980, pp. 39–40)

While the photographs of the American Civil War started a tradition of the pictorial representation of death as a common feature of the reporting of historical or "newsworthy" events, it was not until after 1885 when the halftone process was invented that newspapers and magazines were able to photographically represent the casualties of war, murder, accidents, assassinations, and disaster on a regular basis. Today we are daily witnesses to the deaths of strangers—made famous only because they happen to have been in the wrong place at the wrong time. For some, the newsworthiness of their death does not end with their demise but continues as their funerals become transformed into media events where we can publicly mourn or at least acknowledge the deaths of the already famous, the infamous, and the simply unlucky. Some deaths, such as those of Robert or John Kennedy, became major media events involving the entire world.

The funeral of every president since Lincoln has been pictorially recorded. Americans have for some time taken for granted that the media will supply them with images of their fallen leaders sufficient for mourning. Initially the custom caused some discomfort. There was considerable controversy surrounding a postmortem photograph of Abraham Lincoln. In an 1865 article in *Humphrey's Journal* we are informed:

> *It is known that Messrs. Gurney [the photographer was Benjamin Gurney, son of Mathew Brady's chief competitor] took some very fine negative scenes in and around the hotel where the remains of our late lamented President laid in state in this city [New York]. They had uninterrupted possession of the premises for several hours, and no other artist was allowed any similar privilege by the city authorities. This did not please some other photographers in New York, so they sent on a statement of facts in the case to Secretary Stanton, when that official immediately dispatched officers to Gurney's and seized all the above mentioned negatives they could lay their hands upon and sent them off to Washington. Mr. Gurney followed after, post haste, but whether he succeeded in recovering the negatives we are not informed.*
>
> (cited in Taft 1938, p. 195)

The response of some photographers was a mixture of moral outrage and political and professional jealousy. Gurney was opposed to the war, a Peace Democrat, and considered by some to be a Copperhead (i.e., a Northerner sympathetic to the Southern cause). One "Union" photographer wrote a letter to *Humphrey's Journal* inquiring,

> *Where was the necessity of photographing the remains? Was there not already millions of good representations of the living man that they must desecrate the dead? And why should this privilege be granted to Mr. Gurney, to the exclusion of all other photographers. . . . Had not Mr. Gurney, during President Lincoln's four years administration, sufficiently exhausted his vial of wrath and vengeance against him, that he must now disturb the repose of the dead, and insult and injure the bereaved family and true friends of the departed? The whole scheme was a disgraceful outrage upon humanity.*
>
> (cited in Welling 1978, p. 175)

Most people had assumed that Stanton had successfully destroyed all of Gurney's negatives until they were discovered in 1952 at the Illinois State Historical Society (Welling 1978, p. 175) (figure 3). Figure 4 is an artist's rendition of the same scene that was widely circulated as a lithograph. There is no evidence that a similar outrage followed this image. Perhaps the moral indignation of the writer of the letter quoted above was nothing more than professional jealousy, or the incident may suggest that the artistic rendering of Lincoln's bier was not as offensive as a photograph of the same scene.

News photography offers us the unique "privilege" of being a witness to historically important events that often involve someone's death. Perhaps photography's most "decisive moment" comes when the camera is present at the

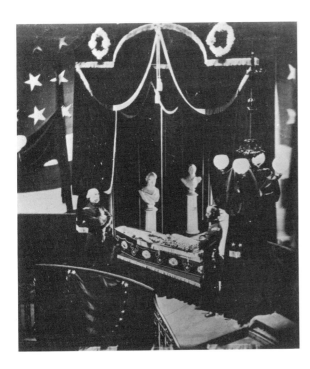

3
*President Lincoln lying in
state, New York. J. Gurney,
1865. Albumen print,
4¼ × 3¾ inches. Courtesy,
Illinois State Historical
Society, Springfield.*

4
The Body of the Martyr
President, Abraham Lincoln.
*Unknown, ca. 1865. Litho-
graph, 11⅞ × 8⅛ inches.
Courtesy, Louis A. Warren
Lincoln Library and Museum,
Fort Wayne, Ind.*

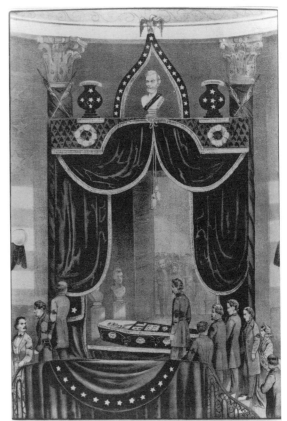

THE BODY OF THE MARTYR PRESIDENT, ABRAHAM LINCOLN.
LYING IN STATE AT THE CITY HALL, N.Y. APRIL 24TH & 25TH 1865.

moment of death. Dramatic, if not theatrical images, like the shooting of Lee Harvey Oswald or the 1972 Kent State National Guard riot with Mary Ann Vecchio kneeling by the body of Jeff Miller, or General Loan shooting the Viet Cong suspect on the streets of Saigon all won the Pulitzer prize because "these frozen moments have been etched into the minds and hearts of everyone" (Leekley and Leekley 1982, p. 6). In the book *Moments,* a compendium of Pulitzer Prize–winning photographs, more than half depict a death or murder (Leekley and Leekley, 1982).[14]

Robert Capa's slightly out-of-focus Spanish Civil War photograph of the Republican militiaman apparently at the moment of his death is a compelling image. Could it be a fiction created by an ambitious but less than honest photographer? (figure 5). Published first in 1936 in *Vu* and *Regards* and then in *Life* on July 12, 1937, the photograph is undoubtedly the most reprinted Spanish Civil War image. According to Knightly (1975), it "is considered by many professionals to be the best war photograph ever taken" (pp. 209–210). Examined carefully, the image is ambiguous and very dependent upon the caption in *Life:* "Robert Capa's camera catches a Spanish soldier the instant he is dropped by a bullet through the head in front of Córdoba." Why is there no apparent wound with blood spurting from the soldier's body? Could it be that the photograph was faked and is famous because it fulfilled viewers' needs for theatrical death?

Knightly, in his iconoclastic book *The First Casualty,* attempted to resolve the question but was unable to arrive at any conclusion. Even though Capa was made into a celebrity because of the photo, his autobiography makes no mention of it. Although Capa did give an interview to the *New York Telegraph* in which he stated that the photograph was real (Whelan 1985, p. 96), none of his associates were able to substantiate the authenticity of the image. John Hersey told Knightly that Capa said the image was taken in the heat of a battle. He supposedly raised his camera out of the trench and snapped without looking. It was months later before he realized the value of the picture. O. D. Gallagher, a *London Daily Express* journalist, reported that when he congratulated him on the success of the picture, Capa cynically replied, "If you want to get good action shots, they mustn't be in true focus. If your hand trembles a little, then you get a fine action shot" (quoted in Knightly 1975, p. 212). It would be ironic if the most famous war photograph were discovered to be a dramatically arranged fake![15]

Capa's biographer, Richard Whelan, has examined the reel of film containing the famous image and discovered another shot of a second soldier "dying" on the exact same spot. For Whelan the accuracy of the image is simply not relevant.

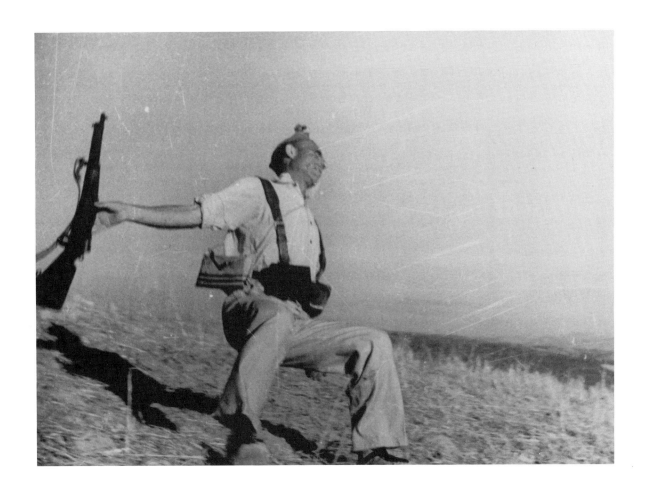

5
Republican Militiaman
Who Has Just Been Shot,
Córdoba Front, Spain.
*Robert Capa, September
1936. Gelatin silver print,
8 × 10 inches. Courtesy, copy-
right Capa/-Magnum Photos.*

But in the end, after all the controversy and speculation, the fact remains that Capa's Falling Soldier photograph is a great and powerful image, a haunting symbol of all the Loyalist soldiers who died in the war, and of Republican Spain itself, flinging itself bravely forward and being struck down. To insist upon knowing whether the photograph actually shows a man at the moment he has been hit by a bullet is both morbid and trivializing, for the picture's greatness ultimately lies in its symbolic implications, not in its literal accuracy as a report on the death of a particular man.

(Whelan 1985, p. 97)

I doubt very much whether Whelan's lack of concern about the veracity of the image would extend to the written word.[16]

While a "newsworthy" death may be an acceptable photojournalistic tradition, in recent years there is a growing feeling that the public examination of the death of a private person is improper because it constitutes an invasion of privacy of the survivors. It can no longer be rationalized by the public's right to know or the notion that the impropriety of invading someone's life at a time of grief is justified because the photograph is somehow valuable to society. Television news coverage has brought the moral conflict to a head. Erma Bombeck devoted an entire column to an expression of that sentiment (*Philadelphia Inquirer,* October 15, 1982, p. 4C).

The Privilege to Grieve Alone
Grief.
It's indescribable.

Even if you could put it into words, no one has to be told what it means because we have all been its victims.

In recent years, the victims have had to endure still another indignity . . . the selling of their sorrow.

Year after year, in the name of freedom to know, camera lenses have invaded the most private and sacred part of our lives . . . the pain of our existence.

A mother kneeling over the battered body of her child and his bicycle. (Tape at 10.) A man emerging from the water with the dangling, pale body of his best friend who has drowned. (Additional pictures on page 15.) Unspeakable pain in the eyes of a movie star at his wife's funeral. (Cover story begins on page 26.) Numb horror as a woman near collapse watches her husband wheeled out under a sheet after a shooting. (Pictures courtesy of photo pool.)

Those who argue in favor of these intimate glimpses of raw emotions

point out that people are mesmerized by the way people handle shock. I am
mesmerized by Robert Redford, but that doesn't give me the right to enter his
life and watch his every move.

I'm not talking about the coverage of disasters and accidents, I'm talking
about the privilege to grieve alone.

Many years ago, a good friend of mine who was a bridesmaid at my
wedding endured a tragedy in her family that found its way to the front page
of the newspaper. The cameras chronicled the tragedy right up to the gravesite
where her father was slowly inched into his grave.

"They took something away from me," she said bitterly. "Something very
precious that belonged only to me. The last private moment with my father. I
can never get it back again. Why? Why did they do it?"

Why indeed. Did it entertain? Did it inform? Did it fill 15 seconds of
vacuum time between sports and weather? Did it feed the curious? Titillate
the bizarre?

Seeing pictures of people who despair takes away something from all of
us. After awhile, the sight of blood, a funeral, or a stretcher becomes so com-
monplace that we no longer flinch from shock or feel the pain.

Sorrow sells. But can we afford it?

An Ann Landers column, "Those Who Suffer Tragedies Have Rights from
the Media" (*Philadelphia Inquirer,* May 21, 1988), quotes MADD's (Mothers
Against Drunk Drivers) list of 12 rights. Among them are: (1) "You have the
right to ask that offensive photographs not be used," and (2) "You have the right
to ask that your photograph not appear in the paper." MADD's representative,
Ausmuss, argues that "as a lifelong journalist, I am aware that catastrophic news
sells papers and gets high TV ratings. For most media, 'bad news is good news.'
Something in human nature makes this so, and nothing can be done to change
it. But we must, at the same time, be sensitive to the feelings of others."

Some people feel that public personages like the family of a politician still
have a right to privacy in their grief. A letter to the *Philadelphia Inquirer,* pub-
lished on March 23, 1992, read:

Intrusive photograph

This is an incredible time in the history of the world. For the first time,
due to our marvelous technologies, we can experience history right in our liv-
ing rooms.

Lunar launches are made available to us. We have access to courtroom
proceedings and Senate confirmation hearings that are extraordinarily interest-
ing and significant in how they are shaping our present and future lives.

> *Still, there are times that the press and other communications media show poor judgement. I believe that the* Inquirer *showed its money-making side by publishing the picture of Menachem Begin's shrouded corpse on the March 10 front page.*
>
> *Specifically, Mr. Begin requested a very private burial and no ceremony. The attempt was clearly to take his death out of the major news media and to afford him a quiet departure.*
>
> *The photograph, while poignant, was intrusive and a clear violation of his desires. The photo served no news benefit and in my opinion was placed there "to sell newspapers."*
>
> *Harry Orensein*
> *Plymouth Meeting*

The propriety of these images has also become an ethical dilemma for photojournalists. Some photographers now feel the need to justify their behavior. In discussing his photographic coverage of the public suicide of mental patient Chester Simpson, Texas news photographer Peter Bradt presents a classic journalistic defense in an article "I, Witness" in the August 1983 issue of *American Photographer:*

> *The next day the story ran on the front page [of the* Wichita Falls Record News] *and the uproar began. . . . A lot of people complained about the images being sensational and in bad taste. But I believe they were legitimate news photos. To my knowledge, a suicide like that had never been photographed, and as our editor, Don James, said, "We felt that the story leading up to the suicide illustrated a shocking failure on the part of the mental health system." Suicide is a difficult thing for people. I know; my brother took his own life six years ago. And don't think I didn't think a lot about that when I finally got out of the lab that night.* But people kill themselves every day and the public needs to know about it, and photographers can help put it in perspective [*emphasis added*].

News images of death are shocking, at times morally dubious, and sometimes even difficult to justify as news. Yet they are very much an accepted part of our lives. We would probably find it peculiar if we did not see at least the funeral photographs at the death of any prominent politician or gangster or movie star or any other public figure. What Alexander Gardner started, the *Six O'Clock Eye Witness News* merely and logically extends—theatrical images of death as "objective news records."[17]

While pictures of death may be an acceptable part of our media fare, some Americans are less comfortable with the idea of producing similar pictures for private use. Photographic memorial cards and tombstones or living video wills are somewhat unusual but not considered morbid or pathological. Other remembrances are viewed more negatively. People who wish to obtain postmortem or funeral photographs face a personal conflict and potential public disapproval if they take pictures or commission someone to do so. They appear to be trapped between contradictory cultural norms—using photography to memorialize important experiences and the belief that material remembrances of death prolong grief and are therefore morbid and unhealthy for the mourner. Because images of those we love who have died form a significant part of the grieving process, we make and use photographic representations of the dead whether our society "approves" or not. We need to gain a better understanding of our private need to remember through photography. This book is an attempt to explore these issues.

one

Precursors: Mortuary and Posthumous Paintings

Photographers acquired, perpetuated, and modified pictorial traditions already in existence in other media. As nineteenth-century businesspeople, they found themselves in direct economic competition with other image-makers, primarily for the "human likeness" market. In order to compete, photographers did two things: they "borrowed" existing conventions in order to appeal to an already existing market and they offered their services to people who theretofore had been economically denied access to having their likenesses preserved. It is a commonplace to suggest that "photography democratized image-making." This democratization was not the result of any political, moral, or even philosophical movement. Photographers did not attempt to modify the class structure of the United States. They simply wanted to exploit a market already partially opened up to them by the actions of limners and silhouette makers who offered the less affluent a chance to have their images rendered. Since painters had imaged the dead long before the invention of photography, it seems quite logical that photographers would attempt to emulate the custom. They did so, and, as a consequence, drove the painters who portrayed the dead out of business.

While death has long been a subject for pictorial representation (Ariès 1985), two varieties of death-related portraiture provide a direct precedent for postmortem photography—the posthumous commemorative or mortuary portrait (Pigler 1956) and the posthumous mourning portrait (Lloyd 1980).[1] The latter is a recently discovered variant of the former. Lloyd explains *posthumous mourning portraits* as follows: "Since the bereaved wished their dead to be restored to them as living presences, it is necessary to define these 'life' portraits as posthumous. And because families commissioned the portraits during the mourning period, the mourning function has been included in the designation" (p. 71).

Mortuary Portraits

Paintings commemorating the death of the rich, the powerful, and the famous are an old tradition (figure 6).[2] The custom apparently first arose in the West in the fifteenth century along with other forms of portraiture as a direct consequence of the rise of individualism, secularism, and the burgeoning of an affluent merchant class seeking status (Llewellyn 1991). In Anton Pigler's semi-

6
John Tradescant, the Elder, on His Deathbed. *Unknown painter, British School, 1638. Oil on canvas, 24 × 29⅛ inches. (Note: inscription in lower left corner reads, "Sr. John Tradescant Senr. lately deceas'd.") Courtesy, Ashmoleun Museam, Oxford.*

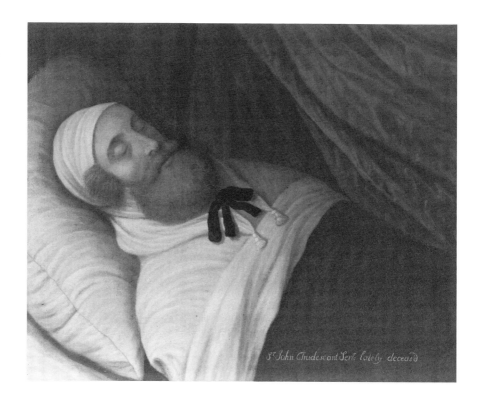

7
Sister Juliana van Thulden on Her Deathbed. *François Duchastel (1616–1679). Oil on canvas, 28¾ × 35 inches. Courtesy, Musée d'Art et d'Histoire, Geneva; photographer, Yves Siza.*

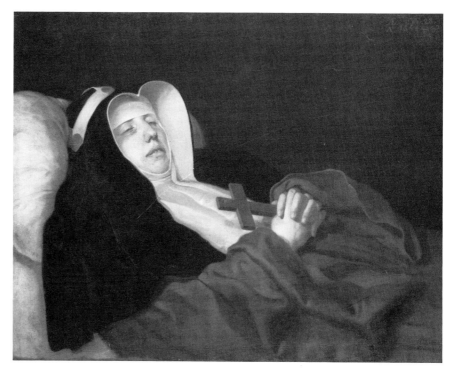

nal study, *Portraying the Dead*, an examination of 300 years of mortuary paintings, he concluded:

> *A survey of European art shows that, of all pictorial expressions of the thought of mortality, funeral portraits were able to withstand longest the rising tide of enlightenment and classicism . . . the habit of funeral portraiture persisted throughout the nineteenth century, with more or less tenacity in different countries; outstanding representations of public life, literature, and the arts were accorded the tribute of at least one drawing or photograph in the newspapers showing them on the bier.*
>
> (Pigler 1956, p. 69).

Ariès (1985) argues that the tradition was far more proscribed than Pigler suggests. "These works [i.e., mortuary paintings], few in number, do not include many men or members of the laity; the custom appears to have been reserved for nuns" (p. 199) (figure 7). Since Ariès does not cite Pigler in his bibliography, he may not have been aware of Pigler's study. In addition, Ariès's popular studies of death tend to overgeneralize assertions with little or no supporting evidence. The scholarly nature of Pigler's work and his careful documentation lend more credence to the latter's statements.

Today, the official funeral photograph has replaced the painted portrait and become a news item widely available through newspapers, news magazines, and television—as seen with the extensive coverage of the viewing and funeral of Tip O'Neill. Since the news coverage upon the death of an important personage does not usually include a death image of the deceased, these photographs and television images are technically not mortuary pictures. This shift away from a representation of the body of the deceased to images of mourners, funerals, and cemeteries is reflected in the private images families produce when one of their members dies (see chapter two for details.).

The artistic "problem" represented by a mortuary picture—painted or photographic—is one almost impossible to surmount. The motivation for the image contains a fundamentally contradictory desire—to retain the dead, to capture some sense of the essence of a being now gone, to deny death. If the purpose of a portrait is to convey a special quality or revealing character trait of the sitter that makes him or her compelling and unique, the face of a corpse hardly lends itself to the display of emotion or personality. Pigler (1956) suggests that these paintings have two common goals: "the desire to proclaim the eternal idea of the vanity and transience of human existence, by representing the end of the individual's earthly life; [and] a realistic representation of the optical sensation" (p. 2).

While a painter can "create" life where none exists, the photographer is more limited. "All likenesses taken after death will of course only resemble the inanimate body, nor will there appear in the portrait anything like life itself, except indeed the sleeping infant, on whose face the playful smile of innocence sometimes steals even after death. This may be and is oft-times transferred to silver plate" (Burgess 1855, p. 80). This seemingly unresolvable problem plagued photographic representation even more than painting. After all, the painter can alter actuality in fundamental ways the photographer cannot. In spite of the inherent limitations of all means of representation—the dead cannot be restored—death-related photographs continue to be made.

Perhaps as a consequence of the inherent limits of the genre, "works [i.e., paintings] of this kind usually belong to the periphery of the painter's or draughtsman's artistic activity. . . . Funeral portraits are, no doubt, expressive in a certain sense, but the range of variety is so slight that individual characterization is found only in exceptional cases . . . few mortuary portraits show real penetration, while the presence of an outstanding artistic personality is felt even more rarely in this field" (Pigler 1956, p. 2). Consequently, mortuary portraiture remained a relatively minor branch of portraiture practiced by less-well-known painters.[3]

Because mortuary paintings of private persons were primarily commissioned by family members as private mourning objects, they are known today only through an accident of history, that is, they survive because an heir decided to sell the painting or donate it to a museum. While an increase in the size of the middle class broadened the practice somewhat in the eighteenth and nineteenth centuries, posthumous commemorative portraits remained, by and large, confined to the upper classes.

Pictures portraying a public figure, such as a pope or king, were sometimes publicly displayed, thus allowing society at large to acknowledge and mourn the passing of an important person. The custom continues today and is to be found in virtually every pictorial medium. One could fill a book with the variety of mourning and funeral mortuary or memorial images of John F. Kennedy or Martin Luther King. In the USSR, there was an industry surrounding photographs of an entombed Lenin. Now the lines in front of McDonald's in Red Square are longer than those in front of Lenin's tomb and there is talk of moving Lenin's body to a cemetery. One therefore assumes that the market for postmortem photographs of Lenin has greatly diminished, if not disappeared altogether, relegated along with busts of Stalin to the "dustbin of history."

Mortuary portraits appeared in America as early as the late 1600s. Among the earliest known examples is a 1664 posthumous image of Miss Elizabeth Eggington, painted by an anonymous limner. On the back of the painting a label

8
A Child of the Hough Fam-
ily. *Unknown Dutch painter,*
ca. 1650. Oil on canvas,
18 × 22½ inches. Courtesy,
Mauritshuis, The Hague.

reads "A child taken after death supposed to be Miss Eggington, Granddaughter
of Rev. John Cotton" (Lloyd 1983, p. 9).[4] These early American works are un-
doubtedly a reflection of European influence. Ariès (1985) suggests that "por-
traits of dead children, also painted as they lie in bed . . . appear in the
seventeenth century" (p. 202) (figure 8).[5]

While most of these early paintings were designed to be private family
objects, at least one early American mortuary painting was intended to be viewed
by the public. Charles Willson Peale, prominent member of the famous family
of Philadelphia artists, painted *Rachel Weeping* in 1772 (figure 9) at his wife's
request upon the death of his daughter Margaret Bordley Peale (Lloyd 1982). It
was created as the family's private record. It was not the first time a deathbed
portrait was requested in the Peale family. "When he [Charles Willson Peale]
was young and just beginning to show artistic talent, his grandmother requested
that he make a deathbed sketch of her son [his uncle]. Frightened by the blue-
lidded eyes in the dead face, young Charles Willson refused" (Lloyd 1982, p. 3).
By 1776 the painting of his dead child was transformed into a display piece.
Peale doubled the original size and added the grieving figure of his wife Rachel.

9
Rachel Weeping. *Charles Willson Peale, Philadelphia, 1772–1776. Oil on canvas, 37⅛ × 32½ inches. Courtesy, Philadelphia Museum of Art; gift of the Barra Foundation, Inc.*

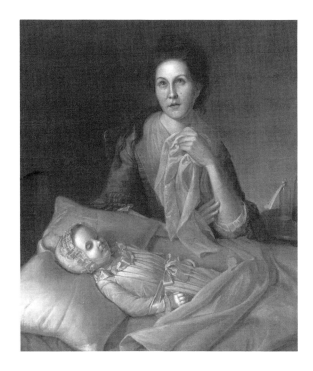

In 1782 the painting was on display at Peale's gallery at Third and Lombard in Philadelphia.

> *On December 4, 1782,* The Freeman's Journal *carried a news item concerning the picture. "The following lines were found in Mr. Peale's New Room, pinn'd to the curtain which hangs before the portrait of Mrs. Peale lamenting the death of her child,*
>
> *Draw not the curtain, if a tear*
> *Just trembling in a parent's eye*
> *Can fill your gentle soul with fear*
> *Or arouse your tender heart to sigh.*
>
> *A child lies dead before your eyes*
> *And seems no more than molded clay.*
> *While the affected mothers cries,*
> *And constant mourns from day to day."*
>
> (Lloyd 1982, p. 7)

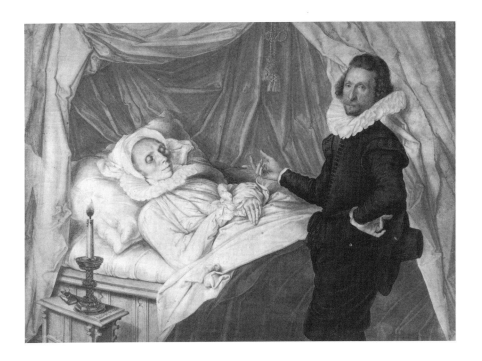

10
Unknown woman on her deathbed with a gentleman standing by. Jacob de Gheyn, seventeenth century. Oil on canvas, 8¼ × 11⅓ inches. Courtesy, British Museum, London.

The infant is presented in bed in nightclothes as if asleep. Stylistically, Peale employed the conventions derived from paintings of deceased children found throughout Europe from the seventeenth century onward (see figure 8). It is the mother's facial expression which clearly indicates that the child is dead. Peale's representation of this dead child and grieving parent also evinces a knowledge of the conventions of narrative mortuary paintings in which a mourner is present (figure 10) and prefigures the manner in which photographers some 50 years later were to portray dead children and their grieving parents (see figure 46).

Artists have always had the unique privilege of employing their skills to make a last record of a deceased family member. Some took advantage of the opportunity. There are at least three paintings in which the subject matter is the artist painting his dead child. Emile Zola in *L'Oeuvre,* an 1885 novel about the lives of artists, describes how Claude Lantier, the hero of the novel, paints his dead son. In 1887, neoimpressionist Georges Seurat made a Conté crayon drawing, *Anäis Faivre Haumonté on Her Deathbed, 1887,* a rendering of his maternal aunt, which he gave to her children (Herbert 1991, p. 269). Monet made a painting of his dead wife.[6]

When the nineteenth-century American cleric Lyman Beecher's child died, his wife produced a pictorial remembrance.

> *When I perceived that we could do nothing, that the child must die, I told Roxana to lie down and try to sleep. She obeyed, and while she slept the child died, but I did not think it best to wake her.*
>
> *On waking, there was no such thing as agitation. She was so resigned that she seemed almost happy. I never saw such resignation to God; it was her habitual and only frame of mind; and even when she suffered most deeply, she showed an entire absence of sinister motives, and an entire acquiescence in the Divine will.*
>
> *After the child was laid out, she looked so very beautiful that your mother took her pencil and sketched her likeness as she lay. That likeness, a faint and faded little thing, drawn on ivory, is still preserved as a precious relic.*
>
> (Beecher 1961, p. 127)

The convention of the "famous personage" mortuary portrait was sufficiently common that Sarah Bernhardt actually parodied it.[7]

> *Sarah Bernhardt . . . was all too well aware of the fascination which the theme of the weak-witted, expiring woman exerted over the males of her time, and she used this knowledge wherever she could to cultivate her own eccentric image. . . . Photographs of her lying thus [i.e., in a narrow cot or coffin] in near-excelsus did the rounds of aficionados and appropriately thrilled men everywhere [figure 11]. In his autobiography* Time Was, *Walford Graham Robertson describes a scene which took place about 1887 at Count Robert de Montesquioi's Paris rooms and which gave him the thrill of a lifetime: "One day, while exploring amongst the curious objects strewn about the rooms, I came upon a tiny photograph in a black frame, the photograph of a dead girl in her coffin. There was nothing of horror in the picture, only pathetic loveliness, and I felt that I had surprised some tragic secret as I hastily replaced the frame and Comte Robert looked up quickly.*
>
> *'You know her, don't you?' he asked.*
>
> *'No,' I whispered. Did I ever see her? Could I have known her when she was alive? 'She isn't dead,' he said smiling. 'That is Sarah Bernhardt.'"*
>
> (Dijkstra 1986, pp. 46–47)

11
Sarah Bernhardt in a coffin.
Unknown, ca. 1870s. Copied
from Bernhardt (1907, facing
p. 270).

Dijkstra (1986) suggests that "representations of beautiful women safely dead remained the late-nineteenth-century painter's favorite way of depicting the transcendent spiritual value of passive feminine sacrifice" (p. 50). While it is not possible to determine whether any American nineteenth-century photographers saw any of the "beautiful dead women" paintings that Dijkstra discusses, the conventions of representation of death displayed in these paintings were commonly known and thus available for photographers who were commissioned to produce postmortem images to emulate.

Posthumous Mourning Paintings

In addition to mortuary paintings where the deceased is portrayed on his or her bier, the custom of portraying the dead as if they were alive was popular in nineteenth-century America. Moreover, these paintings were sometimes based on a postmortem daguerreotype of the subject. According to Alfred Frankenstein, in his study of the American painter William Sidney Mount,

> *Painting portraits of the dead and especially of dead children was part of every artist's stock in trade in nineteenth century America. Mount repeatedly painted such portraits, but he seldom did so without recording a protest against the practice. Thus, in his catalogue for the year 1846, he makes the following entry: "Portrait of Rev. Charles Seabury, painted after death from memory for his son Rev. Samuel Seabury D.D. I only charged him twenty dollars. And the last I hope I shall paint after death. Death is a patron to some painters, I had rather paint the living." Later entries on the same theme run as follows: "A portrait of Frances Amelia Moubray, $50.00—after death. Death encourages the fine arts." "For portraits after death I must charge double price & be careful how I strain my eyes by painting after Daguerreotypes." But it was not always a matter of copying photographs; Mount observes that one advantage the painter has over the photographer is that the painter can remember the faces of dead people.*
>
> (Frankenstein 1968, p. 26)

Posthumous mourning paintings were a publicly acknowledged and socially acceptable practice. Paintings were hung in public spaces like parlors. Artists placed advertisements in local newspapers offering the service on a regular basis. How common these paintings were is only now being recognized: "Grete Meilman, Vice President, the American Painting Department of Sotheby Parke-Bernet Inc., estimates that approximately seventy-five percent of the children's

portraits sold through Sotheby fall into this category [i.e., posthumous mortuary portraits]" (Lloyd 1978/80, p. 111).

The obscurity of the genre—Lloyd is the first art historian to recognize it—is due to the fact that the deceased children are portrayed as if alive with "disguised" death symbols, that is, a willow tree in the background, or a wilted flower in the child's hand. Sometimes the portrait contains nothing to indicate that it is a posthumous rendering. For example, Mount's portrait of Jedediah Williamson is only known as posthumous because Mount's account books contained the following entry: "I made a sketch of Col. Williamson's son after he was killed by a loaded wagon passing over his body" (Frankenstein 1968, p. 26).

With *A Portrait of Camille* by Shepard Alonzo Mount, documentary evidence of the use of these icons exists (figure 12). "In the artist's portrait of Camille Mount, painted in 1868, the clouds do signify a posthumous rendering. Camille was Mount's granddaughter, the child of Joshua Elliott Mount. Shepard was present when the infant died, the cause of her death ascribed to teething. From a life drawing taken while the child was ill, the artist composed a posthumous likeness, which he considered 'one of the best portraits of a child that I

12
A Portrait of Camille.
*Shepard Alonzo Mount
(1804–1868), Long Island,
N.Y., 1868. Oil on canvas,
17 × 14 inches. Courtesy,
The Museums of Stony
Brook, Stony Brook, Long
Island, N.Y.*

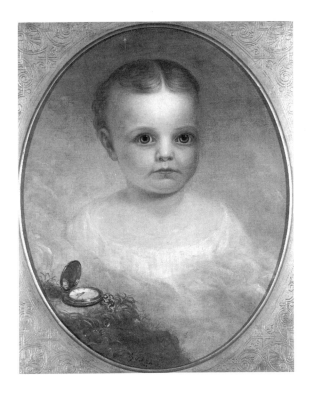

ever painted'" (Johnson 1989, p. 54). In a letter to his son, William Shepard Mount, he wrote:

> *"Alas! how everything fades from us. . . . She was laid out in a beautiful casket and she looked like an angel—Her eyes were bright and heavenly 'til the last. I painted her with Mr. Searing's [Camille's maternal grandfather] watch lying in the foreground. The hands pointing to the hour of her birth while she is seen moving up on a light cloud—the image of the lost Camille. She was in the habit of holding her Grandfather's watch to her ear, and to all others who came around her, she did the same. . . . Camille moves toward a shining star fixed in the heavens, while the pleasures of adoring grandfathers and ticking pocket watches remain behind."* Mount portrays the child at the transitional moment between life and death. The solid parcel of earth supporting the watch represents the tangibility of earthly existence. In addition to serving as a personal reference, the ticking watch is a metaphor for life, the beating heart and the passing of time. Surrounded by clouds, which separate the infant from the physical world, Camille ascends to heaven, a pictorial concept derived from Christian iconography.

(Johnson 1989, p. 54)

Posthumous mourning paintings are to be found among the middle-class Protestants, primarily in the northeastern United States, in the middle of the nineteenth century (ca. 1830–1860). However, examples can be found as late as the 1890s in the West. When Leland Stanford, Jr., the only son of the prominent California financier and founder of Stanford University, died at the age of 15 of typhoid fever in 1884, several French artists, Léon Bonnat, Félix Chary, Gustave Courtois, Emile Munier, and Charles Landelle were commissioned to produce life portraits from photographs. The custom of commissioning posthumous mourning portraits with allegorical elements such as Leland, Jr.'s, depiction as an angel was in vogue in Paris in the 1880s, a culture that influenced the Stanford family (Osborne 1982). The paintings, including Emile Munier's *Leland Stanford, Jr. as an Angel Comforting His Mother* and *Christ Blessing the Little Children,* a work by the Salviati firm of Venice, showing Leland, Jr., among the little children (figure 13), were kept in a private room at the Stanford house and later transferred to the Leland Stanford, Jr. Memorial Gallery in Stanford University's museum.[8]

In the nineteenth century, itinerant and small-town painters flourished in America. These limners were seldom academically trained and consequently mixed conventions and genres with apparent ease. Two examples of mourning paintings produced by these painters, conventionally called "folk art," are rele-

13
Christ Blessing the Little
Children. *Salviati firm,
Venice, ca. 1890s. Oil on
canvas, 51¼ × 37⅞ inches.
(Note: Leland Stanford, Jr.
stands among the little chil-
dren, immediately to the left of
Christ.) Courtesy, Stanford
Museum of Art, Stanford
Family Collection; gift of Jane
Stanford.*

14
Mourning picture. Edwin Romanzo Elmer (1850–1923), 1890. Oil on canvas, 28 × 36 inches. Courtesy, Smith College Museum of Art, Northampton, Mass.

15
Unidentified family. U.S. View Company, Richfield, Pa., ca. 1890s. Albumen print on cardboard mount, 7½ × 9¾ inches on 10- × 12-inch cardboard mount. Courtesy, Center for Visual Communication, Mifflintown, Pa.

vant to this study. In Edwin Romanzo Elmer's 1890 posthumous mourning painting (figure 14), the artist combines elements of a mourning portrait with the photographic conventions of the view photograph, a type of photograph extremely popular at this time among rural and small-town homeowners (Ruby 1983a) (figure 15). Mr. and Mrs. Elmer, in mourning dress, are seen seated in front of their home. At the left of the canvas stands Effie, their deceased daughter, with her toys and pet. The painting seems to serve a multitude of purposes. It is a portrait of the family. And at the same time, they mourn their dead child and celebrate their economic and social status by choosing to be portrayed in front of their home.

There is some evidence to support the notion that posthumous mourning paintings

> *functioned as an icon for the bereaved; contemplating it was part of the mourning ritual. Because the artist represented the deceased as alive, a delicate pictorial balance has to be maintained between life and death. It was achieved in two ways. On the one hand, the figure of the deceased, generally life-sized, was placed in his former habitual environment. On the other hand, a death symbol—sometimes disguised, sometimes easily identifiable—was normally included.*

> (Lloyd 1980, p. 73)

Lloyd has conjectured that the paintings

> *were commissioned by bereaved families for use in mourning rituals. Sitting in front of a posthumous portrait during the mourning period and viewing it annually on the occasion of the death was a regular ceremony in the nineteenth century, as evidenced in the 1860s portrait of the Buckley-Pomeroy family [figure 16]. Assembled before a life-sized portrait in the style of the 1830s, the Buckley-Pomeroy family appears to view one young girl crowning another with a floral wreath. Julia, the child being crowned, is dead. The wreath being placed on her head by her sister, Mary Josephine, is a funeral chaplet. Mary Josephine appears twice in the painting—within the painting and among the mourners. Sitting in a gloom, her left elbow resting on two books, she stares at her childhood self and her long dead younger sibling.*

> (Lloyd 1978/80, p. 105)

If Lloyd is correct, it seems reasonable that postmortem photographs served a similar purpose.

16
Mourning painting of Buckley-Pomeroy family. American school, mid-nineteenth century. Oil on canvas, 36 × 42 inches. Courtesy, Kennedy Gallery, New York.

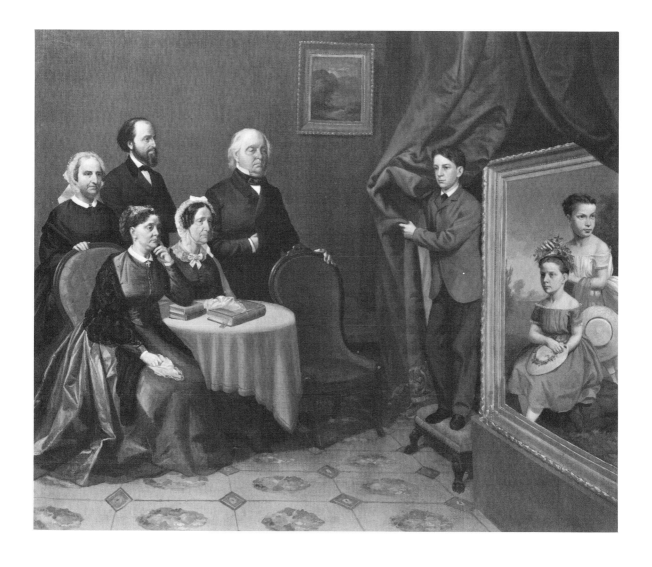

Other sources of information about the social customs surrounding posthumous paintings, or for that matter, postmortem photographs, are strangely lacking, considering their apparent popularity. According to Ann Douglas (1974), "openly fictionalized and avowedly factual accounts of deathbed scenes and celestial communications crowded the bookstalls in the decades before and after the Civil War. This consolation literature, an important phenomenon in nineteenth century American culture, incessantly stressed the importance of dying and the dead; it encouraged elaborate funerary practices, conspicuous methods of burial and commemoration, and microscopic viewings of the much inflated afterlife" (pp. 496–497). While it would seem logical to assume that discussions of the place of these images in mourning would appear in consolation literature, they do not.[9]

Posthumous mourning paintings are puzzling because they were produced at the same time photographers were making postmortem photographs (see below). Moreover, they flourished when the general business of painted portraits was on the wane, that is, from 1830 to 1860 (Lloyd 1978/80, p. 106). There is no evidence that painters and photographers were in direct competition with each other for this market. In the general field of portraiture, painters were losing the battle to photographers for the traditional portrait customer. At the same time, photographers found new markets among the less affluent who could afford the 25 cents necessary to have their daguerrean likeness taken.

It seems unlikely that photographic posthumous portraits replaced posthumous mourning paintings. The differences between the paintings and the photographs are sufficient to suggest that the motivation for commissioning one was different from the other. Painters created the illusion of life in death. In comparison, photographers, as we shall presently see, offered a much more imperfect—even shoddy—illusion, that is, the pretense that the person was merely sleeping rather than dead. At best, postmortem photographs constitute a failed attempt at trompe l'oeil which fooled no one. Their function was not to keep the dead alive but to enable mourners to acknowledge their loss.

Some photographers and painters were aware of the others' existence and actually cooperated. The journal of William Sidney Mount, a rural American painter, provides us with evidence that posthumous mourning paintings were sometimes painted from a daguerreotype rather than directly from a corpse. In 1852 Mount wrote, "I hope to paint no more portraits after death or from daguerreotypes" (quoted in Lloyd 1980, p. 73). It is not altogether clear whether Mount means that he painted from a daguerreotype taken when the person was alive or dead. The practice of using daguerreotypes and other photographs as a study is to be found among a number of artists: "It became a common practice to take advantage of photography for taking accurate representations of persons

either deceased or for other reasons inaccessible. Even an avowed enemy of the camera like the academician Hippolyte Flandrin did not abstain from using photographs, one of them for a posthumous portrait. Less conventional artists like Courbet, Manet, Degas, Cézanne and Gauguin were equally indebted to photography in similar cases" (Scharf 1968, p. 32).

An article by a daguerreotypist sheds further light on the problem. In 1855 Nathan Burgess wrote a detailed account of photographing the dead, "Taking Portraits After Death." He assumed that "The only object in taking a portrait of the deceased would be to provide an outline of the face to assist the 'painter in the delineation of the portrait and in this particular it has been found of essential service'" (Rinhart and Rinhart 1980, p. 300). It can be surmised that Burgess had enough commissions for death portraits to be able to write a definitive article on the subject, but it is difficult to believe that all of the postmortem portraits he made were merely artists' studies.

Taking Portraits After Death

By N. G. Burgess

The occupation of the Daguerrean Artist necessarily brings him in contact with the most endearing feelings of the human heart, more especially is this turn when called upon to copy the "human face divine."

"After life's fitful fever is o'er."

How often has he been called upon to attend at the house of mourning to copy that face who, when in life was so dear to the living friends, and with what doubt and hesitation has he essayed the task.

The only object of a portrait of the deceased can be to retain a facsimile of the outline of the face to assist the painter in the delineation of the portrait, and in the particular it has been found of essential service.

Having considerable experience in this branch of the art, I will transcribe my method for the benefit of the readers of the Journal [Burgess then goes into technical details about technology, posing, etc.].

If the portrait of an infant is to be taken, it may be placed in the mother's lap, and taken in the usual manner by a side light, representing sleep. . . .

By making three or four trials, a skillful artist can procure a faithful likeness of the deceased, which becomes valuable to the friends of the same if no other has been procured when in life.

All likenesses taken after death will of course only resemble the inanimate body, nor will there appear in the portrait anything like life itself, except indeed the sleeping infant, on whose face the playful smile of innocence sometimes steals even after death. This may be and is oft-times transferred to the silver plate.

However, all the portraits taken in this manner, will be changed from what they would be if taken in life—all will be changed to the sombre hue of death.

How true it is, that it is too late to catch the living form and face of our dear friends and will illustrate the necessity of procuring those more than life-like remembrances of our friends, ere it is too late—ere the hand of death has snatched away those we prize so dearly on earth.

(Burgess 1855, p. 80)

The career of Augustus Wetherby offers some additional insight into the relationship between photographic postmortem portraits and posthumous mortuary paintings. Wetherby was an itinerant portraitist who practiced his craft in the Boston area from 1839 to 1854, when he moved to the Midwest and opened a daguerreotype studio. He pursued photography until 1874, when he retired. Two volumes of Wetherby's extant account books cover the period from 1839 to 1862. "Nearly fifteen percent of Wetherby's portrait commissions between 1839, when he started keeping his account books, and 1854, when he moved west, were for portraits of the deceased or seriously ill" (Ploog 1990, p. 78). A typical entry states:

1842
Jan Mrs. Lyon Dr. (debtor) for one Portrait of Mr. Lyon after death.
taken from corps [sic] *and recollection $5.00*

The earliest mention of a daguerreotype, before Wetherby started taking them, is in reference to his painting. In December 1841 he completed a portrait "after death from a very indestinct [*sic*] Daguerreotype miniature." It is not until 1846, however, that the phrase "after death from Daguerreotype" was used regularly, replacing the phrase "after death from corpse" (Ploog 1990, p. 78).

In Denmark there is an example of the father of a dead child having both photographs and a drawing made.

In 1890 the famous Danish literary-critic Georg Brandes lost his little daughter Astrid who was suffering from diphtheria. In his memoirs Georg Brandes left this description: "I drove to a photographer hoping to possibly immortalize the very last sight of her. His equipment was installed in one of the theaters in Copenhagen. We drove there as the day was disappearing and the light was waning. At last we succeeded in making two plates of her—lying there in her little dress all decorated on the couch.

"In fact she looked lovely as we later placed her in her little featherbed in the coffin—with an abundance of flowers placed on it. The painter Harald Slott-Møller made, as a gesture of love, a colour-sketch of the child in the few short moments that were left. At nine o'clock they came and nailed the coffin. What a moment."

(Brandes 1908, in Kildegaard 1986, p. 77)

Both photographers and painters advertised their services in a similar fashion. "During the winter of 1847 William Stoodley Gookin placed his advertisement in a small Connecticut paper: 'His method of taking portraits of deceased persons, and his success in getting good likenesses, is well known to the public'" (Lloyd 1980, p. 71). The style of his advertisement is reminiscent of advertisements during the same period for daguerreotypists. In the September 9, 1845 issue of the *Livingston County Whig* of Geneseo, New York, daguerreotypist Noah North placed the following ad: "Daguerreotype Portraits: N. North would inform the inhabitants of Mt. Morris village and vicinity, that he has taken rooms over J. A. Mead's Store on Main Street, where with a complete apparatus, he is prepared to take Daguerreotype Likenesses in miniature size, and put them up in neat Morocco cases, or otherwise, when desired. . . . N.B. He would say to those who are desirous to 'secure the shadow ere the substance fade,' that NOW is the time, while life, health and opportunity offers."[10]

Daguerreotypists and painters of posthumous and commemorative mourning paintings tended to come from the same socioeconomic class. Pigler (1956) notes that in general "Commissions of this kind [i.e., mortuary portraits] were entrusted to artists, of modest talents, who happened to be on hand" (p. 2). Lloyd (1978/80) suggests that the same was true for mourning paintings: "Artists of repute gladly refused such work. The ghoulish task, therefore, fell to poor young artists, those living in rural areas or who had come up from the trades and traveled the itinerant circuit" (p. 105). Similarly, many daguerreotypists arose from the trades. The Rinharts note that several daguerreotypists both painted and took portraits (1980, p. 105). It therefore seems reasonable to suggest that these image-makers knew about the work of others and did not consider it a threat serious enough to endanger their livelihood.

Since photographic portraits of the dead continue to be taken today while posthumous mourning paintings had disappeared by the turn of the century, two logical possibilities exist. The motivation for commissioning painted portraits was different from that for photographs. Consequently, when funeral and mourning customs changed during the last quarter of the nineteenth century, the need for the paintings waned without influencing the demand for postmor-

tem photographs. The alternative explanation is that the market for portraits of the dead, like the general market for portraits, became dominated by photography.

The idea of photographing the dead came from the general tradition of portraying the dead, which is as old and widespread as the idea of portraiture itself. Photographers had two pictorial traditions to draw upon—the public commemorative portrait and the private mourning portrait. They chose to use the conventions of the commemorative portrait to produce privately intended postmortem portraits. That is, they portrayed the dead person in repose for the private use of the bereaved.

two

One Last Image: Postmortem and Funeral Photography

It is not merely the likeness which is precious—but the association and the sense of nearness involved in the thing . . . the fact of the very shadow of the person lying there fixed forever! . . . I would rather have such a memorial of one I dearly loved, than the noblest artist's work ever produced.

(From a letter by Elizabeth Barrett to Mary Russell Mitford, describing Barrett's reaction to a postmortem daguerreotype, quoted in Gernsheim and Gernsheim 1965, p. 64)

Joe wasn't sure why he had taken the snapshots. Funeral photographs had never been a family tradition, although some of the old-country Germans, Marie's people, had always taken coffin portraits. Perhaps that was where he had got the idea. Still, it wasn't like him. But then lately he had been acting in surprising ways that he could hardly credit. The world had changed since his wife had died.

Mark was tearing open the flap when Joe warned him. "I wouldn't look at those now," he said quietly. "Not here. Wait until you get home. She's in a coffin and I'll warn you—she doesn't look herself."

That was an understatement. The mortician's creation, that's what she was. A frenzy of grey Little Orphan Annie curls, hectic blotches of rouge on the cheeks, a pathetic, vain attempt at lending colour to a corpse. So thin, so thin. Eaten hollow by cancer, a fragile husk consumed by the worm within.

"What?"

"They are pictures of your mother in the coffin, of your mother's funeral," said Joe deliberately.

"Jesus Christ," Mark said, stuffing the envelope in his pocket and giving his father a strange, searching look. Or was it only his imagination? Joe had trouble reading his boy's bearded face. The strong, regular planes had been lost in the thick curling hair, and only the mild eyes were familiar.

(Vanderhaeghe 1985, p. 153)

But at last I sit here with the strange and frightening picture in my hands—still not faded—it belongs to a historical time passed—such as I myself only unprecisely [sic] remember—it shows my elder sister Lily in a very white bed. Her long beautiful braided hair—that everyone talked about, lying loose on the sheet. Her hands folded, cupping a perfect rose. The eyes half opened and

the lips slightly parted and you can easily tell from her hollow cheeks that she had been ill. She seems to be sleeping a light, dreamless sleep. Yet she is dead. . . . I was never allowed to forget the myth . . . Lily would never have done this and that. And I did it all. For years I envied her. . . . The photograph of her lying on her deathbed I only dared to look at in the company of my elder brother. It seemed too beautiful and strange to approach. Another photograph of her was displayed by the side of our bookshelf—there she was with her arms around my brother's neck in a white dress and white boots and all her hair floating like silk down her shoulders. Very often—when I was alone—I used to stick my tongue out at her.

<div align="center">(Gress 1975, p. 13, in Kildegaard 1986, p. 84)</div>

The custom of photographing corpses, funerals, and mourners is as old as photography itself. It was and is a widespread practice and can be found in all parts of the United States among most social classes and many ethnic groups. While some believe it was a morbid nineteenth-century custom no longer practiced, many funeral directors and professional photographers can testify to its continuance (see chapter four for details). This chapter examines the range of postmortem and funeral photographic activity from 1840 to the present. An analysis of the conventions of representation and their change through time and place is undertaken.

False Conceptions and Misperceptions

As noted in the Introduction, death-related photography has been generally overlooked and misunderstood by photographic scholars as well as those with a general interest in the subject of death. Moreover, there are several misconceptions about the practice commonly found in the literature of the history of photography that require correction.

Both Welling (1978, p. 67) and the Rinharts have suggested that postmortem photography is uniquely American. "Somehow or somewhere in America began a unique innovation—photographing the dead. For the first time the masses of the population were offered a means of preserving an exact image of their dead for posterity. The custom must have begun sometime in the early 1840s. . . . This innovation was strictly American and was widely practiced by American daguerreotypists" (Rinhart and Rinhart 1971, p. 323). With a bit of tautology that ignores centuries of mortuary paintings, they also argue that it has to have been an invention of photography. "It had no precedence in the history of man; it could not for photography itself was born in 1839" (Rinhart and Rinhart 1971, p. 323).

In addition, several authors have suggested that the custom has virtually disappeared, although they appear to disagree as to the date of its demise. "Between 1855 and 1860, the popularity of the daguerreotype process gradually waned. . . . During these same years the custom of memorial photography fell into disuse as well" (Rinhart and Rinhart 1967, p. 81). "Although such daguerreotypes or photographs [i.e., postmortems] may have offered solace to bereaved mothers, they are too gruesome to contemplate with pleasure. Fortunately, the practice disappeared with the aging of the art" (Taft 1938, p. 196). "During the 1920s formal post-mortem photography disappeared in mainstream middle class America" (Burns 1990, caption for figure 72).

Howard C. Raether, executive director of the National Funeral Director's Association, shares this assumption about the custom's lack of popularity in contemporary America.

> *Presently there don't seem to be many families that want this to be done [i.e., have postmortem photographs taken]. While they don't want the death and the funeral to be private, they resent making the death and the funeral public to the extent of photography by anyone. There are exceptions to this. There are motorcycle gangs that apparently like the publicity which comes following the death of one of their members. In the process some feel they want pictures in remembrance of their deceased members, pictures to be put in their clubhouse or other gathering place. There still are some ethnic groups, if Gypsies can be so classified, that want pictures taken of funerals for members of their tribes.*

(personal communication, December 9, 1981)

As the evidence presented in chapter one clearly indicates, the practice of portraying the dead did not originate with photography nor was it ever exclusively American. It was and is found throughout Europe and many other parts of the world (Boerdam and Oosterbaan 1980; Kempe 1980, pp. 4–5; Kildegaard 1986). The evidence collected for this study argues against the notion that the custom is less frequently practiced today, nor is there any reason to believe that it is the exclusive practice of a few ethnic enclaves. Based on the attire of the deceased and the background in the photographs, the custom may be said to be predominantly lower middle class, although family-produced casket photographs of Princess Grace of Monaco appeared in the European tabloids.

In *Wisconsin Death Trip,* Lesy (1973) assumed the practice to have been a morbid Victorian invention indicative of an unhealthy attitude toward death altogether common in the nineteenth century. Whether you consider the custom of photographing the dead as a symptom of a sick society or not is more a reflection of one's attitude toward death than anything else. For some Americans,

the very mention of the word *death* is considered unhealthy and all public displays of grief are regarded as pathological. Evidence is presented in chapter four that strongly suggests that these pictures do have a positive value for some people in the latter part of the twentieth century. Assuming that photographing the dead is always a morbid act is merely a reflection of our culturally encouraged need to deny death.

The reasons why Americans do not generally know about postmortem photography are complex and revealing about our attitudes toward death. The absence of any public knowledge of these activities is a reflection of our general studied ignorance about death and the cultural activities surrounding it. In times past Americans were more open about these practices than they are now. In fact, some people are so uncomfortable with the idea of a photograph of a corpse or funeral that they destroy any images of death should they discover them in their family photo collection. Several corpse photographs I acquired for this study were given to me by people who removed them from their family photo collection because they wanted them out of their homes.

Some examples of privately produced nineteenth-century corpse photographs have become public and accessible as part of the general transformation of old photographs into commodities in the art market and as collectibles in flea markets, as can be seen in *Sleeping Beauties* (Burns 1990), a book based largely on one person's private collection. As people buy, sell, and collect the family photographs of other people, the images lose their original purpose and meaning and become objects of aesthetic contemplation, or curiosities. This transformation causes some people to become alienated from their morbid reaction to death photographs and instead become fascinated with the artful way *other* people in *other* times produced these pictures. Because postmortem photographs from the pre-World War I era are more widely circulated than more recent examples (they are not old enough to be valuable except to a few collectors who specialize in postmortem photographs), it is naturally assumed that the practice was more common then than now. It is a false assumption.

The Openness of the Nineteenth Century

During the first 40 years of photography (ca. 1840–1880), professional photographers regularly advertised that they would take "likenesses of deceased persons." Advertisements that state that "We are prepared to take pictures of a deceased person on one hour's notice" were commonplace throughout the United States. The prominent firm of Southworth & Hawes ran the following advertisement in the 1846 Boston business directory: "We make miniatures of

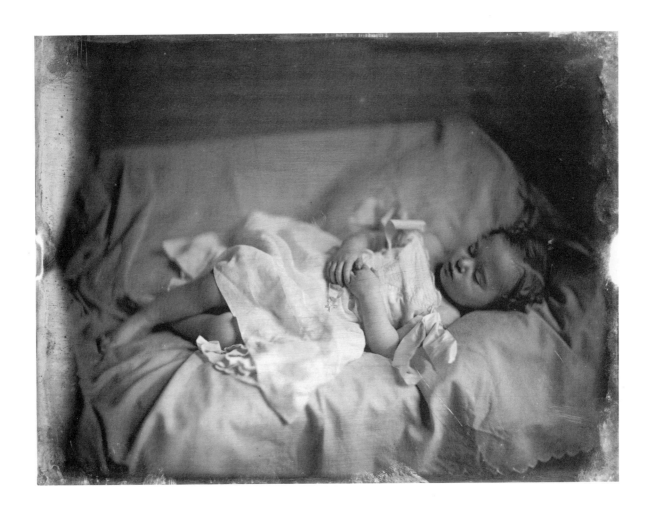

17
Postmortem photograph of unidentified child. Southworth & Hawes, Boston, ca. 1850s. Daguerreotype, full plate. Courtesy, International Museum of Photography at George Eastman House, Rochester, N.Y.

children and adults instantly, and of Deceased Persons either at our rooms or at private residences. Our arrangements are such that we take miniatures of children and adults instantly, and of DECEASED persons either in our rooms or at private residences. We take great pains to have Miniatures of Deceased Persons agreeable and satisfactory, and they are often so natural as to seem, even to Artists, in a deep sleep" (cited in Rinhart and Rinhart 1980, p. 299) (figure 17).

The practice was sufficiently common that black mats, often decorated with floral patterns, were sold by photographic supply houses. Companies like the Scovil Manufacturing Company of Waterbury, Connecticut, and the Mausoleum Daguerreotype Case Company of New York sold daguerreotype cases designed for "likenesses of deceased persons, and for sepulchral daguerreotypes" (Rinhart and Rinhart 1967, pp. 80–81).

An 1854 advertisement in *Humphrey's Journal* (January 15, p. 302) for the sale of a studio stated: "Daguerrean Gallery for Sale—The only establishment in a city of 20,000 inhabitants and where pictures of deceased persons alone will pay all expenses."

Professional photographers matter-of-factly discussed in professional trade journals techniques for photographing the dead. Josiah Southworth, of Southworth & Hawes, in an 1873 panel discussion on techniques of photographic portraiture, recalled his approach:

When I began to take pictures, twenty or thirty years ago, I had to make pictures of the dead. We had to go out then more than we do now, and this is a matter that is not easy to manage; but if you work carefully over the various difficulties you will learn very soon how to take pictures of dead bodies, arranging them just as you please. When you have done that the way is clear, and your task easy. The way I did it was just to have them dressed and laid on the sofa. Just lay them down as if they were in a sleep. That was my first effort. It was with a little boy, a dozen years old. It took a great while to get them to let me do it, still they did let me do it. I will say on this point, because it is a very important one, that you may do just as you please so far as the handling and bending of corpses is concerned. You can bend them till the joints are pliable, and make them assume a natural and easy position. If a person has died, and the friends are afraid that there will be a liquid ejected from the mouth, you can carefully turn them over just as though they were under the operation of an emetic. You can do that in less than one single minute, and every single thing will pass out, and you can wipe the mouth and wash off the face, and handle them just as well as though they were well persons. Arrange them in this position, or bend them into this position. Then place your camera and take your pictures just as they would look in life, as if standing up before you. You don't go down to the foot of the sofa and shoot up this way. Go up on the side of the head and take the picture so that part of the picture that comes off from you will come off above the horizontal line. So it would be as if in a natural position, as if standing or sitting before you. There is another thing which will be useful to you in carrying out your operation, and that is a French style mirror about four feet and not very wide. This will suit some cameras, arranging the mirror so the reflection of the party will be thrown upon it in an easy, graceful, natural way, and then take your pictures from the mirror without much trouble. I make these remarks because I think that they may be very valuable to somebody.

(Southworth 1873, pp. 279–280)

Published anecdotal comments and professional advice about how to accomplish the task suggest that the attitudes of nineteenth-century photographers toward postmortem photographic commissions were not very different from those expressed recently by professionals (see discussion of contemporary practice in chapter four). They seemed to accept the professional responsibility of taking the pictures and doing a good job if asked. Some express sympathy for their bereaved patrons; others feel the task to be a very unpleasant one indeed. There is one significant difference between the nineteenth and twentieth centuries: in the nineteenth century photographers openly advertised and discussed the practice.

Among the earliest known accounts of a photographer taking a corpse photograph is James F. Ryder's 1873 recollections of his days as a daguerreotypist in central New York State in the 1850s. In recounting the attitudes of the townsfolk to his practice, Ryder states:

> *I was regarded with respect and supposed to be a prosperous young fellow. All were friendly and genial—save one. The blacksmith, a heavy, burly man, the muscular terror of the village disapproved of me. Said I was a lazy dog, too lazy to do honest work and was humbuggin [sic] and swindling the people of their hard earnings. He, for one, was ready to drive me out of the village.*
>
> *The greater my success the more bitter his spleen, and in the abundance of his candor denounced me to my face as a humbug too lazy to earn an honest living. He said he wouldn't allow me to take his dog; that I ought to be ashamed of robbing poor people. Other uncomplimentary things, he said, which were hard to bear, but in view of his heavy muscle and my tender years, I did not attempt to resent.*
>
> *Well, I left that quiet town and brawny blacksmith one day and moved to another town a few miles distant. A week later I was surprised at a visit from him. He had driven over to the new place to find me. He had a crazed manner which I did not understand and which filled me with terror.*
>
> *He demanded that I put my machine in his wagon and go with him straight at once. I asked why he desired it and what was the matter. Then the powerful man, with heavy chest, burst into a passion of weeping quite uncontrollable. When he subsided sufficiently to speak he grasped my hands, and through heavy weeping, broken out afresh, told me his little boy has been drowned in the mill race and I must go and take his likeness.*
>
> *A fellow feeling makes us wondrous kind. My sympathy for the poor fellow developed a tenderness for him in his wild bereavement which seemed to bring me closer to him than any friend I had made in the village. To describe his gratitude and kindness to me after is beyond my ability to do.*

(Ryder 1873, pp. 144–146; cited in Welling 1978, p. 67)

Daguerreotypist Gabriel Harrison gave a flowery account of his work as a photographer of corpses.

The sun rose gloomily, no bright birds with their sweet music appeared to herald in the day—no aqua fontana *sparkled in the sun-beams, for a bleak north-west wind, and dark fleeting clouds gave token of a wintry approach; and oh! how sad was the face of the first customer who saluted me on entering the Gallery.*

Her pale lips, though motionless, spoke despair—her dark sunken eyes told of intense suffering, and her black tresses raggedly gathered over her broad white temples indicated the agitation of her mind. Her garments coarse, but neat, loosely encircled her well shaped frame. When she spoke, her tremulous, anxious voice sent a thrill like an electric shock though me. In wild accents she addressed me.

"Oh! sir, my child Armenia is dead, and I have no likeness of her; won't you come immediately and take her picture."

The number and place were taken and in a few minutes I was at her door. The house was an old dilapidated frame building on Elm street. I gently knocked at the door and it as soon opened.

"Does Mrs. G——, live here?" I asked.

"No, sir; down in the basement."

Into a deep cellar basement I descended—the door was partly open, I walked in and what a mournful scene entered my gaze; the dying embers in the grate gave more light than the heavenly rays which entered through the low windows. On a scantily furnished couch lay the victim of the foul destroyer, marble like and cold—the mother, on her knees beside the bed leaned over her darling, her only child, with her face buried in her hands, and giving away to low heart-rendering choking sobs. For a moment I dared not disturb that mother's anguish.

"Madam."

"You are here," she said, as she started to her feet. "Oh! a thousand, thousand thanks."

Gently we moved the death couch to the window in order to get the best light, though but a ray. What a face! What a picture did it reveal. Though the hand of God is the most skillful, yet I thought, had the sculptor been there to chisel out that round forehead, to form that exquisite shoulder, to mark the playful smile about those thin lips, and to give the graceful curves of those full arms that lay across her now motionless heart, what a beautiful creation would come from his hands.

The mother held up a white cloth to give me reflected light to subdue the shadows. All was still, I took the cap from the camera. About two minutes had elapsed, when a bright sun ray broke through the clouds, dashed its bright beams upon the reflector, and shedding, as it were, a supernatural light. I was startled—the mother riveted with frightful gaze, for at the same moment we beheld the muscles about the mouth of the child move, and her eyes partially open—a smile played upon her lips, a long gentle sigh heaved her bosom, and as I replaced the cap, her head fell over to one side. The mother screamed.

"She lives! she lives!" and fell upon her knees by the side of the couch.

"No," was my reply; "she is dead now, the web of life is broken."

The camera was doing its work as the cord that bound the gentle being to earth snapped and loosened the spirit for another and better world. If the earth lost a flower, Heaven gained an angel.

(Harrison 1851, pp. 179–181)

In 1865 (the carte de visite era) a Mr. J. M. Houghton wrote a brief note in the *Philadelphia Photographer* (vol. 6, p. 241) in a straightforward manner giving professional advice on taking a postmortem picture.

The other day I was called upon to make a negative of a corpse. The day happened to be a bright one, and I overcame the above-mentioned difficulty in the following manner: I selected a room where the sunlight could be admitted and placed the subject near a window, and a white reflecting screen on the shade side of the face. As usual, the reflection from the screen was insufficient to equalize the light upon the subject, so I caused a pretty strong light to be thrown against the screen with a mirror, which caused an equal play of light upon the face, and an excellent negative was obtained without flatness. By varying the strength of the reflection from the mirror, the color of the screen and the distance of the screen from the subject, the above-named difficulty can be greatly lessened when the sunlight can be had.

In the *Philadelphia Photographer* in 1877 (vol. 10, pp. 200–201), appeared an article by Charlie E. Orr, of Sandwich, Illinois, "Post-mortem Photography," giving "assistance to some photographers of less experience, to whom it might befall the unpleasant duty to take the picture of a corpse."

Post-mortem Photography

Having been an anxious and interested reader of our invaluable journal, the Philadelphia Photographer, *for several years past, and not having read much*

on the above mentioned subject (except from my friend John L. Gihon), I thought, perhaps, a short article might afford assistance to some photographer of less experience, to whom it might befall the unpleasant duty to take the picture of a corpse.

My mode of procedure is as follows: where the corpse is at some distance and cannot be conveyed to the glass-room, my first step is to secure proper conveyance, select and carefully prepare a sufficient quantity of plates, pack necessary instruments, implements, chemicals, etc., being careful not to forget any little thing necessary to manipulation. Proceed at once to the cellar or basement of the building, that being more spacious, and generally affording better opportunity of shutting off the light than any other apartment in the house, set up the bath, have your collodion and developer in readiness, your fixer, etc., handy, secure sufficient help to do the lifting and handling, for it is no easy manner to bend a corpse that has been dead twenty-four hours. Place the body on a lounge or sofa, have the friends dress the head and shoulders as near as in life as possible, then politely request them to leave the room to you and your aides, that you may not feel the embarrassment incumbent should they witness some little mishap liable to befall the occasion. If the room be in the northeast or northwest corner of the house, you can almost always have a window at the right and left of a corner. Granting the case to be such, roll the lounge or sofa containing the body as near into the corner as possible, raise it to a sitting position, and bolster firmly, using for a background a drab shawl or some material suited to the position, circumstance, etc. Having posed the model, we will proceed to the lighting, which, with proper care, can be done very nicely. I arrange the curtains so as to use the upper portion of the windows, allowing the light to flow a little stronger, but even and smoother from one side, and just enough from the other to clear up the shadow properly, turning the face slightly into the strongest pencil of light you can produce a fine shadow effect if desirable.

Place your camera in front of the body at the foot of the lounge, get your plate ready, and then comes the most important part of the operation (opening the eyes), this you can effect handily by using the handle of a teaspoon; put the upper lids down, they will stay; turn the eyeball around to its proper place, and you have the face nearly as natural as life. Proper retouching will remove the blank expression and the stare of the eyes. If the background should not suit you, resort to Bendann's style of printing and make one that will. Such with me has proved a successful experience.

There is even one attempt at professional humor about the task. In *Anthony's Photographic Bulletin* for 1872 (vol. 3, no. 12, December, p. 783), a Chicago photographer named W. Handsome had the following letter published:

> *I was called upon the other day to make a picture of a dead man. I went to see how best I might do so before taking material, etc. On getting to the door I heard the cry peculiar to the Irish wake business, and entered hat in hand. No one knew me evidently, and I had time to take stock of the surrounding, A shanty, minus plaster, in the burnt district of Chicago [this was soon after the great fire of Chicago], an inner room with ever so many wax tapers in glass candle-sticks each forming a cross, a canopy of white sheets, under which lay the coffin, and the once man. I told my mission, fixed the time for taking etc. and remarked, "this is the man who fell from the baker's wagon and broke his neck, is it not?" The woman who made so much noise as I entered, hastily answered, "Oh, no, thank God! he died with cholera morbus" (Exit Photo [-grapher]).*

There is scant documentary evidence of how the "users" of these images felt about them. In a letter written by Eva Putham to her Aunt Addie (Adelaide Dickinson Cleveland) on February 7, 1870, from Northbridge, Massachusetts, Eva comments on the death of the child Mabel, Adelaide's sister and Eva's aunt: "How lonely you must be, how could you endure it. If it were not for the assurance that it's *all* for the best. I am glad that you could get so good a picture of the little darling dead Mabel as you did, the fore head and hair look so natural" (from The Grace Cleveland papers, Special Collections, The John Hay Library, Brown University, Providence, Rhode Island).

After the 1880s the trade journals no longer carry articles about photographing the dead and photographers do not advertise the service. Among the last professional acknowledgments of the practice was this item which appeared in 1891 in the *American Journal of Photography* (vol. 12, August, p. 350): "According to the *British Journal of Photography*, flash light is now successfully used in photographing the dead. The artificial light overcoming the difficulties heretofore experienced in photographing a corpse. The editor states that he was 'recently shown very satisfactory results'—of their kind—obtained by this means."

Since the activity continued in a seemingly undiminished manner, the editors of these journals must have decided that a public discussion of the task was either unnecessary or no longer in the best interests of the profession. Apparently, the knowledge that photographers offered this service was sufficiently widespread as to make the public announcement of the fact unnecessary. The ease with which nineteenth-century photographers discussed the task of photo-

graphing the dead is surely some indication of how culturally normative the practice was. The range of possible practice for a professional photographer is completely circumscribed by the public's interest in buying the service. The fact that these discussions disappeared from professional journals and the advertisements were gone from the newspapers by 1900 is also a sign of a shift in public sentiment. Many authors have commented on the differences between nineteenth- and twentieth-century attitudes toward death in America. Gorer suggests that

> During most of this period [i.e., the nineteenth century] death was no mystery, except in the sense that death is always a mystery. Children were encouraged to think about death, their own deaths and the edifying or cautionary death-beds of others. It can have been a rare individual who, in the nineteenth century with its high mortality, had not witnessed at least one actual dying, as well as paying their respect to "beautiful corpses"; funerals were the occasion of the greatest display for working class, middle class, and aristocrat. The cemetery was the centre of every old-established village, and they were prominent in most towns. It was fairly late in the nineteenth century when the execution of criminals ceased to be a public holiday as well as a public warning.
>
> (Gorer 1965, p. 195)

In the twentieth century death was ignored, forgotten, and denied, at least in public. As I shall discuss later, the practice of photographing the dead has continued to the present day. No one publicly acknowledged that they provided the service and customers simply stopped talking about it. Once they acquired the images, mourners showed them only to trusted intimates.

Styles of Photographically Representing the Dead

Photography was invented so that Westerners could record and represent the world. The technology offers a unique way to redeem the past—a highly realistic pictorial record of that which is no more. It provides us with a mechanical memory. While photography is able to "permanently" record *any* place or event deemed memorable, it is Americans' virtually unlimited and insatiable need for human likenesses that accounts for the enormous popularity of photography in the United States. In a world where a metaphysical hope for immortality is questioned by many, photographs promise a materialist realization of eternity.

This need has its historical roots in the nineteenth century. It has been said

by many people that, in America, the nineteenth century belonged to the middle class. Full of a sense of themselves and their importance, they pursued public immortality through the construction of museums and other temples to the arts and sciences. Privately they sought to emulate the aristocracy by having their portraits made. It was only natural that photography should become overwhelmingly popular in a country where the majority of its citizens consider themselves to be middle class.

> *The photographic portrait was seen as a means of physical preservation, a kind of instant immortality. . . . More and more people came to be aware of their own importance and to have a feeling that history was made by ordinary people like themselves, as well as knights, great warriors, princes and kings. Crucial to an awareness of one's place in history is a sense of one's life as an extension and continuation of other lives. Where the serf of the Middle Ages would be all too content to bury dead relatives quickly and forget about them as soon as possible, the middle class nineteenth century American felt that it was important to remember his father, and important for his son and his son's son to remember him; that he was indeed someone of worth and part of an historical continuum.*
>
> (Snyder 1971, p. 74)

Most photographic representations of the human form, alive or dead, are best understood as likenesses rather than portraits.[1] In the case of commercial photography, professional photographers provided their clients with a recognizable reproduction. The sitter was framed in the center. Props and backgrounds were standardized—purchased by the photographer from a supply house. The setting revealed little personal about the sitter. The pose was simple, straightforward. The lighting was flat. The sitter's costume was most often their "Sunday best." As clothing became more and more standardized and store-bought, the social status of the sitter, let alone his or her profession or ethnicity, became obscured. Even when props were used, they were most often a book or photo album that probably belonged to the photographer rather than the sitter.[2]

Most images simply detailed the sitters' features. The expression was either one of a neutral or flat affect, particularly when long exposure times were required by the insensitivity of the film, or the opaque "cheese" smile we now all associate with being photographed. Seldom does there appear to be any attempt to convey some unique characteristic of the sitter, i.e., to portray, rather than merely represent. We are left with an image of what someone looked like and little about his or her character or personality. It is probably safe to assume that most sitters assumed a passive role with the photographer and in turn the pho-

tographer lacked the skill or interest to attempt anything other than recording the customer's likeness.[3] Snapshots that portray are even less frequent than professionally made photos.

From the beginning of photography, some professionals were aware of the distinction between a likeness and a portrait. When it was economically feasible and the camera operator had the technical skill and artistic vision, an attempt was made to offer the clients photographic portraits. Today, prestigious firms like Bachrach clearly attempt to portray. The studio photographers I have encountered with a rural and lower-middle-class urban clientele assume that few sitters are interested in "artistic" images. They want a recognizable likeness. Attempts at "artistic" lighting are often regarded by the clients as underexposed mistakes. Attempts at highlighting or otherwise modeling the face with light is so rare among professional studio photographers that it is referred to as "Rembrandt" lighting.[4]

In Sobieszek's discussion of the portraiture of Southworth & Hawes, he cites the writing of their contemporary, Marcus Aurlieus Root. Root claimed that most of his sitters considered also

> faithful likeness the chief desideratum in portraiture, the mere head and bust are preferable to a larger proportion of the figure. He added further that if an ordinary portrait was simply a faithful likeness, an artistic portrait was an expression of "livingness" and "individuality." "For a portrait . . . however splendidly colored and however skillfully finished its manifold accessories, is worse than worthless if the picture face does not show the soul of the original—that individuality or self-hood, which differentiates him from all beings, past, present, or future." "Expression," Root added, "is a sine qua non towards what a man really is, whether in an original or a portrait."
>
> (Sobieszek 1976, pp. xx–xxi, quoting from
> Root 1971 [1864])

Postmortem photographs, by their very nature, force the photographer to actively construct the scene and to deliberately pose the sitter. And yet, Southworth's description of techniques for composing a deceased subject, cited above, seems to have had little effect on the rest of the profession. Figure 17 clearly shows that Southworth practiced what he preached. But it is a most unusual postmortem photograph. Remarkably few postmortem photographs display this skill for composing the body. The majority are simple likenesses. They record the features of the deceased and nothing more.

Intentionality is always difficult to determine when contemplating a photograph or any other mediated communicative form in which the sender and

receiver are separated by time and space (Worth and Gross 1981). One is forced to conjecture about whose intention you are looking at in a commercially produced photograph—the sitter's or the photographer's. At times the certainty that anything was consciously intended, other than the simplest desire for a recognizable likeness, has to be called into question. While all photographs are culturally bounded artifacts, some yield more information about the culture of their maker and subject than others. As I suggested in the Introduction, any cultural artifact stripped of its provenience is more useful as an object of meditation than one of analysis. With those limitations in mind, let us examine the images to see what can be learned from them.

There are some stylistic consistencies that appear to straightforwardly reflect cultural attitudes toward the dead and the rituals surrounding them. From 1840 until 1880, three styles of postmortem photography emerged. Two types were designed to "deny death," that is, to imply that the deceased was not dead, while a third variant portrays the deceased with mourners. These conventions should not be regarded as strictly chronological in that once established some continue to be employed to the present time. Changes in styles of representation that do occur at the turn of the century can be attributed to technical and social changes in funerary and burial customs.

The Last Sleep

The association of death with sleep is as old as Western culture itself. In classical Greece, the sons of night were Hypnos, god of sleep, and his twin, Thanatos, god of death. This connection can be traced to the present day. From Homer and Virgil to Saint Paul, death was described as a "deep rest," and a "deathly sleep." Martin Luther called death a "deep, troubled sleep," and the grave, a "bed of repose." "The expression 'asleep in God' is a Huguenot one. . . . One takes care, therefore, when speaking in the presence of a corpse. Silence is observed both in the death chamber and in the cemetery: one whispers there, one does not shout. One says that one is afraid of 'waking the dead'" (Ragon 1983, pp. 207–208). Theodore Cuyler, in his 1873 privately printed *The Empty Crib: The Memorial of Little George,* describes a visit to the "sleepers" at Brooklyn's Greenwood Cemetery, calling the cemetery a "vast and exquisitely beautiful dormitory." [5]

As a pictorial convention. "the last sleep" enacts a sentiment toward death which, according to Kenneth Ames, dominated the latter half of the nineteenth century in America. "In the ideology of the late nineteenth century, death did not really occur. People did not die. They went to sleep. They rested from their

labors" (Ames 1981, p. 654). James Farrell suggest that

> *Americans employed many analogies and images that express "the modern be-lief that the process [of death] is easy." Woods Hutchinson acknowledged that "while disease is often painful, death itself is gentle, natural, like the fading of a flower or the falling of a leaf." In an article entitled "Sleep and Death," how-ever, John H. Gardner highlighted the most popular image of painless death in periodical literature. One writer stated matter-of-factly that "in fact, it is as painless as falling asleep." Dr. E. L. Keyes believed it "to be more than prob-able that the final act of dying is as simple and painless as going to sleep—and practically, we all die daily, without knowing it, when we go to sleep for the night."*

> (Farrell 1980, p. 57)

18
The Last Sleep. *George Lamb-din, 1859. Oil on canvas, 40 × 54¾ inches. Courtesy, Museum of Art, Raleigh, N.C.*

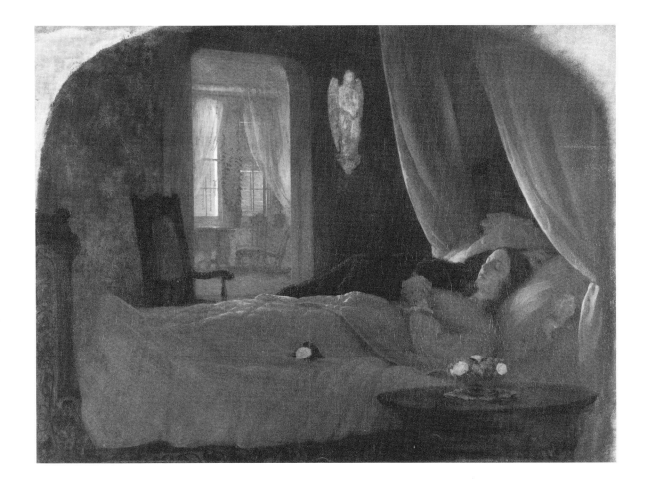

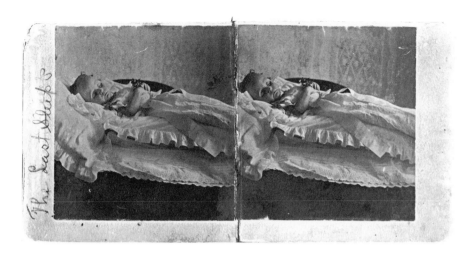

19
Postmortem photograph of unidentified child. Unknown, ca. 1870–1890s. Albumen print, handmade stereograph. (Note: inscription "The Last Sleep" written on the side.) Courtesy, Center for Visual Communication, Mifflin-town, Pa.

It is therefore not surprising that "the last sleep" is a commonplace convention in nineteenth-century photographs—one that dominates from 1840 to 1880. The sentiment was also given expression in paintings of the same period. When George C. Lambdin's 1859 painting entitled *The Last Sleep/The Dead Wife* was exhibited at the Yale Art Gallery, critic Eugene Benson (1870) wrote: "We should like to write of Lambdin's 'Last Sleep,' No. 41, than which we know no more religious, no more touching, nor more satisfying and chastening expression of death in life" (figure 18).[6] A cursory glance at the photographs from this period makes it obvious that photographers intended to create the illusion of people "asleep" and not dead. The Southworth & Hawes advertisement cited earlier offered "to have Miniatures of Deceased Persons agreeable and satisfactory, and they are often so natural as to seem, even to Artists, in a quiet sleep" (cited in Rinhart and Rinhart 1980, p. 300). Amateurs even wrote the sentiment on their handmade stereographs (figure 19).

In the July 1858 issue of *The Photographic and Fine Art Journal,* the editor comments on the masterful way in which a daguerreotypist is able to make a dead child look asleep.

Here is another just tribute to artistic worth:

Life from the Dead.—We have been shown a daguerreotype likeness of a little boy, the son of Thomas Dorwin, taken after his decease, by Mr. Barnard, of the firm of Barnard & Nichols. It has not the slightest expression of suffering, and nothing of that ghastliness and rigity [sic] of outline and feature, which usually render likenesses taken in sickness or after death so painfully revolting

*as to make them decidedly undesirable. On the other hand it has all the fresh-
ness and vivacity of a picture from a living original—the sweet composure—
the serene and happy look of childhood. Even the eyes, incredible as it may
seem, are not expressionless, but so natural that no one would imagine it could
be a post mortem execution. This is another triumph of this wonderful art.
How sublime the thought that man, by a simple process, can constrain the
light of heaven to catch and fix the fleeting shadow of life, even as it lingers
upon the pallid features of death.*

*Hail glorious light that thus can timely save
The beauty of our loved ones from the gave!*

Most photographs examined for this study produced prior to 1880 con-
centrated on the facial features of the deceased. A minority showed the entire
body. But regardless of whether the image was a close-up or not, the body rested
on domestic furniture, often a sofa, usually draped with a coverlet or sheet (figure
20). A small number are shown in a coffin (figure 21). Sometimes, a dead child
is displayed as if asleep in a buggy (figure 22). When the setting can be seen, it
appears to be the living room or parlor of a private home. Flowers, a book, or a
religious article such as a cross are sometimes placed in the hands or on the chest
in an attempt to compose the image (figure 23).

*20
Postmortem photograph of
unidentified child. Harrison,
Lock Haven, Pa., ca. 1890–
1910. Tinted gelatin silver
print on cardboard mount,
carte de visite. Courtesy, Cen-
ter for Visual Communication,
Mifflintown, Pa.*

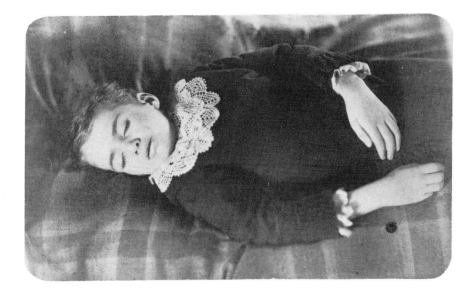

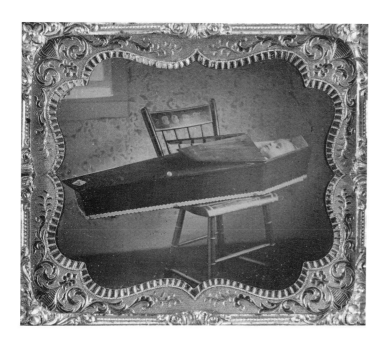

21
Unidentified child in a coffin on a chair. Unknown, ca. 1850–1870s. Tintype, ⅙ plate. Courtesy, the Strong Museum, Rochester, N.Y., copyright 1992.

22
Postmortem photograph of unknown child in buggy. Phillips New Gallery, Main Street near Sixth, Lafayette, Ind. Tinted gelatin silver print on cardboard mount, ⅜- × 7½-inch print on 6½- × 9½-inch mount. (Note: bedspread as backdrop probably indicates the photograph was taken at home.) Courtesy, Center for Visual Communication, Mifflintown, Pa.

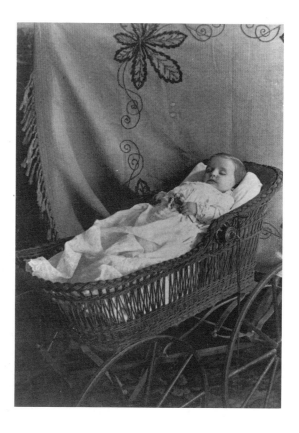

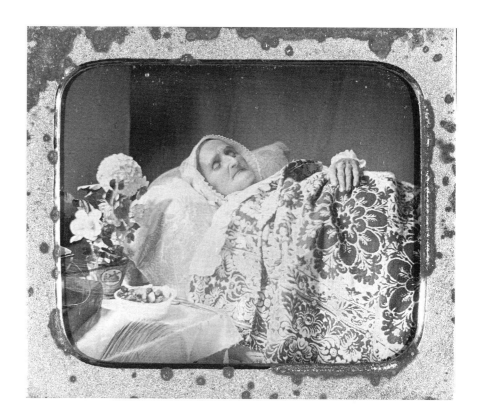

23
Postmortem photograph of unknown woman under blanket with hand uncovered, flowers and dish on table. Unknown, ca. 1840–1860s. Daguerreotype, ⅙ plate. Courtesy, the Strong Museum, Rochester, N.Y., copyright 1992.

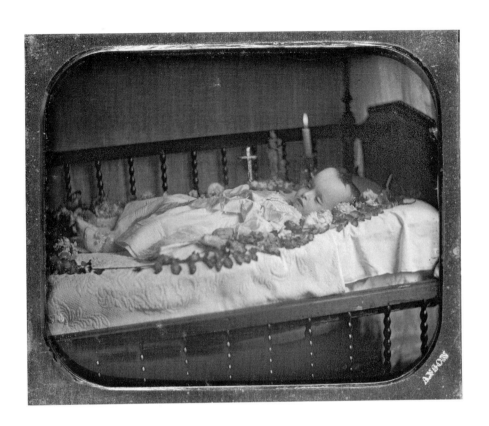

24
*Postmortem photograph of
unidentified child in bed with
flowers, a cross, and lit candles.
Anson's Studio, 589 Broadway,
New York, ca. 1840–1850s.
Daguerreotype, ⅙ plate.
Courtesy, the Strong Museum,
Rochester, N.Y., copyright
1992.*

Rarely is the photograph personalized, i.e., designed to convey something about the deceased as an individual. Even when objects are present they look more like standard props used to enhance the composition than the personal property of the deceased, much like the ubiquitous book that so many sitters held in carte de visite photographs. A rare number of postmortem images are composed in a painterly fashion (figure 24). Children are occasionally portrayed with one of their toys—an image undoubtedly fraught with deeply sad remembrances for the parents (figure 25). At times the intended symbolism is obscure. Figure 26 is a cabinet card of a deceased child with rosary beads, a bell, and a pencil. While the meaning of the beads is certainly not problematic, why a bell and pencil?

There were some practical reasons for the popularity of close-up images of the deceased on the sofa in the parlor. Embalming was not common in America until after 1880, and ready-made coffins were not generally available. Funeral parlors were nonexistent. The corpse was placed on a board over ice to retard

25
Postmortem photograph of unknown child with doll. Mrs. H. Latourrette, Artist, 214 E. Fifth St., Dayton, Ohio, ca. 1860–1880s. Albumen print on cardboard mount, carte de visite. Courtesy, the Strong Museum, Rochester, N.Y., copyright 1992.

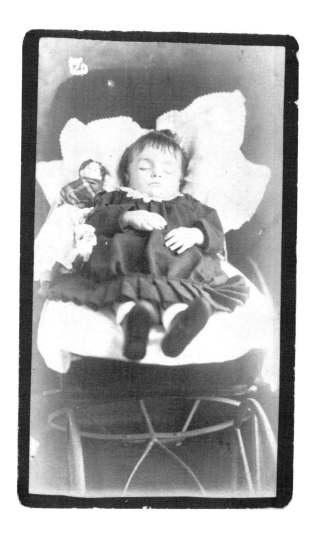

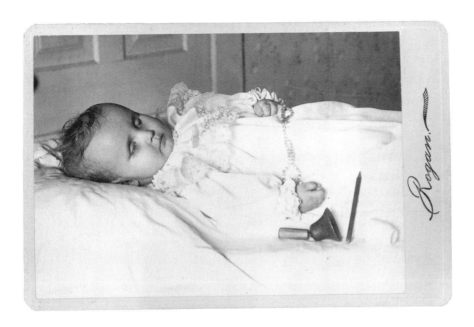

decomposition. Viewing occurred, if at all, while the family was waiting for the coffin to be completed. The reason some photographers advertised that they could come to the deceased's home with only an hour's notice is that the entire burial process sometimes took only one day. The majority of the postmortem sittings entered in Southworth's account book note a charge for a carriage, indicating that the photograph was taken at the home of the deceased.

> *Before the 1880s, undertaking was largely an informal, unorganized enter-*
> *prise, often the adjunct of a furniture business. In the small towns and rural*
> *areas where most Americans lived, a death in the family set a train of tradi-*
> *tion into motion. A member of the family or a neighbor began to prepare the*
> *body for burial. He—or she, for often these last rites were performed by*
> *women—placed a board between two chairs, draped it with a sheet, laid the*
> *body upon it, and washed the corpse. Sometimes the features of the corpse had*
> *to be prepared for presentation. To close the mouth, people used a forked stick*
> *between the breast bone and the chin, fastened with a string around the neck.*
> *To close the eyes, they placed a coin on the eyelids. Then they dressed the body*
> *for burial, either in a winding sheet or a shroud. In warm weather, they put a*
> *large block of ice in a tub beneath the board, with smaller chunks about the*
> *body.*

While these preparations proceeded, another neighbor went to notify the cabinetmaker or furniture dealer, who provided a coffin from his small stock or made one to order. In the early nineteenth century, the coffin was simply a six-sided box with a hinged lid. After 1850, the coffin might be lined with cloth, to counter the severity of the rough wood. In either case, on the day of the funeral the undertaker carted the coffin to the house in a spring wagon. There, he placed the body in the coffin for the funeral, which usually proceeded according to a religious formula under the direction of a minister. After the ceremony, survivors viewed the corpse "in open air," closed the coffin, and set it back on the wagon or on a bier for the trip to the graveyard. At the graveyard, either the sexton or some friends had dug a grave, and after the body had been committed to the earth, these same people scooped the dirt back into the hole

(Farrell 1980, pp. 147–148)

The "last sleep" pose seems to be an excellent example of technology and ideology being in a close fit. If the sentiment was to regard death as the last sleep, then surely you did not want a postmortem photograph taken in a coffin—a certain sign of death. Moreover, coffins were usually made of rough-hewn lumber without a liner. Not exactly the most pleasant setting for the last, and in some cases only, image of the deceased.

By the turn of the century, the pose was supplanted by other photographic practices. However, the sentiment continued to be popular. Farrell suggest that "Often funeral directors in the period [i.e., 1880–1920] described their productions in terms of people asleep . . . they tried to blur the distinction between life and death" (Farrell 1980, p. 161). In David Sudnow's (1967) ethnography of dying and death in hospitals, he mentioned that when the staff prepares a body "a patient's eyelids are always closed after death, so that the body will resemble a sleeping person" (p. 66).

A variation of "the last sleep" pose represents an attempt to actually conceal the death. For want of a better label, this style can be titled "alive, yet dead." Sometimes the body was placed in an upright position—often in a chair (figure 27).[7] The eyes were open or even painted on afterwards as this item from an 1898 Wisconsin newspaper suggests: "Mrs. Freidel had a picture taken of her little baby in its coffin. Then when a fellow came up the road who did enlargements she had just the baby's face blown up to a two foot picture. But, since the baby's eyes were closed, she had an artist paint them open, so she could hang it in the parlour" (Lesy 1973, n.p.) (figure 28).

The illusion the photographer was trying to create is not one of a person at rest, but alive. The need to create the fantasy was so strong that sometimes

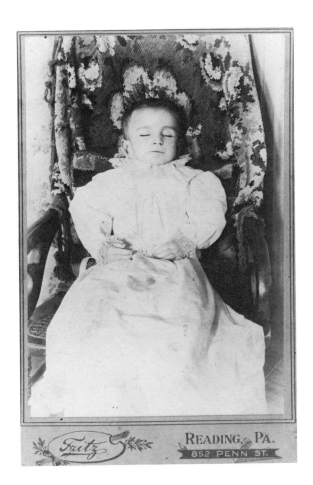

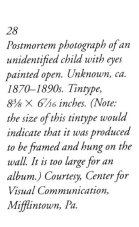

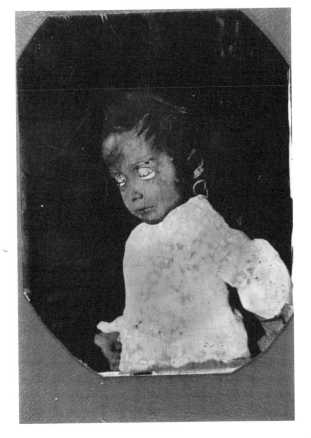

27
Postmortem photograph of unknown child in chair. Fritz, Reading, Pa., ca. 1880–1900. Gelatin silver print on cardboard mount, cabinet card. Courtesy, Center for Visual Communication, Mifflintown, Pa.

28
Postmortem photograph of an unidentified child with eyes painted open. Unknown, ca. 1870–1890s. Tintype, 8⅜ × 6⁷⁄₁₆ inches. (Note: the size of this tintype would indicate that it was produced to be framed and hung on the wall. It is too large for an album.) Courtesy, Center for Visual Communication, Mifflintown, Pa.

29

*Vignetted postmortem photo-
graph of unidentified African-
American woman. Lovell,
Amherst, Mass., ca. 1880–
1900s. Gelatin silver print on
cardboard mount, cabinet
card. (Note: the photograph
has been vignetted and the
image turned 90 degrees so as
to provide the illusion that the
woman is alive.) Courtesy,
Center for Visual Communica-
tion, Mifflintown, Pa.*

the photographer would take the picture of the body supine and then turn the photograph 90 degrees so that it appeared to be upright (figure 29).[8] These images resemble the posthumous mourning paintings discussed earlier and were undoubtedly motivated by the same needs.[9]

Casket Photographs

During the era of the cabinet card photograph (ca. 1880–1900), the custom of photographing the dead as if asleep continued but with less frequency and with far fewer close-ups. As mentioned earlier, the idea that death was "the last sleep" remained popular long after the "last sleep" pose was replaced with images that

clearly marked the subject as deceased. The ideology of death and its material manifestations in funeral customs and death-related picture taking assumes a complexity not found in the nineteenth century. While "last sleep" poses represent some attempt at artifice, the majority of casket photographs are straightforwardly composed documents. With the rare exception of people like James Van Der Zee (see figure 52), professional photographers completely stopped trying to portray the dead. What creative energy professional photographers expended in the twentieth century was devoted to the narrative scenes of grief discussed below. Even these "portraits" seem to disappear by the 1940s, when professionally produced death-related photographs become largely confined to a few highly conventionalized views.

From 1880 to 1910, the most common image was that of the entire body, usually in a casket, thus making it impossible to pretend that the deceased were asleep or "dead, yet alive" (figure 30).[10] The setting for casket photos was still the private home or possibly the parlor of a funeral home, which so resembled a private home as sometimes to be indistinguishable. The props became more elaborate. In addition to flowers and other objects placed in the hands or on the chest, there were sometimes funeral floral arrangements. While the images were still produced by professionals commissioned to do the work, no one advertised the service, perhaps an indication that public sentiment was beginning to change.

Photography was trapped by its own realist limitations. It could not bring the deceased back to life in the way that posthumous mourning paintings did. However, this limitation did not appear to diminish the popularity of postmortem photography nor did it cause an increase in the number of posthumous paintings. In fact, the paintings virtually disappear by the end of the nineteenth century, the Stanford paintings, described in chapter one, being among the last (see figure 13).

The advent of casket and funeral photographs was most likely a reflection of three alterations in the funeral customs of Americans—embalming, the replacement of the coffin with the casket, and the increasing popularity of funeral flowers. Initially, embalming was introduced as a means of transporting bodies. It gained its popularity during the Civil War, when families wanted their loved ones who were killed in battle to be returned home for burial. It rapidly became popular because it enabled survivors to have an extended viewing of the remains prior to burial. It also permitted friends and relatives who lived far away to participate in the funeral, thus making it possible to have more elaborate funerals. By 1890, it had replaced ice as the preferred means of preserving a corpse (Farrell 1980, p. 159). Photographers now attended to their postmortem commissions in the funeral home where the funeral director controlled the setting. It was

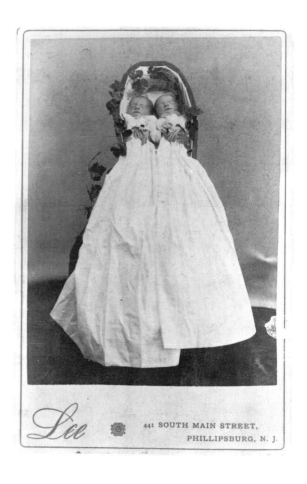

30
Postmortem photograph of un-identified twins in one coffin. Lee, Phillipsburg, N.J., ca. 1880–1900. Gelatin silver print on cardboard mount, cabinet card. Courtesy, Center for Visual Communication, Mifflintown, Pa.

unlikely that the photographer could pose the corpse in any manner that suited his or her taste.

Those in the business of producing funerals sought new ways to enhance the illusion that the deceased was not really dead. W. P. Hoenschuh, a turn-of-the-century authority on funerals, expressed the dominant feeling: "One idea should always be kept in mind and that is, to lay out the body so that there will be as little suggestion of death as possible" (cited in Farrell 1980, p. 160). To that end, the container used to dispose of the body went through a significant change in appearance. "Early nineteenth century Americans had become accustomed to the coffin, a wooden box shaped by the local undertaker to fit the body of the deceased. But during the same period that cemeteries supplanted graveyards and funeral directors succeeded undertakers, caskets replaced coffins.

The Stein Co. and others began to mass-produce caskets which differed from coffins in richness and ostentation, in shape in name and in purpose" (Farrell 1980, p. 169). In some sense, the photographers' work was at cross-purposes to the efforts of the funeral directors. The photographs were irrefutable evidence of death while the funeral parlors were "slumber rooms" for the eternally asleep.

During the early twentieth century, postmortem and casket photographs were augmented by other photographic commemorations of death. The attention shifted away from a concentration on the likeness of the deceased alone to an acknowledgment of the mourners and the social event of a funeral and viewing. As noted before, the new images are a reflection of changes in attitudes toward death. It was a time when the private funeral was becoming more complex. "According to Joseph N. Green [author of *The Funeral,* written in 1900], 'often the placement of the casket in the room, gracefully canopied by an attractive curtain and banked against flowers artistically arranged, forms a picture so beautiful as to relieve the scene of death of some of the last memory of the departed in the home'" (Farrell 1980, p. 177).

While the deceased were still portrayed, close-ups were almost never used. Instead they were shown in the casket with the symbols of the funeral surrounding them. By the 1930s professional photographers standardized their approach to include two views—one where approximately one half of the body was seen and a second where the entire casket was visible. The conventions, whether the photographer be a professional or snapshooter, remain virtually unchanged to the present day (figures 31 and 32). Some twentieth-century images strain the limits of the designate portrait or human likeness in that the deceased occupies only a small portion of the frame and in some cases the body is not even visible (figure 33).

The role of the professional photographer has diminished in this century, but it has not totally disappeared. More than half of the professional photographers in Pennsylvania have taken funeral pictures in the last decade. However, the commissions are rarities—only once or twice in each photographer's career. Their services are never advertised. In addition, several funeral directors have told me that they have taken postmortem photographs and have done so throughout their professional life. One director even went so far as to buy a Polaroid camera solely for this purpose. (See photographers' and funeral directors' surveys in chapter four for details.)

A letter from Margaret Marshall Sanders to her mother, written in Rochester, New York, on May 30, 1908, provides evidence that the practice was sufficiently common at this time for the writer to know about a photographer who specialized in postmortem photography in the Rochester area. Also, note that Mrs. Sanders is careful to specify who will be allowed to look at the picture. This

31
Postmortem photograph of T. Bailor. Paul Smith Studio, Port Royal, Pa., ca. 1940s. Gelatin silver print, 8 × 10 inches. Courtesy, Center for Visual Communication, Mifflintown, Pa.

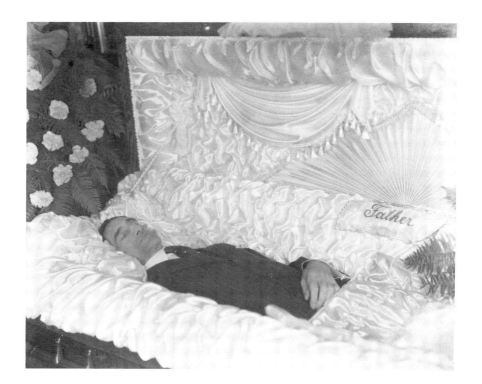

32
Postmortem photograph of T. Bailor. Paul Smith Studio, Port Royal, Pa., ca. 1940s. Gelatin silver print, 8 × 10 inches. Courtesy, Center for Visual Communication, Mifflintown, Pa.

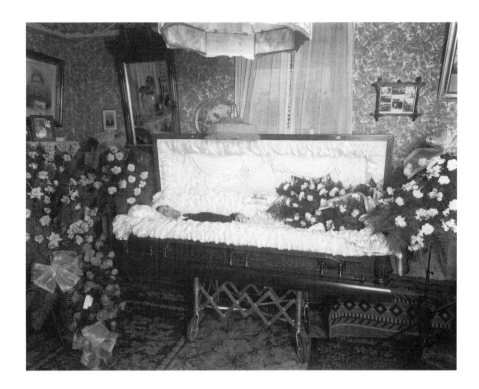

33
Postmortem photograph of Irvine McCohan. Paul Smith Studio, Port Royal, Pa., September 23, 1943. Gelatin silver print, 8 × 10 inches. Courtesy, Center for Visual Communication, Mifflintown, Pa.

circumspection suggests a shift in attitude—the practice was becoming a private matter. The images were produced for the eyes of family members only. In the letter, Mrs. Sanders describes the circumstances surrounding a stillbirth of her sister Rida.[11] While preparing for the funeral and burial of the dead child, Mrs. Sanders attempts to locate a photographer through the American Express office. They recommend one who is already engaged. The photographer suggests another.

> *I went to the Main Street of the city and climbed a staircase.* Found a good natured man whose speciality is photographing the dead [*emphasis added*]. I said, "Get your things together quickly and come with me—and telephone for a carriage. I can't walk." [*He tells her they have only two blocks to walk.*] A few minutes later he was lugging his big bag up the street and guiding me across crowded crossings. . . . The undertaker was very kind. He and this Mr. Price [apparently the photographer][12] arranged things and I directed. "No caskets, no flowers—nothing to suggest dead to the mother." They put the baby on a pillow and then I said, "Give it to me." I took it in my arms and looked down on it and tried to smile. I had the man do a good many plates, then I said "I am doing this for my sister and as I have told you she is dangerously ill and is worrying about the baby. A crisis may come when a picture of it may be helpful to her. But I don't want a poor picture, and if I don't like the proofs we will have the plates destroyed." The photographer said he would do his best, and I hurried back to the Hospital . . . She [Mrs. Sissell, a friend of the family, who was also involved in organizing the funeral and burial] arrived at the undertaker's with a photographer just after I left, but of course under the circumstances the man [funeral director] had to tell her. I said I was sorry she had not gone in and taken her photographs. The more pictures we have of the dead baby for Rida the better. . . . Must not forget to say that the proofs of the photos are good, only as I said to the photographer I am not looking pleasant enough. "I don't wonder you could not smile that day" he said. I don't want anyone to see the photos except King [the father of the dead child], Grace [a family friend] and Sister Sissell till Rida does but she will be sure to send you the first one.

By the early 1890s, Kodak made it possible for people to take funeral pictures without involving outsiders. Families started to rely on themselves and gave fewer commissions to professionals. The family snapshooter or, in some cases, the funeral director, started taking these pictures as soon as the technology was available, as can be seen in the early circular Brownie camera image of figure 34.

34
*Photograph of coffin. How-
land & Chandler, Los Angeles,
ca. 1890s. Oval gelatin silver
print on cardboard mount,
5½ × 4¼ inches. Courtesy,
the Strong Museum, Rochester,
N.Y., copyright 1992.*

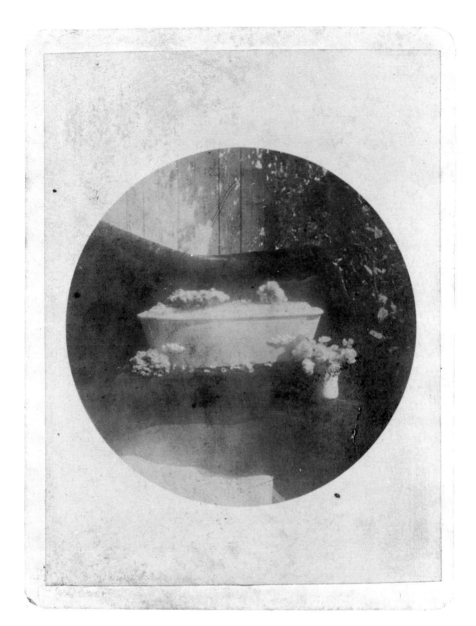

35
Photograph of Miss Jamison's casket, Florida. Unknown, ca. 1910. Gelatin silver print, 2¼ × 3¼ inches. Courtesy, Center for Visual Communication, Mifflintown, Pa.

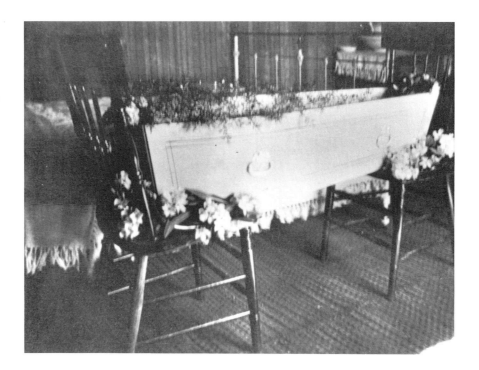

36
John Wheeler with his grandmother, Sarah Lyden Wheeler, Marblehead, Mass. James Wheeler, 1991. Ektacolor print, 4⅞ × 3½ inches. Courtesy, Center for Visual Communication, Mifflintown, Pa.

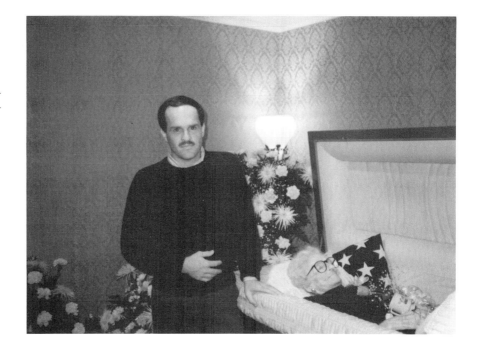

Figure 35 was taken in the late teens in Florida and is an example of a shift away from postmortem images. According to the sister of the deceased, the parents of the young girl disagreed about having a postmortem picture taken. They decided not to ask a "stranger" to take the picture nor could they deal with an image of the body, so they compromised and took their own photo of the casket (Olive Jamison, personal communication, August 21, 1983). The intention was not to have a remembrance of the face of the deceased but of her death.

Given the apparently growing sentiment against the practice of death photography, owning a camera provided families with a measure of privacy. By the 1950s when inexpensive flashbulbs made indoor photography virtually error-free, privately produced images became the most common form of funeral photography. Today, casket and other funeral pictures are most often taken by family members (figure 36). Some family members cover the event of a funeral much in the same way that one would cover a wedding. The maker of figures 37 and 38 produced several funeral albums for his extended family, keeping a copy for himself. He felt that it was his duty as family historian to record funerals much as one would document weddings, confirmations, bar mitzvahs, and other rites of passage.

The family camcorder will undoubtedly become the dominant instrument in the recording of family histories in the near future. In an article in the *Harrisburg Patriot-News* (June 28, 1991, p. C10) entitled "Camcorders Are Subtly Changing the Picture of American Life," Marja Mills notes that "in Oak Lawn [Illinois], the Rev. Dan Willis looks up at a graveside funeral service and sees one of the machines whirring away even there. 'They got the hearse pulling up and everything' Willis said."

Given the private nature of the act and the way these photos are used, it is possible to be unaware of the custom of taking funeral photographs, unless one is a member of a family that takes these images. Furthermore, there is a general reluctance to show the images or acknowledge the practice outside of the family for fear of being considered morbid. All of the families I interviewed for this study became very anxious when I broached the subject. In some cases, it took several interviews before anyone was willing to openly discuss their family funeral photos. A number of funeral directors I know concede that they find spent flashbulbs in the wastebasket of the viewing room after the family has visited. Neither the director nor the family ever discusses the matter.

Only rarely does the private act of taking a casket picture become known to the public and then only through the intervention of the news media. It appears to be more likely that your funeral photographic habits will be deemed newsworthy if you are poor or belong to a minority group. For example, in a *Philadelphia Inquirer* article on January 3, 1988, about the funeral of a Puerto

*Photograph of Roy Hartman
in casket, with Walter Rex,
funeral director, Port Royal,
Pa. Harold Hartman, 1979.
Kodacolor print, 3½ × 3⅜
inches. Courtesy, Center for
Visual Communication,
Mifflintown, Pa.*

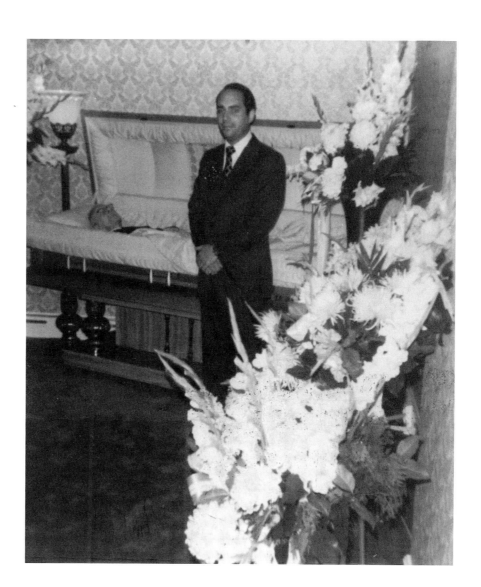

*38
Photograph of funeralgoers at graveside, Port Royal, Pa. Harold Hartman, ca. 1970s. Kodacolor print, 3½ × 3⅜ inches. Courtesy, Center for Visual Communication, Mifflintown, Pa.*

Rican infant who died of AIDS, the story states that "While mourners filed out to waiting cars, Frederick Gonzales [uncle of the child] arranged delicate sprigs from the display and a pink carnation into a bouquet alongside the dead baby's head. Then, with tears on his cheeks, he stood back from the casket and snapped a picture with a small plastic camera." The portrayal of private deaths as news seems to be confined to the publicly powerful and to poverty-stricken minorities—everyone else is invisible.

Babies, Pets, and Loss

A household pet, particularly the family dog, serves as a surrogate child for many American families (Ruby 1983b). "The social metaphor that pet owners are to pets as parents to children is expressed in a whole variety of sentiments and behaviors. Animals are photographed as children, and like children, they serve as social connectors" (Katcher and Beck 1991, p. 267). The grief that one experiences at the death of a pet is similar to the sadness experienced at the loss of a child or spouse. It is therefore only logical to find pets pictorially commemorated in death as in life, like children. Ellen Fisch of Garden City, Long island, paints

39
The tombstone of the Testa family, the Pet Cemetery, Colma, Calif. Pearl Jones, 1984. Gelatin silver print, 8 × 10 inches. Courtesy, Pearl Jones.

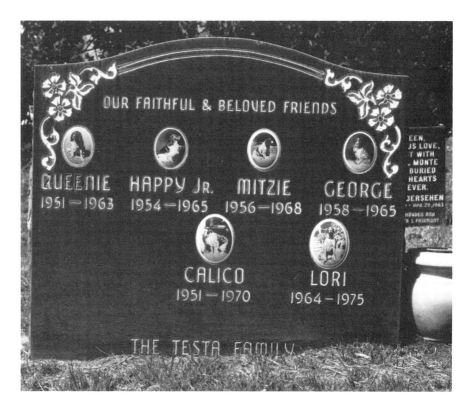

40
Photograph of dead dog. Unknown, ca. 1870–1890s. Albumen print on cardboard mount, $3^{15}/_{16}$ × $5^{1}/_{2}$ inches. Courtesy, Center for Visual Communication, Mifflin-town, Pa.

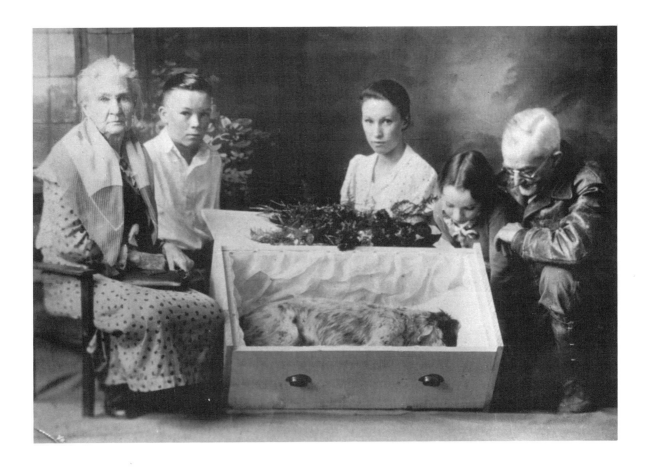

41
Joe Bagley, his children and mother with their dog Spot. Elfie Huntingdon, 1934. Gelatin silver print, 5 × 7 inches. (Note: Joe trained Spot to entertain school children as well as prospective customers who came to buy his honey. Bagley and Huntingdon were partners in a photo studio.) Courtesy, Rell G. Francis, Springville, Utah.

oil portraits of recently deceased and terminally ill dogs from photographs. She is commissioned by the animals' owners to "make them young and full of spots." Without apparently realizing it, Fisch is "reinventing" the posthumous mourning picture discussed in chapter one (Winerip 1990). The sentiments found on tombstones in pet cemeteries clearly attest to the emotional position pets occupy. The pet cemeteries I have visited in the Philadelphia and Los Angeles areas contained a large number of photographs on the tombstones (figure 39). While they are apparently rare, postmortem pet photographs do exist (figure 40).[13] In some cases a pet can become a "business partner" as it was with Spot, Joe Bagley's trained dog. Joe used Spot to entertain school children and induce potential customers to buy his honey. When Spot died, Joe, his mother, and his children posed in a tableau of grief around Spot's coffin while Joe's partner in the photographic business, Effie Huntingdon, took a memorial photo (figure 41).[14]

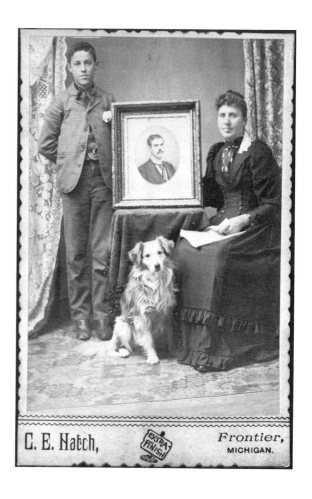

42
Photograph of young man, dog, and a woman holding framed photograph of man. C. E. Hatch, Frontier, Mich., ca. 188?–1900. Gelatin silver print on cardboard mount, cabinet card. Courtesy, the Strong Museum, Rochester, N.Y., copyright 1992.

Family Funeral Photographs and Narrative Scenes of Grief

The centrality of the family, nuclear and extended, in middle-class American life has been commented on by countless scholars. Photographs serve to further idealize and memorialize this social institution. When the absence of a member of the family makes the photograph incomplete, a solution must be found. One means of "creating" a family unit where one does not exist is to substitute a photograph of the missing member, as can be seen in figure 42. This convention has been used throughout the history of photography. Most often it is impossible to determine whether the person represented is merely living in another place, away on business, or deceased.[15] An unusual exception to these ambiguous images is the daguerreotype of a woman attired in widow's weeds holding a post-mortem daguerreotype of a child (see figure 18 in Burns 1990).

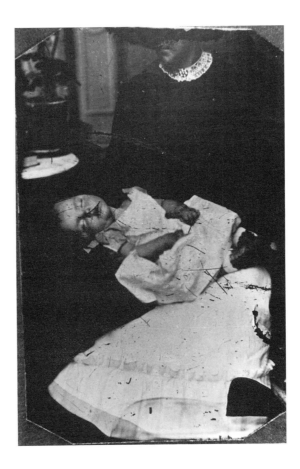

43
Postmortem photograph of child on lap of mother. Unknown, ca. 1870s. Tintype, ¼ plate. Courtesy, Center for Visual Communication, Mifflintown, Pa.

Some images of the family were clearly motivated by a desire to record the deceased with their kin—a last family image. When the subject was a child, it was sometimes held in the arms or on the lap of his or her parent(s) as though the child was asleep. The pose can be found from the daguerrean era to the present day.[16] In some cases, particularly during the early days of photography, the photographer was so successful in creating an illusion that a viewer cannot determine whether the child is asleep or dead (figure 43).

Whether or not there is a display of grief on the face of either parent is difficult to determine, at least with many of the cased images. It is an artifact of the technology. The facial expression of the parents in figure 44 is somber, but it is not too far removed from the neutral affect expression found in most da-

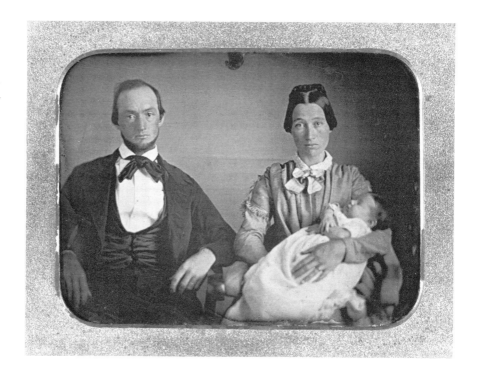

guerreotype likenesses.[17] In the photographic studio of the 1840s through the 1860s, people were placed in restraints—clamps that prevented any head movement. They were told to sit perfectly still, not even to blink. The result was an image of a person without facial emotion holding a rigid, expressionless posture. In the twentieth century, there is an erroneous tendency to read the expression of these photographic subjects as belonging to a somber controlled people.

Remove the dead child from figure 44 and you have a commonplace daguerrean pose. There is no apparent effort made to convey the grief of the sitters; perhaps the idea of expressing emotion was beyond the technical competence of the photographer or was considered socially inappropriate by the grieving parents. The only clue to the nature of the image is the child's face. The majority of these family death tableaux are unadorned renderings of the likenesses of the sitters. Perhaps the motivation of the parents was simply to have a family picture—not to present themselves as grieved parents. Hence the lack of emotion in their faces or in the body posture. We are looking at the only family picture the parents had taken with their child.

45
*Unidentified mother with
dead child. Unknown, ca.
1840–1860s. Daguerreotype,
⅙ plate. Courtesy, the Strong
Museum, Rochester, N.Y.,
copyright 1992.*

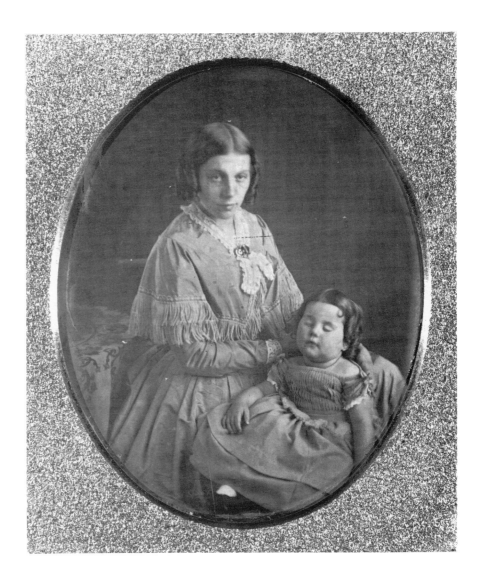

Some of these family mourning scenes are clearly constructed to convey feelings. These portraits extend on a continuum from attempts to merely arrange the parent in a less conventional manner as seen in figure 45,[18] a daguerreotype in which the woman's head is tilted slightly forward, to carefully arranged images. On a rare occasion there are theatrically posed images of grief that have a folksy *Rachel Weeping* quality to them (figure 46). I am not implying that the photographers were consciously emulating the painting. While it is difficult to determine how widely known Peale's painting was, it is a safe assumption that it

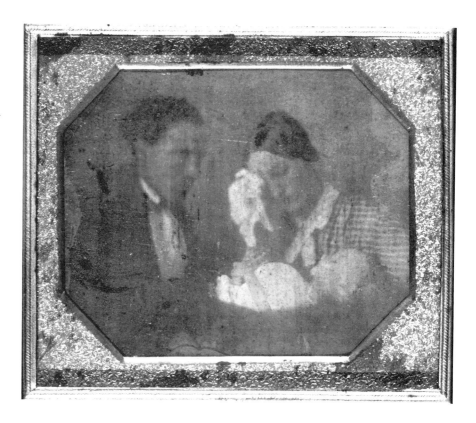

did not serve as a conscious model for many photographers. The pose assumed
by Mrs. Peale in the painting (see figure 9) and the poses assumed by the grieving
parents in these photographs undoubtedly derive from similar repertories of
emotional expression familiar to photographers, painters, and their subjects, as
well as those who viewed the images.[19]

At times, the postures in the photographs appear as if the photographer
arranged the subjects in a dramatic attitude of grief borrowed directly from the
sentimental romantic paintings, lithographs, and pictorialist photographs of the
nineteenth century such as Henry Peach Robinson's classic 1858 composite pho-
tograph, *Fading Away* (figure 47). These portrayals of grief, regarded today as
overblown and sentimentalized, were also popularly expressed in commercially
produced photographic postcards such as *The Orphans* (figure 48).

There is a significant difference between mourners in a family narrative
photograph and commercially constructed images. The people in the family
photos were representing themselves, whereas the people in mourning pictures
were most often not representing anyone in particular, that is, they were models,

47
Fading Away. *Henry Peach Robinson, 1858. Albumen print, 23¾ × 37⅞ inches. Courtesy, the Royal Photography Society, Bath, England.*

48
The Orphans. *Robert McCrum, postmarked 1906, published by Bamforth, New York. Postcard. (Note: the inscription reads:*

> *While they prayed the Angel has come And taken the soul of the orphan home.*
> *"Ora Pro Nobis."*

Words used by kind permission of Hopwood and Crew Ltd., 42 New Bond St., London. W. Bamforth's Life Model Series [England] N.Y.C.) Courtesy, Center for Visual Communication, Mifflintown, Pa.

49

Photograph of unidentified child looking at deceased woman. Unknown, ca. 1840–1860s. Daguerreotype, ⅙ plate. Courtesy, the Strong Museum, Rochester, N.Y., copyright 1992.

types, or generalizations. These conventionalized mourning pictures are stylistically similar to memorial pictures found in the United States beginning with the death of George Washington in 1799. In these memorial pictures, the mourners are supposed to represent the entire nation. (See chapter three for more details.) While it may not be possible to demonstrate a direct link between any one postmortem photographer and these images, the sentiments concerning death and its pictorial representation were commonly available. So it can be argued that both the photographers and the mourners knew how one is *supposed* to look when one is depicted as grief-stricken.

There can be little doubt that the mourners and the photographer self-consciously determined to employ the pictorial and theatrical conventions of the time to represent their feelings in the daguerreotype of a family tableau with the mother with handkerchief to brow (see figure 46), or a child contemplating a dead parent (figure 49), or a family member dressed in an outfit matching that of her deceased relative (figure 50).[20] The practice of narrative mourning tableaux extended into the twentieth century, as can be seen in an Oklahoma image from the 1930s (figure 51) and from James Van Der Zee's work (figure 52). Health care professionals have recently "reinvented" postmortem photography and produce family narrative snapshots, as is discussed in chapter four (figure 53).

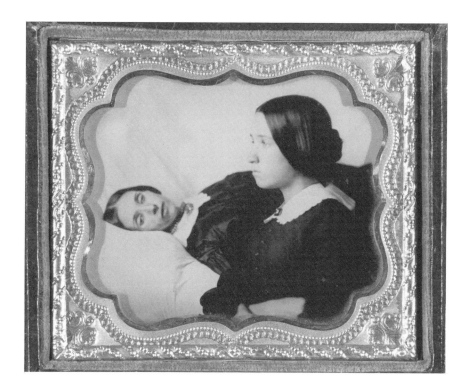

50
Photograph of unidentified mourner with deceased woman. Unknown, ca. 1840–1860s. Ambrotype, ⅙ plate. (Note: both women are dressed in similar mourning clothes, perhaps indicating they are sisters or cousins in mourning for a relative.) Courtesy, the Strong Museum, Rochester, N.Y., copyright 1992.

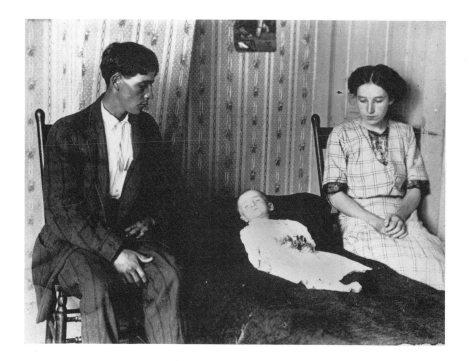

51
Postmortem photograph of unidentified child on bed with grieving parent on either side. Unknown photographer, ca. 1930–1940s. Gelatin silver print, 4½ × 7 inches. Courtesy, Center for Visual Communication, Mifflintown, Pa.

52

Composite postmortem photograph of unidentified child. James Van Der Zee, New York, ca. 1930s. Gelatin silver print, 8 × 10 inches. Courtesy, Donna Van Der Zee, New York.

53

Unidentified parents with their stillborn child. Unidentified, 1980s. Polaroid. Courtesy, Irwin J. Weinfeld, The Reuben Center for Women and Children, Toledo, Ohio.

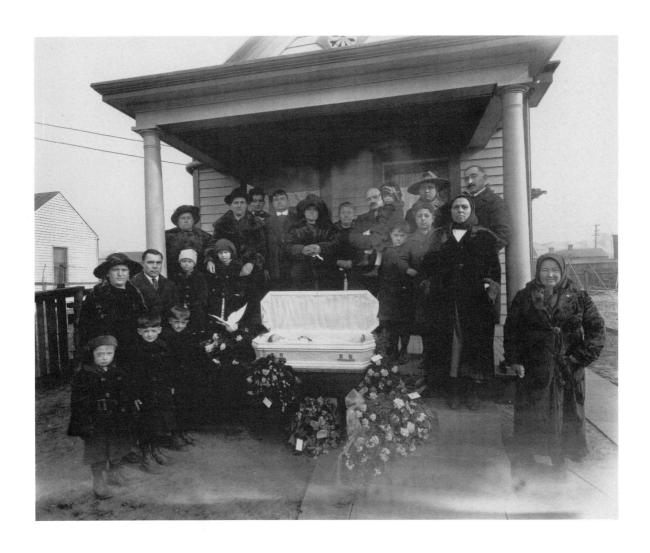

54
Photograph of unidentified group of mourners. Caufield and Shook, ca. 1920–1940s. Gelatin silver print, 8 × 10 inches. Courtesy, University of Louisville Archives.

Some death-related photographs consist of members of the family standing around the casket or at graveside. These images commemorate the death of adults as well as children. They first appear in the 1880s when the funeral became more elaborate. The emphasis is placed on those gathered, their grief, and on the funeral as a social gathering—an approach that continues up to the present.

Funerals are a time when families get together. While a sad occasion, it is not unusual for family members to use the event to conduct family business and have a social time. It is therefore not illogical that family pictures are taken at the time of the funeral. Figure 54 is a picture of a family gathering occasioned by the funeral of the child in the casket. Its primary function would appear to

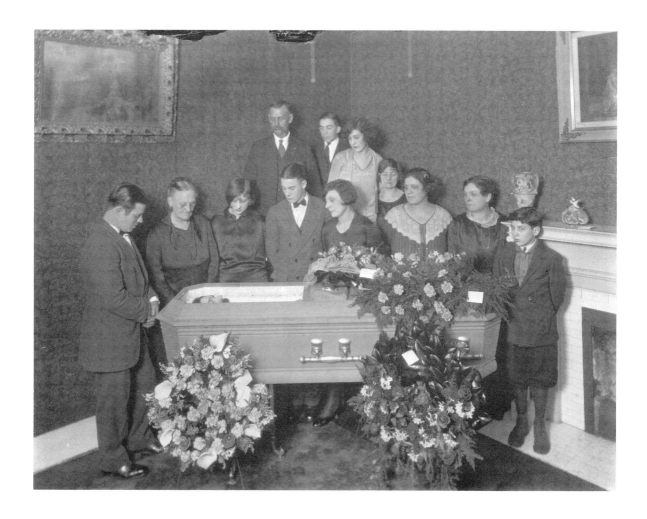

55
Mourners gathered around a coffin. Caufield and Shook, ca. 1920–1940s. Gelatin silver print, 8 × 10 inches. Courtesy, University of Louisville Archives.

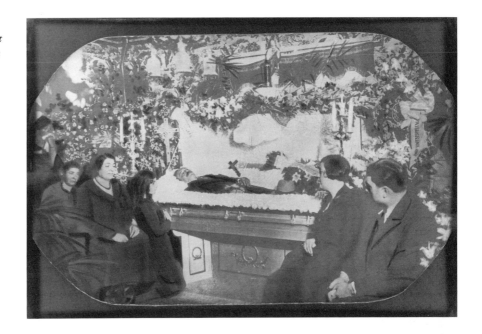

56
Mourners seated around casket of James Pearce, plumber from Scranton, Pa. Unknown, 1938. Hand-tinted gelatin silver print, 15¼ × 9⅜ inches, oval. (Note: Mrs. Pearce was a colorist and is apparently in the picture.) Courtesy, Center for Visual Communication, Mifflintown, Pa.

be to commemorate the gathering of these people. It is an event to record, like all important rites of passage. Like postmortem photographs, it is also something to be sent to family members who were unable to attend. Other images clearly intend to convey the feelings of mourners as they gaze at the deceased in an artistically orchestrated tableau (figure 55) or as mourners "naturally arranged" around the coffin, as seen in figure 56.

The movement away from death being represented primarily in a postmortem photograph toward images of mourners and funerals can also be seen in the advent of graveside pictures where the deceased is represented only by the gravestone. Graveside family photographs are found as early as the carte de visite era (figure 57). Examples have been located as stereographs (figure 58), turn-of-the-century silver prints (figure 59), and snapshots (figure 60).[21] A few of these images are designed to convey feelings, such as "Mrs. Bird at her mother's grave" where we see the mourner, properly attired in black with flowers in hand, sitting beside the newly decorated grave of the deceased (figure 61).[22] Figure 62 is a good example of the blending of the styles. All but two of the mourners are standing in a portrait pose; the two kneeling girls are posed in postures of grief.

57
Photograph of mourners at a gravesite with floral wreath encircling the image. Jaeger & Co., 31 Van Houton Street, Patterson, N.J., 1867. Albumen print on cardboard mount, carte de visite. (Note: the inscription on the obelisk reads "Son of James and Sarah Crecson Died Sept. 2, 1867 Aged 23 years and 7 months.") Courtesy, Center for Visual Communication, Mifflintown, Pa.

58
"Last resting place of Charlie and Maudie, R.P.C." Unknown, ca. 1870–1890s. Albumen print, stereograph. (Note: on the back someone has written "Cousin at New Carlisle.") Courtesy, Center for Visual Communication, Mifflintown, Pa.

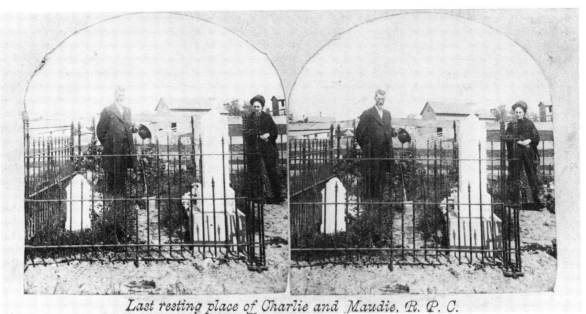

Last resting place of Charlie and Maudie, R. P. C.

59
Harvey Andrews with his family at the grave of his dead child, Victoria Creek Canyon, near New Helena, Custer County, Neb. Solomon Butcher, 1887. Gelatin silver print, 8 × 10 inches. Courtesy, Nebraska State Historical Society, Lincoln.

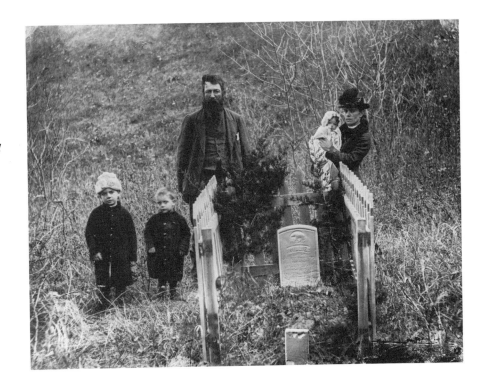

60

Photograph of unidentified mourners at graveside. Unknown, 1947. Gelatin silver print, 2¾ × 4½ inches. (Note: inscription on back reads "Nov 20, 1947 Gettysburg, PA.") Courtesy, Center for Visual Communication, Mifflintown, Pa.

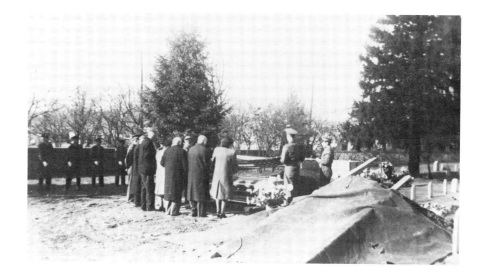

61

Mrs. Bird at her mother's grave. George Edward Anderson (1860–1928), May 30, 1898. Gelatin silver print, cabinet card. Courtesy, Rell G. Francis, Springville, Utah.

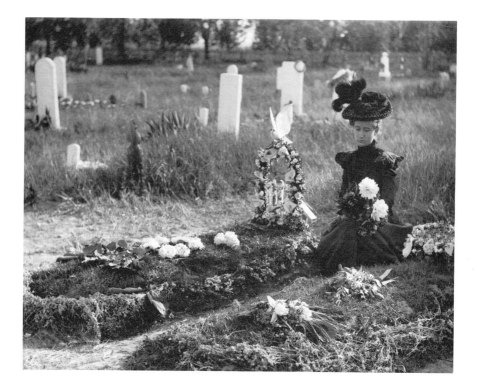

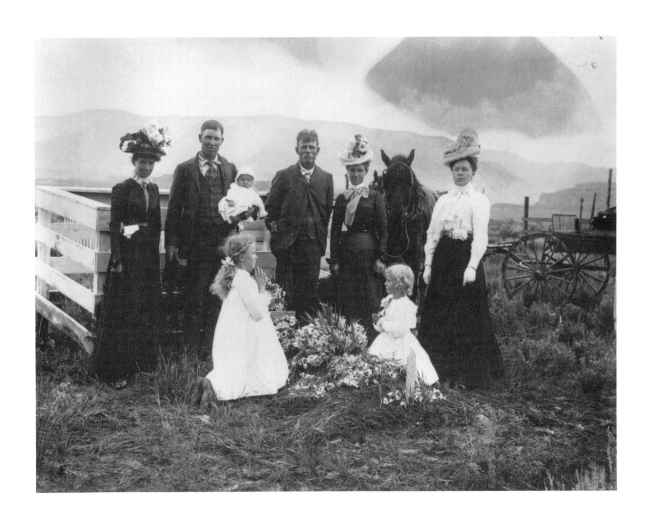

62
Millerd [sic] *Walker and wife
at graveside, Rifle, Colo. Fred
Garrison, early 1900s. Gela-
tin silver print, 8 × 10 inches.
Courtesy, the Garrison Collec-
tion, Colorado Historical
Society, Boulder.*

Mourning Portraits and Jewelry

During the second half of the nineteenth century, formal funeral and mourning clothes were expected attire for middle- and upper-class survivors. Widowhood could become a full-time occupation in which women attired themselves in widow's weeds for their entire adult life. Specialized attire and other accouterments of mourning were so common that an industry developed around it. In Philadelphia, as well as in many other American and European cities, mourning stores offered their wares to grief-stricken and stylistically aware people. "Philadelphia Mourning Store, Jones and Fisher, 918 Chestnut Street, Black Dresses, Gowns, Silks, Shawls, English Crepes, Gloves, etc." ran an advertisement in the *Juniata Republican/Sentinel* (Pennsylvania), May 23, 1887.[23]

From prephotographic times until the 1920s, some mourners, most often women, were photographed or painted in their mourning attire. Figure 63 is an Ezra James oil portrait of Mary Watson showing a woman in mourning dress. In the background is an urn with vital statistics; this combines the memorial picture with a portrait of a young woman in mourning for her dead sister Emily, who, according to the inscription on the urn, died in 1817.[24]

63
A Daughter of Elkanah Watson. *Ezra Ames (1768–1836), ca. 1818. Oil on canvas, 30 × 23⅘ inches. (Note: inscription on stone indicates that the painting was accomplished after 1817.) Courtesy, Princeton University Art Museum, Princeton, N.J.*

According to Snyder (1971), "it became common for surviving members of a family, at the time of a funeral, to have portraits made of themselves in their mourning clothes. This would allow the family to recall the moments of their deepest sorrow and, indirectly, the object of their sorrow" (p. 68).[25] Given the lack of provenience for most of these images, it is not possible to know whether the woman in mourning in figure 64 is a grieving widow or a bereaved parent. Others seem self-evident (figure 65). Rarely, the grief-stricken mother is photographed in mourning clothes holding her dead baby (figure 66).

64
Photograph of unidentified woman in mourning dress. Unknown, ca. 1840–1860. Daguerreotype, ⅙ plate. (Note: the woman is wearing a mourning hair brooch that probably contains a photograph on the reverse side.) Courtesy, Center for Visual Communication, Mifflintown, Pa.

65
Photograph of woman in mourning with child. Unknown, ca. 1850–1870s. Ambrotype, ¼ plate. (Note: a label in the case reads: "Clara Annett Henry, son John Henry, Daughter of James and Annett [sic] Quinn.") Courtesy, Center for Visual Communication, Mifflintown, Pa.

66
Photograph of an unidentified woman in mourning clothes holding a dead baby. Unknown, ca. 1860–1880s. Tintype, ½ plate. Courtesy, the Strong Museum, Rochester, N.Y., copyright 1992.

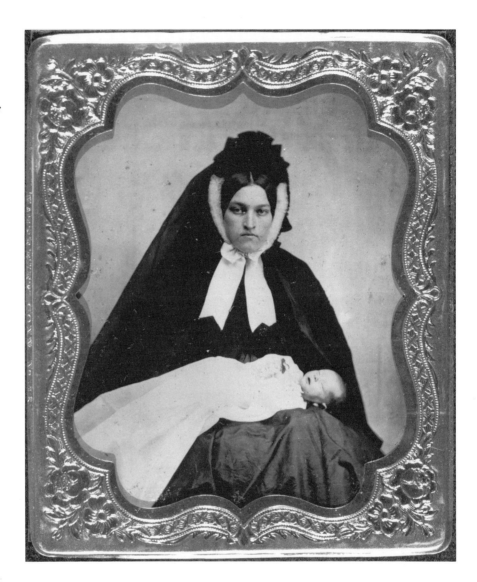

68
Unidentified mourners.
Unknown, ca. 1870–1890s.
Gem tintype. Courtesy, Wm.
B. Becker, Huntington Woods,
Mich.

67
Unidentified grieving woman.
Unknown, ca. 1860–1880s.
Albumen print on cardboard
mount, carte de visite. Cour-
tesy, the Strong Museum, Roch-
ester, N.Y., copyright 1992.

69 and 70
Gold mourning brooch. Hair on front, daguerreotype of Elizabeth McCune on back. Oval, 1¾ × 2 inches. Courtesy, Shirley Sue Swaab, Melrose Park, Pa.

A few "grieving widow" photographs such as the carte de visite shown in figure 67 and the gem-sized tintype (figure 68) defy easy interpretation. The poses are extremely theatrical. The viewer's normal desire to have a recognizable likeness of the sitter is frustrated. Yet there is no evidence that the carte or tintype were commercially published and sold. Whatever the original purpose was, it is now lost to us.

One of the logical extensions of mourning clothing was mourning or memorial jewelry. Widows wearing mourning jewelry are known as early as the 1600s in England. When Queen Victoria made the trappings of long-term widowhood fashionable, many British widows emulated her affectation of black clothes and dark accessories. It is logical to assume that the custom was borrowed from England by Americans (Swaab 1981). Some mourning rings and brooches contained photographs of the deceased along with their braided hair (figures 69 and 70). Commercially produced memorial jewelry and mourning clothing disappeared among an Americanized middle class by 1920, when public displays of mourning became déclassé. Within the last few years, partially as a result of AIDS, public evidence of mourning has had a resurgence. Consequently some individuals make and use "folk" pieces. For example, the *Philadelphia Inquirer*

published a photo on October 18, 1992, of Hazel Snow with a lapel pin she made with a photo of her slain daughter on a teddy bear pin—her daughter had collected these pins. It was the mother's way of remembering. And California jewelry maker Sandra Harding has created the "Victorian Death Portrait," a necklace containing a reproduction of a nineteenth-century postmortem photograph of a child. Harding got the idea for the jewelry when she visited an exhibition at the California Museum of Photography on death and photography. She has sold over 3,000 necklaces, mainly to women in their twenties, and is contemplating the development of an entire line of "death" jewelry (Sandra Harding, personal communication, June 18, 1994). Apparently symbols of mourning are becoming a fashion statement.

For those confronting a death, wearing mourning clothes and jewelry served two functions. First, the apparel served as a reminder to the mourners of their loss and thus kept the work of grief in their consciousness. Second, the clothes acted as a sign to society of the mourners' propriety. Having your picture painted or photograph taken provided a record of your status not unlike the photo of the soldier in uniform.

In this chapter, corpse and funeral photography have been examined from the nineteenth century until today. The custom arose out of the desire to obtain a last remembrance of the deceased and to commemorate the social occasion of the funeral. While more public prior to 1900, the practice remains one avenue available to those who wish to confront the finality of death. However, some would prefer to remember people as being alive, that is, to memorialize them. In the next chapter some of the ways in which people memorialize the deceased through photographs are explored.

Postmortem photography was socially acceptable and publicly acknowledged in nineteenth-century America. Professional photographers were regularly commissioned to portray the dead. They advertised the service in newspapers and held professional discussions in their journals about the best way to accomplish the task. The photographs were a normal part of the image inventory of many families—displayed in wall frames and albums along with other family pictures. Prior to the 1900s, most death pictures were portraits of the deceased which attempted to deny death by displaying the body on a living room sofa as if asleep. At times, the illusion of actually being alive was attempted. Later, the deceased was displayed in a casket with an increasing emphasis on the social event of the funeral and less on an isolated close-up portrait. At times the mourners alone were photographed to commemorate the propriety of their grief. In this century, professional photographers occasionally take these pictures. However, most families take their own photos. They circulate them privately. As a consequence, many people assume that the custom has been abandoned. It has

not. Instead, it has become the private act of mourners seeking to mitigate their loss with an image that will not fade.

As I shall demonstrate in chapter four, counselors working with the parents of stillborn children and children who die in neonatal hospices provide evidence that these images can have a positive value in coming to terms with grief. As an anthropologist, I regard these photographs not as vernacular art or some sort of support for my ethnocentric and personal feelings about how one is supposed to grieve, but as artifacts that reveal some of the ways people in the United States have devised to heal the social wound of death.

three

Memorial Photography

Some pictorial commemorations of death seem less problematic than others. In this chapter, public and personal photographic memorializations are explored. In contrast to postmortem and funeral photography, few twentieth-century Americans seem offended by the idea of remembering someone who has died with a photograph of them taken while they were alive. On the contrary, it is one of photography's main functions to provide a means to remember. Writing and picture making have, in many significant ways, replaced human memory and become the primary means by which twentieth-century Western humanity remembers. In Ridley Scott's 1982 film, *Blade Runner,* androids are equipped with memory implants. They are also supplied with snapshots of their fictitious families to enhance the illusion of having memories of their "childhood" and to make their feigned humanness appear more believable to them. While memorial photographs and postmortem and funeral photographs may appear to be similar because they both deal with death, remembering a life that is over is an impulse that is fundamentally different from remembering a death. I argue in this chapter that both are important if one is to accommodate a death.

Public Memorial Representations

Memorial pictorial representations of deceased persons are found throughout America's history. These commemorations are normative expressions of grief in many cultures, including those that have restrictions on human representation, as witnessed at the death of the Ayatollah Khomeini, when his image was paraded through the streets of Teheran by his devoted followers.

In the United States, public expressions of grief, whether in the form of a porcelain milk pitcher depicting the apotheosis of George Washington, or a Martin Luther King T-shirt, are expected, promoted, and given moral support when the deceased was a public figure. Mourning fallen heroes is an essential social ritual for the continuation of any society. When a person dies, his or her family must mend the tear in their private social fabric through ceremonies and rituals of mourning. Without an outlet, grief can become pathological. In a similar fashion, societies need a means to remember their fallen heroes. One of several memorializing devices available to us is a photographic representation of the dead.

Memorial images of people like Robert and John Kennedy and John Lennon or even relatively minor celebrities like a baseball player (figure 71) decorate almost any surface, from coffee mugs to throw pillows. They are a logical continuance of the ancient and widespread custom of memorializing the dead with a life image. The custom keeps alive the memory of someone important by portraying him or her as a vital, live person. While some people may find the velvet paintings or three-dimensional postcards of Elvis Presley and Martin Luther King sold by street vendors to be in bad taste, commemorating and memorializing our dead heroes is a common, unproblematic custom.

Scholars of the material culture of mourning suggest that images like the "Apotheosis of Washington" signal the beginning of this means of expression in America. It apparently originated in Philadelphia (Schorsch 1979, p. 47) and rapidly became an international industry, as the memorial to George Washing-

71
Memorial baseball trading card of Ken Hubbs. Topps No. 550, 1964. Offset printing, 3½ × 2½ inches. Courtesy, Center for Visual Communication, Mifflintown, Pa.

IN MEMORIAM

KEN HUBBS

ton painted on china attests (figure 72).[1] Washington's image appeared in various forms in great numbers as a national symbol of the grief felt at losing the father of our country. The custom was borrowed directly from the European, and especially British, practice of memorializing important personages in textiles, ceramics, and prints (Schorsch 1976, 1979). During the Federal period, Americans accepted these prints of "heroic death" as a legitimate art form to be publicly displayed in the parlor. "In an 1845 oil painting that can be seen at the Museum of Fine Arts in Boston a mourning print is displayed on the living room wall in a picture entitled *The Rev. John Atwood Family* by Henry F. Darby" (McCulloch 1977, p. 19). When Lincoln was assassinated, the "industry" of public mourning was born anew (figure 73). It continued with McKinley and has been renewed at the death of almost every important personage since.

When the carte de visite album and stereocard craze hit the United States in the 1860s, people started collections of famous personages, purchasing millions of cards from companies like E. H. Anthony & Company of New York. The apotheoses of Lincoln and Washington were among the more popular images for patriotic Americans to have in their family albums (figure 74), thus further extending the concept of the mourning picture. In the African-American community, when a prominent figure such as Adam Clayton Powell, Clara Ward, or Martin Luther King dies, funeral photo albums are commercially produced and sold. Stylistically, they resemble the event albums produced by newspapers on the occasion of a flood or even a war like the Gulf War. They are chronicles of a newsworthy event, souvenirs of a loss to the community.

In addition to these public displays of sorrow over the death of important public figures, mourning pictures for private citizens became fashionable in the early nineteenth century, undoubtedly as a direct response to the popularity of the mourning pictures of Washington. The pictures employed a complex iconography of willow trees, urns, mortuary obelisks, an allegorical figure in mourning, and other symbols eclectically borrowed from Christian and classical imagery. The inscription is often confined to "Sacred to the Memory of ———." One notable change in these private mourning pictures is that, unlike mourning pictures devoted to George Washington where the president is usually represented by a bust portrait, the deceased in a private mourning picture is almost never pictured. Those people portrayed in the pictures are "generic" mourners, not specific individuals. The deceased is represented solely by the dates of his or her birth and death.

Young girls attending private seminaries and finishing and boarding schools in the early 1800s were taught the "useful arts of embroidery and sewing by producing their silk embroidered and painted folk versions of these tributes to the father of our country and the great emancipator. Pictorial embroideries

72
Memorial to Washington.
Unknown, ca. 1800. China
painting on glass,
26⅝ × 19¼ inches. (Note:
based on a print engraved and
published by Simon Chau-
don & John J. Barralet,
Philadelphia, January 1802.)
Courtesy, Winterthur
Museum, Wilmington, Del.

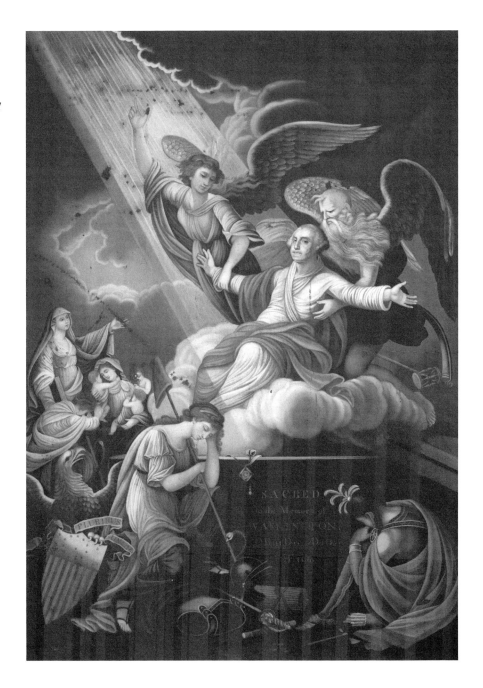

73

In Memory of Abraham Lincoln, the Reward of the Just. *William Smith, Philadelphia, 1865. Color lithograph, 18¾ × 24 inches. (Note: exactly the same as figure 72, except Lincoln's head replaces that of Washington.) Courtesy, Louis A. Warren Lincoln Library and Museum, Fort Wayne, Ind.*

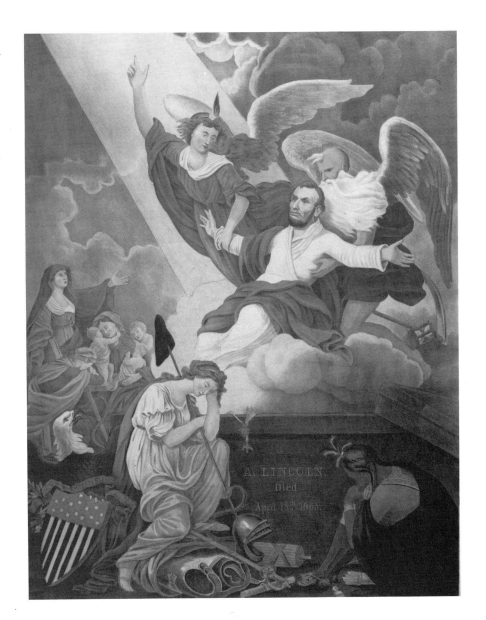

on silk were an eighteenth century art, but they have come down to us in greatest numbers from the Federal period. . . . One of the most fashionable expressions of schoolgirl skill in this technique was the mourning picture" (Ring 1971, p. 570). These students of the "delicate arts" extended the practice by making mourning pictures of their deceased family members. The fashion of handmade images had reached its peak by 1815 but examples can be found through mid-century (Ring 1971, p. 574). By the end of the Civil War, the female seminary movement ended and along with it the custom of producing embroidered mourning pictures. The need for memorial images did not cease. The means to satisfy the desire changed.

By the 1840s the market for handmade mourning pictures memorializing private persons became so large that Nathaniel Currier produced mourning picture lithographs with a space left blank for the vital statistics of the deceased (figure 75). A handicraft became industrialized and standardized. A number of other printers followed suit. "Many engravers in Lancaster and Reading, Penn-

74
A photograph of a lithograph of Washington and Lincoln as martyrs. Unknown, ca. 1865–1880s. Albumen print on cardboard mount, carte de visite. Courtesy, Louis A. Warren Lincoln Library and Museum, Fort Wayne, Ind.

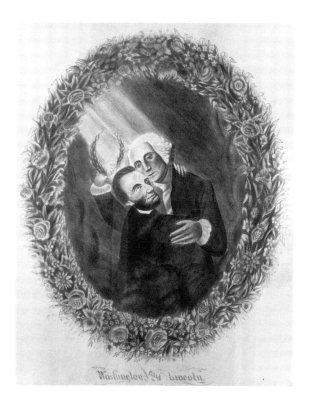

75
Mourning picture of the Robie family, last date of death, 1853. Printed by N. Currier, ca. 1850s. Lithograph, 8⅝ × 13¼ inches. Courtesy, Center for Visual Communication, Mifflintown, Pa.

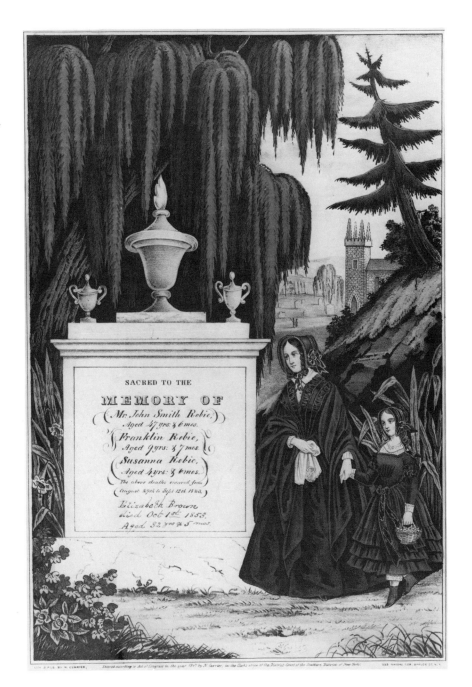

sylvania, printed hand-colored family memorials in the 1840s" (McCulloch 1977, p. 51). These engravers also produced birth, marriage, and baptismal certificates that competed with the Pennsylvania German hand-lettered fraktur prints. In the 1890s and into the twentieth century, several companies offered printed death commemoratives, some with a provision for a photograph of the deceased (see below). Handmade mourning pictures virtually disappeared by the 1870s. A notable exception is the tribute—a reverse painting on glass that may be an imitation of the cabinet card memorials discussed below—shown in figure 76.

76

Handmade memorial for Crawfford Irven Brown, "Born April 26, 1851, Died January 21, 1904 at 10 A.M." Unknown, ca. 1904. Reverse painting on glass with tintype, 25½ × 13½ inches. Courtesy, Center for Visual Communication, Mifflintown, Pa.

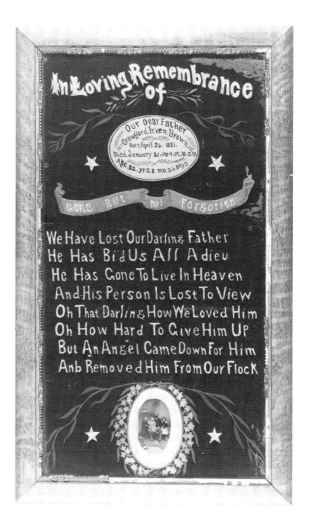

In *Huckleberry Finn,* published in 1884, Mark Twain satirically described the interior of a "proper" American house that contained these markers of grief. While Twain is obviously ridiculing the nineteenth-century preoccupation with mourning and death, the description must have some basis in actual practice or the satire would have been lost on his readers.

> *They had pictures hung on the walls—mainly Washingtons and Lafayettes, and battles, and Highland Marys, and one called* Signing the Declaration. *There was some that they called crayons, which one of the daughters which was dead made her own self when she was only fifteen years old. They was different from any pictures I ever seen before; blacker, mostly, than is common. One was a woman in a slim black dress, belted small under the arm-pits, with bulges like a cabbage in the middle of the sleeves, and a large black veil, and white slim ankles crossed about with black tape, and very wee black slippers, like a chisel, and she was leaning pensive on a tombstone on her right elbow, under a weeping willow, and her other hand hanging down her side holding a white handkerchief and a reticule, and underneath the picture it said "Shall I never See Thee More Alas." . . . Another was a young lady with her hair all combed up straight to the top of her head . . . and she was crying into a handkerchief . . . and had a dead bird laying on its back. . . .*
>
> *The young girl [who made them] kept a scrapbook . . . and used to paste obituaries and accidents and cases of patient suffering . . . and write poetry after them. . . . Every time a man died, or a woman died, or a child died, she would be on hand with her "tribute" before he was cold. . . . Everyone was sorry she died, because she had laid out a lot more of these pictures to do. . . . With her disposition she was having a better time in the graveyard.*
>
> (Twain 1965 [1884], p. 98)

In an 1873 book about women in America, there appears a more straightforward description of the parlor of a proper grandmother's house:

> *. . . the one remaining picture of the room. This represents a tall, white tablet, with the inscription "Sacred to the Memory of" visible across the top. At the side of this tablet leans a composed female in black attire, holding to her right eye one corner of a voluminous handkerchief, while the other trails to the ground at her feet. The weeping willow, arching close above her head, does not touch her with one of its leaves, and all its branches grow in a singular manner, either to the right or left, and in parallel lines. But however faulty these objects might appear as works of art, they are beyond criticism as the products of beloved fingers, and are enshrined in a thousand sweet associations.*
>
> (Woolson 1873, p. 241)

Toward the end of the nineteenth century, memorial photographs and off-set memorial cards designed to be placed in a photo album and as wall hangings displaced lithographs and handmade pictures. They also signaled another change—the deceased was now pictorially represented.

Memorial Photographs

Photographic memorials first appeared in the 1860s and continue to the present day. The deceased is represented while still alive with some written indication of the death: vital statistics, a bit of verse, or simply a black border around the image. Sometimes family members took a carte de visite or cabinet card photograph of the deceased while yet alive and turned it into a memorial card simply by writing the vital statistics of the person depicted on the back of the photograph.

While carte de visite memorial cards from the 1860s and 1870s are rare, some do exist (Darrah 1981, p. 145).[2] Figure 77 is a lithographed memorial card cut to the size of a carte de visite with a reproduction of a daguerreotype. Figure 78 is the obituary of Almira Parker photographically reproduced and cut to fit a carte de visite photo album. The scarcity of these carte de visite memorials, when compared to the mass-produced cabinet card memorials discussed below, suggests that these cards were either the invention of a bereaved family member or perhaps their photographer. Photography is the product of the industrial revolution. The activity of picture taking has always been standardized by the industry that manufactures the technology and is forever trying to convince the buying public that they "need" the latest invention for making or displaying their photos. However, when readily available products do not satisfy the needs of the public, images are "invented," practices are "subverted," and uses "modified." Both cultural difference and individuality are thereby expressed.

By the era of the cabinet card (i.e., 1880–1900), photograph album memorials were more common. The Mildred Patterson memorial cabinet card shows Mrs. Patterson in her wedding dress (figure 79) with an "In Memoriam" on the back (figure 80). According to her granddaughter, the deceased's husband, Pennsylvania Senator John J. Patterson, mailed these photographs as death announcements. Sometimes memorial cards were also given out at funerals (McCulloch 1981, pp. 55–56).

Memorial portrait photographs are clearly derived from the memorial pictures of famous and public persons like George Washington. In the prephotographic era memorials were confined to presidents and other nationally famous persons. With the advent of photography, the practice was extended to include

Copy of Daguerreotype taken at 6 years of age.

MARIA JANE HURD.
Died in Springfield, Mass. March 12th 1849 aged 12 Years.

MY RESOLUTIONS FOR THE NEW YEAR.*
JANUARY 1st 1848.

1st Try to keep the Sabbath Day holy.
2d To be lovely, meek, and gentle.
3d To be a lamb of God and love Him.
4th To try and read my Bible every night and morning and not neglect my prayers.
5th Try to be a friend to my associates.
6th To be always ready to give up to any body [when it is not wrong to do so]
7th To remember that the eye of God is upon us in all that we do.
MARIA JANE HURD.

I love them that love me, and those that seek me early shall find me. PROVERBS. VIII. 17

* Found in her little Portfolio after her death.

77
*Memorial card for Maria Jane
Hurd, died in Springfield,
Mass., March 12, 1849. Un-
known, ca. 1849. Lithograph,
carte de visite. Courtesy,
Pennsylvania State University,
William Darrah Collection,
University Park.*

—Died—Almira Parker. Almira Brown was born in Rutland county Vermont, June 26, 1847. She accompanied her parents to Indiana in 1849. Was married to her now bereaved husband, James Parker, June 25, 1866 Died at Lohrville, Iowa, June 6, 1889. Services were held at Lohrville June 7 by Rev. E. G. Swem.

She was born into this world in the month of June and was married and died in the month of June.

Sister Parker gave her heart to God in a meeting held in March of the present year and died in peace. The church was too small to accommodate the friends and neighbors who came to shed many tears of sympathy with the bereaved family.

78
*Memorial card for Almira
Parker, died June 6, 1889.
Unknown, ca. 1889. Albumen
print on cardboard mount,
carte de visite. Courtesy,
Pennsylvania State University,
William Darrah Collection,
University Park.*

310 STATE ST.
MILWAUKEE.

In Memoriam.

Mildred Franks Patterson,

Wife of

John I. Patterson,

Born in Chicago, Ills., March 23, 1863.

Married November 2, 1887,

Died November 21, 1889.

"Nearer my God to Thee."

79
*Mildred Patterson memorial
card. Stein, Milwaukee, 1889.
Gelatin silver print on card-
board mount, cabinet card.
Courtesy, Center for Visual
Communication, Mifflin-
town, Pa.*

80
*Back of Mildred Patterson
memorial card. Stein, Milwau-
kee, 1889. Cabinet card.
Courtesy, Center for Visual
Communication, Mifflin-
town, Pa.*

81

*Memorial to Sam B. Barritz
[sic], born at York, Pa., on
May 12, 1838, and died at
Des Moines, Iowa, on June 12,
1902. German Literary
Board, Burlington, Iowa, pub-
lishers. Vignetted halftone pho-
tograph on printed cardboard
with stand, 5⅝ × 8 inches.
Courtesy, Center for Visual
Communication, Mifflin-
town, Pa.*

Born at York, Pennsylvania,
May 12, 1838.

Died at Des Moines, Iowa
June 12, 1902.

Sam'l B. Barnitz D. D.

For twenty-one years Western Secretary of the Board of Home Missions of the General Synod
of the Evangelical Lutheran Church in the United States of America.

German Literary Board, Burlington, Iowa, Publishers.

82

*Memorial roundel. Unknown,
ca. 1900. Tinted gelatin silver
print, 4¾- × 3⅜-inch oval
photograph, 9 inch roundel
with "Rock of Ages" design.
Courtesy, B. and H. Henisch
(published in* The Photo-
graphic Experience: An
Exhibition Catalog, *B. and
H. Henisch; University Park,
Pa.: The Palmer Museum of
Art, 1988).*

people like Mrs. Patterson, the wife of a senator, or a minister from York, Pennsylvania (figure 81). By World War I, commercially available photographic memorial buttons became available (figure 82). Sometimes photographs were used to memorialize those martyred in labor struggles, as is the case with a memorial reading "In Memory of Ida Brayman . . . who was shot & killed by an Employer Feb. 5th, 1913 during the great struggle of the Garment Workers of Rochester." The postcard, copyrighted by the union, contains a picture of Ms. Brayman in a heart-shaped vignette (figure 83). Photography is again seen as a mechanism that extended and expanded human representation to a broader base than was possible with earlier forms of pictorial media.

Memorial and Funeral Cards

From the 1880s to the 1920s, commercially printed memorial cards were produced in large numbers. The custom of commemorating the dead with a memorial card became further democratized. Anyone who could afford the services of a memorial cardmaker could become "immortalized." One's status in the community no longer determined who would be memorialized. The cards were white or black cardboard mounts with a gold edge cut to fit in a cabinet card photograph album. They fell into disuse when the cabinet card and its precut albums were replaced by snapshots held in place in the family album by adhesive corners or clear vinyl overlays. Visually, the cards resemble Currier mourning lithographs with popular mourning motifs like willow trees or angels (see figure 75). The cards were printed with the vital statistics and occasionally a vignetted photograph of the deceased together with verses and artistic decorations espousing popular sentiments about death and grief.

"Over 100 verses, in several languages, were available to be printed below the photograph, but the most popular sentiment was: 'Gone but not forgotten'" (McCulloch 1981, pp. 55–56). In a 1920s catalog from H. F. Wendell, the largest manufacturer of these cards, 24 English verses are offered together with eight German, and one each in Swedish, Danish, French, and Norwegian. An example:

> No. 19
> Father, Brother, Sister, Daughter or any name may be used in place of Mother.
> We miss thee from our home, dear mother,
> We miss thee from thy place,
> A shadow o'er our life is cast.
> We miss the sunshine of thy face.
> We miss thy kind and willing hand,
> Thy fond and earnest care,
> Our home is dark without thee—
> We miss thee everywhere.

Memorial cards first appeared in Europe and were probably the inspiration for the memorial card in the United States, although the British cards were not made to fit into a photo album and did not contain photographs or other pictorial representations of the deceased (figure 84). According to James Curl,

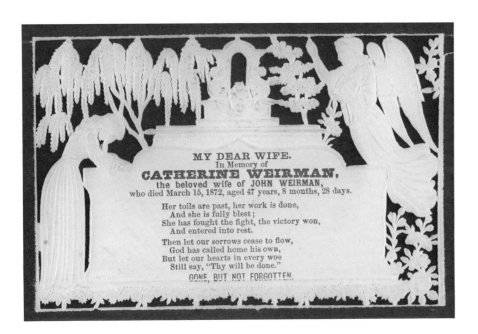

84
British memorial card for Catherine Weirman, died March 15, 1872. Unknown, ca. 1872. Printed, 3 × 4⅝ inches. Courtesy, Center for Visual Communication, Mifflintown, Pa.

Mourning-cards . . . were supplied by the undertaker, specially printed for the particular funeral with traditional symbols of grief: the inverted torch, the weeping willow, the shrouded urn, and kneeling female mourners. . . . Naturally, mourning-cards needed mourning-envelopes, and black-edged envelopes and note paper became obligatory. Black sealing wax, black stamp boxes, black ink, and mourning-pens were not unusual. . . . The cards were intended as reminders of the dead so that the recipient would be sure to offer prayers for the dead and for the bereaved family. . . . Mourning-cards were also printed in memory of notable personages. Those for Queen Victoria were inscribed with sentiments such as "The entire world mourns her loss."[3]

(Curl 1972, pp. 13, 17)

The cabinet memorial card was common in the northeastern and midwestern United States from the 1890s until the 1920s.[4] At least three companies specialized in their manufacture. H. F. Wendell & Co. of Leipsic, Ohio, claimed to be the largest. From their 1902 catalog: "H. F. Wendell began in the business in 1898 in a small way. Three years later the business was the largest of its kind in America" (figure 85). Wendell cards are the ones most frequently found today in flea markets in the Northeast.

85

Cover, H. F. Wendell & Co.'s 1902 catalog. Unknown, 1902. Offset print, 4¾ × 7¼ inches. Courtesy, Center for Visual Communication, Mifflintown, Pa.

We Make Life Size Crayon Portraits—the good
kind. Send for Catalogue.

This is
the
Building
We Own
and
Occupy

CATALOGUE OF

Fine Memorial Goods

MANUFACTURED BY

H. F. WENDELL & Co.

EX-EDITORS OF THE LEIPSIC TRIBUNE

LEIPSIC, OHIO

*"The Only Memorial Card House in the West Having Its Own
Building and Equipment."*

KEEP THIS CATALOGUE

If you are not interested please hand to some bereaved friend.
We will be responsible for money lost in the mails if sent
by registered letter or post office money order.

ALL CARDS ARE MAILED POSTPAID

Wendell makes it clear where the idea came from and what one was supposed to do with the cards. From a letter attached to a 1902 catalog: "The custom of commemorating the virtues of departed friends by means of memorial cards is not a new one. It has the dignity of age. It has existed for many years in Europe and now it is common in all parts of the civilized world for the family of the deceased to send to each one of the relatives and friends an appropriately inscribed memorial card. You will see that the enclosed card is suitable either for framing or for the album." In their 1912 catalog, they discussed the size of their business:

A Few Words About Ourselves. Way back in 1898 Mr. H. F. Wendell started this memorial business in a small way and in three years it developed into the largest memorial business of its kind in America and is now the largest in the world.

From this you must know that we are reliable and responsible in every way, and you need have no hesitancy in sending us your order. You will find us well rated in Dunn's and Bradstreet's [sic] *and we refer by permission to the Bank of Leipsic, Citizen's State Bank or the Mayor and the Posdt master* [sic] *of Leipsic, Ohio.*

Catalogs for the Art Printing Company of Elkhart, Indiana, and W. R. Seymour & Company, Philadelphia, offered essentially the same cards. The Seymour and Wendell companies had wall-sized memorials. Wendell's "Golden Gates Memorial" was 16 by 20 inches, unframed, and an elaborate version of the smaller card with a provision for a photograph. The Seymour company offered a "Wax Flower Memorial" which incorporated the card into a wax flower wall hanging. Seymour also advertised prayer cards and a "Satin Mounted Memorial Card" 10 by 12 inches. Wendell also offered mourning calling cards and produced so-called crayon portraits—photographs enlarged, framed, and colored to resemble an oil painting or charcoal drawing.

Apparently, all of these companies worked the same way. They would obtain obituary information from a source. In Wendell's case he would pay a penny an obituary to women from all over the United States who would collect the notices from the local newspapers and mail them to him. The women were recruited with small ads in dozens of small-town newspapers. Based on the information obtained from the obituary, a card would be printed on speculation and sent with a catalog and other promotional literature. An undated catalog from the Art Printing Company explained the process.

The Beautiful and appropriate custom of using Cabinet Memorial Cards at the time of the death of a loved one is firmly established in this, as well as the old country.

They are sent to friends and relatives, and are kept sacredly in loving remembrance by those receiving them.

As the regular channels of trade cannot be conveniently used in furnishing these beautiful Cabinet Memorial Cards we are compelled to approach you in the hour of your bereavement [figure 86].

The Memorial Card Co. of 706 Chestnut Street, Philadelphia, would affix the following message to the back of the card they sent on speculation:

This memorial card is sent to you for your inspection. If you wish to keep it the price is 25 cents, which amount please return to us with the slip, in this enclosed return envelope. If you do not wish to retain it, cross off your name and address on the large envelope wherein we sent it to you, and drop it into a letter-box and it will be returned to us at our expense. For price list and other information see the accompanying Descriptive Circular and price list.

Most of the cards were not photographic. In a Wendell catalog from the 1920s, 12 cards are offered. Three are photographic. Here is the description of one of the photo cards:

86
Memorial for Arthur Robinson, died December 18, 1891, aged 1 year. John Russell Company, Los Angeles, 1891. Offset print, cabinet card. Courtesy, Center for Visual Communication, Mifflintown, Pa.

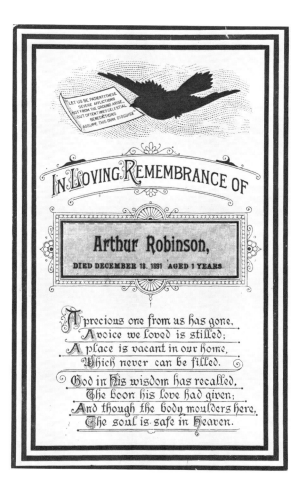

87
Memorial for Mrs. Stephen J. Gifford, died May 28, 1906. Wendell Card Co. Leipsic, Ohio, 1906. Offset with halftone photograph, cabinet card. Courtesy, Center for Visual Communication, Mifflintown, Pa.

88
Memorial card for Bessie May Sprague, died December 26, 1895. Globe M. C. Co., Philadelphia, 1906. Offset with gelatin silver print, cabinet card. Courtesy, Center for Visual Communication, Mifflintown, Pa.

Style No. 53. For a very attractive memorial card which is also quite inexpensive for use with a photograph, the style illustrated here is in demand. When ordering this design be sure to send a photograph and write your name on the back for identification and it will be returned undamaged. If necessary we can copy tin types or select the head from a group photograph. We guarantee the photographs we make to equal the original. . . . Price with Photograph— One card 90¢. . . . 12 for $3.95 [figure 87].

Sometimes people would modify a memorial card by adding a photograph of their own (figure 88). In one case, the grieving children produced a folk art rendition of a memorial card with a tintype photograph of their father (see figure 76).

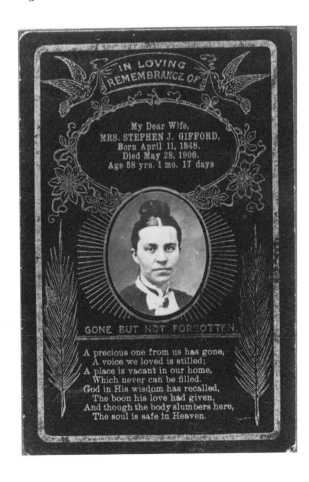

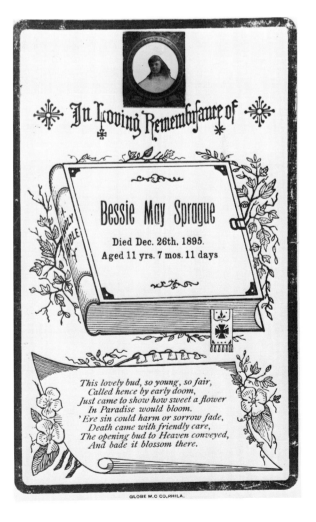

Memorial cards designed for photo albums died out by the 1930s because cabinet card-sized mounts no longer easily fit into family photo albums. A modern version of the memorial card was revived or reinvented in the 1950s by the Permanent Record Company of Memphis, Tennessee, and in the 1970s by McCray Press in Saginaw, Michigan, and by several other companies in Florida. According to a representative from McCray, they obtain their customers by subscribing to over 250 newspapers in 18 states adjacent to Michigan (Robert Daniels, personal communication, June 15, 1991). The obituaries are reset into type and printed together with a photograph, if one appeared in the newspaper, on a specially designed form. The "memorial obituary" is then encased in plastic and sent out on speculation to surviving family members whose addresses they obtain from a telephone book. According to McCray, the memorial obituaries have become so popular that survivors write to the press to have them made for their deceased relatives. Funeral directors sometimes contact McCray on behalf of their clients. Neither representatives from McCray nor Permanent Record were aware of the earlier manifestation of memorial cards (figure 89).

Video memorial tributes, offered by National Music Service Corporation of Spokane, Washington, utilize the music video format to create a new kind of memorial image. These short video programs, approximately 6 minutes in length, consist of a montage of photos of the deceased, scenic backgrounds, music, and religious or secular sentiments—all selected by the family as reflecting the values of the deceased. The service is offered to families when they are making arrangements for a funeral. Given the speed of express mail and the relatively uncomplicated format of the tribute, the finished videotape can be supplied within a few days to be "shown at visitations, as well as during funeral, prayer and memorial ceremonies" (Bernard Weiss, National Music Service, personal communication January 11, 1993). While the service is relatively new, over 10,000 video memorial tributes have been generated. Within a few years, videotapes and CD/ROM disks will replace the photo album as the chief repositories of our memories.

Vincent Oswecki of Windsor, Connecticut, had a video tribute produced at the death of his mother. His response is similar to many people to all death-related photography—initial revulsion and then gradual acceptance. "I thought it was in bad taste and kind of tacky . . . that was my first reaction." But after viewing the tape, he now regards it as "a nice little compact memory. . . . You just put it in the VCR and there you go . . . a convenient reference for my daughters. As they grow older I can say, 'here's a little something on your grandmother. It has a little fluff and a bit of corniness but . . .' It would be an expression of positive roots" (quoted in Jacobson 1992, p. 1C).

A TRIBUTE
published in the pages of
HAZLETON, STANDARD-SPEAKER
HAZLETON, PENNSYLVANIA
SEP 2 1975

Memorial Obituary

Entered Into Eternal Rest
Sunday, Aug. 31, 1975

Evan C. Llewellyn

Evan C. Llewellyn, 75, of 4251 County Line Road, Chalfont, died on Sunday in Abington Memorial Hospital, Pa., after an illness of 18 months.

Born in Beaver Brook, he was a son of the late David and Margaret (Edwards) Llewellyn, and was a member of the Welsh Congregational Church, Hazle Village, and was an associate member of the Montgomeryville Baptist Church, Colmar.

He was a member of the F&AM Henry Williams Lodge 624 of Hatboro.

He was employed by the National Drug of Philadelphia.

Surviving are his wife, the former Alice King, two daughters, Mrs. George D. (Alice) Miller of Arlington, Va., and Mrs. Robert (Margaret) Roth of Dresher, six grandchildren, a sister, Mrs. E. W. (Sarah) Bohlander of Lititz, and two brothers, David of Beaver Brook, and William of Philadelphian and several nieces and nephews.

He was preceded in death by two sisters, Margaret and Catherine and two brothers, Samuel and Gordon.

The funeral will be held at 2 p. m. Thursday from the Kirt and Nice Funeral Home, 6301 Germantown Ave., Philadelphia. Friends may call from 7 to 9 p. m. Wednesday. Interment will be in Hillside Cemetery.

89
Tribute to Evan C. Llewellyn, from the Hazleton Standard-Speaker *(Pennsylvania), September 2, 1975. Laminated by Permanent Records of Memphis, Tenn., 10 × 5 inches. Courtesy, Center for Visual Communication, Mifflintown, Pa.*

Floral Memorial Photographs

Photographs of funeral flowers are as old as the custom of using flowers in funerals.[5] Their existence is a reflection of the shift in attention from the deceased to the funeral discussed in chapter two. Some funeral directors make a practice of taking pictures of flowers as they arrive to send back to the customer as proof of their existence. Family members have commissioned professionals as well as taken their own snapshots as memories of the event of the funeral. Some images display the flowers without any context; others have a banner with "Mother" or "At Rest" printed on it (figure 90), while still others show the flowers in the funeral parlor or at the gravesite (figure 91). Sometimes the photographer makes

90
Photograph of a funeral wreath with inscription, "Rest in Peace." S. A. Ford, opposite post office, Grundy Center, Iowa, ca. 1880–1900s. Gelatin silver print on cardboard mount, cabinet card. Courtesy, Center for Visual Communication, Mifflintown, Pa.

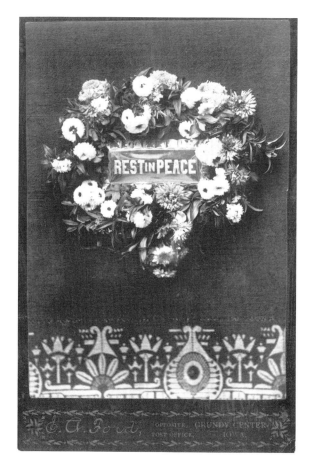

91
Photograph of a display of funeral flowers in a cemetery. George Thompson, Artistic Photographer, Orange, Mass., ca. 1880–1900s. Gelatin silver print on cardboard mount, cabinet card. Courtesy, Center for Visual Communication, Mifflintown, Pa.

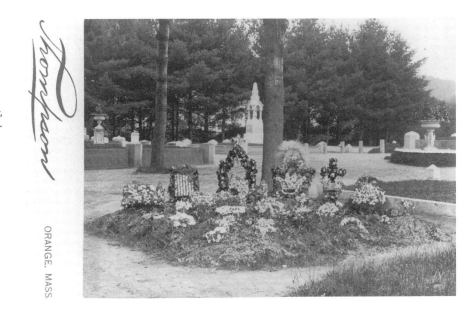

an arrangement of flowers with a life photograph of the deceased, thus producing a floral memorial photograph (figures 92 and 93). While most of the funeral flowers that are photographed are straightforward floral arrangements, sometimes they are sculpted into a form such as the B&O locomotive seen in figure 94.

The idea of photographing funeral flowers was sufficiently common and of interest to the stereograph buying public to warrant the publication of commercial floral arrangements, as shown in figure 95, by photographic publishers such as the Kilburn Brothers of Littleton, New Hampshire. Photographing funeral flowers as well as tombstones (figure 96) is an additional indication of the importance of the funeral and its material trappings in the commemoration of a death. These images seem to have both a practical and a symbolic side to them. With these photographs, mourners who contributed to the purchase of funeral flowers or grave markers were able to see the results of their contribution even if they could not be physically present. On a more abstract level, floral and tombstone images soften remembrance by only indirectly referring to the death.

Producing "skeleton" or "phantom" leaves and then photographing them was an accepted pastime for middle-class women during the middle of the nineteenth century. "The soft tissues of leaves, flowers, and seed pods were removed by any one of several fermentation or chemical methods, leaving a delicate trac-

92

Photograph of floral arrangement with superimposed bust of man. Lamont and Mack, 111 N. Centre St., Pottsville, Pa., ca. 1880–1900s. Gelatin silver print on cardboard mount, cabinet card. Courtesy, Center for Visual Communication, Mifflintown, Pa.

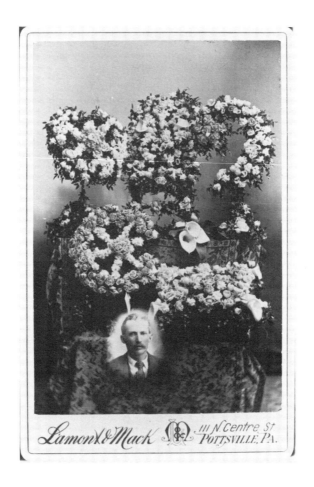

93

Photograph of a floral arrangement with superimposed bust of child. Thomas, Shamokin, Pa. Gelatin silver print on cardboard mount, cabinet card. Courtesy, Center for Visual Communication, Mifflintown, Pa.

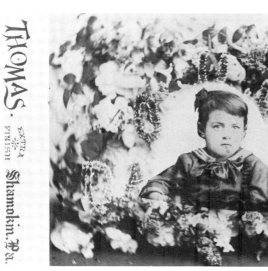

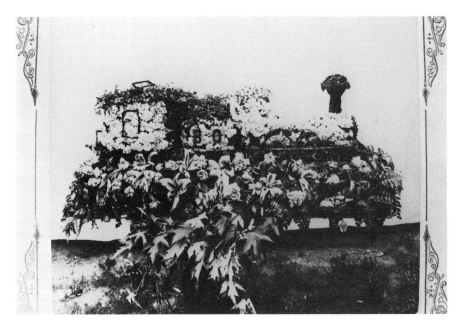

94
Photograph of B&O funeral wreath. U.S. View Company, Richfield, Pa., ca. 1890–1900s. Albumen print on cardboard mount, 8 × 10 inches. Courtesy, Center for Visual Communication, Mifflintown, Pa.

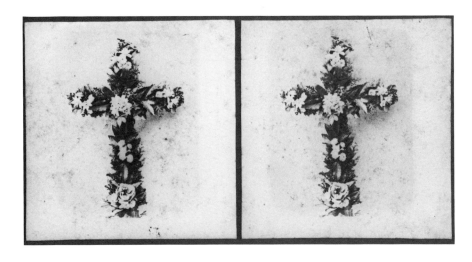

95
Photograph of a floral cross with printed inscription "No. 397 Cross." Photographed and published by Kilburn Brothers, Littleton, N.H., ca. 1870–1890s. Gelatin silver print on cardboard mount, stereograph. Courtesy, Center for Visual Communication, Mifflintown, Pa.

96
Photograph of the tombstone of Thomas R. Palmer, died June 21, 1905, and his wife, Maria, died December 27, 1937. Grant Mellott, Photographer, Needmore, Pa., 1937. Gelatin silver print, postcard. Courtesy, Center for Visual Communication, Mifflintown, Pa.

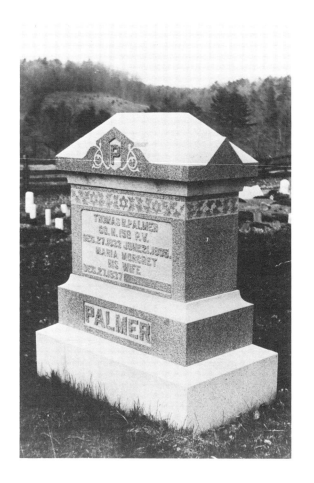

97
1152—The Martyrs—Lincoln and Garfield. Littleton View Co., publishers, sold by Underwood and Underwood, copyright 1894. Gelatin silver print on cardboard mount, stereograph. Courtesy, Center for Visual Communication, Mifflintown, Pa.

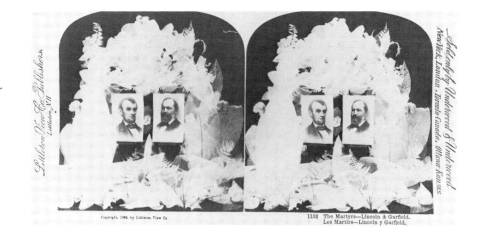

ery of vascular tissue. The plant parts were then dried and arranged in artistic still-lifes" (Darrah 1977, p. 189). When completed, the leaves were placed under a glass dome on the mantelpiece or on a table. Skeleton leaves were a popular topic for stereographs commercially produced by the London Stereoscopic Company, Soule, and B. W. Kilburn. At least one American stereophotographer, L. L. Rogers, claimed to have specialized in skeleton leaf memorial stereographs (Lou McCulloch, personal communication, November 2, 1983). "Scores of funeral skeleton leaf arrangements, especially wreaths with a portrait of the deceased, are widely scattered in the trade lists of American photographers 1867–1878" (Darrah 1977, p. 190). Luminaries like Lincoln, Charles Sumner, Garfield, Robert E. Lee, Queen Victoria, and Pope Leo XII were memorialized in this fashion, thus linking skeleton leaves with the memorialization of the dead (figure 97).

Illustrated Tombstones

Cemeteries are places where the public and private observances of death overlap. Placing a tombstone on someone's grave is at once the personal act of the mourner memorializing the loved one and a publicly available monument. Since the garden cemetery movement of the nineteenth century, people have been encouraged to use the cemetery as a place of repose and relaxation (Simon 1980). Cemeteries are seen as public places and, more recently, as a repository of important information.

> *A cemetery should reflect the local, historical flow of attitudes about community. It is, after all, a community of the dead, created, maintained, and preserved by the community of the living. In many ways it should be a "filtered" and modified reflection of the living community, with an added dimension of controlled chronological depth. At least, the cemetery should have some hints for us about prevailing views of God, acceptable implications of life and death, intensity of status differentiation, and relative values of kin and other social-interactive relationships.*
>
> (Dethlefsen 1981, p. 137)

The custom of portraying the deceased on the tombstone is found in a number of cultures. Some peoples, e.g., Palestinian Arabs and Iranians, construct memorial tableaux in a glass enclosure by the grave. The enclosures usually contain a picture of the deceased and other remembrances. They are renewed and the contents changed during visits to the gravesite. To an outsider, they

resemble the artist Joseph Cornell's boxes. The iconography of representation and design motifs on tombstones is a rich, vast and complex subject deserving of a study of its own.

Puritan America did not commemorate the dead with portrait tombstones. Instead they decorated tombstones with cherubs, winged death heads, soul effigies, willow trees, coffins, urns, and other symbols of death. The purpose of these decorations was to remind the viewer of the certainty of death, a memento mori. A common early American epitaph read

> *Stranger, stop and cast an eye;*
> *As you are now, so once was I.*
> *As I am now, so you shall be;*
> *Prepare for Death and follow me.*
>
> (Nelson and George 1982, p. 164)

According to Snyder (1971), tombstone portraiture began in the United States in the latter half of the eighteenth century. One of the earliest known portrait stones was of the Rev. Grindall Stone, cut in 1744 by William Codner after a design by Thomas Johnson. As Ludwig (1966) points out, "the rise of the portrait stone is an indication of the slow movement away from religious themes and it is ironic to note that ministers as a class led the way. In their desire to be remembered in the communities they served their stone effigies became tribal totems of a life departed rather than symbolic visions of a life to come" (p. 316).

By the beginning of the nineteenth century,

> *new values and new attitudes toward death were replacing the piety of eighteenth century Puritanism. The affairs of the world replaced men's concerns with preparation for the next. The portrait stones are evidence that men were more concerned with their image before man than with their image before God. Death meant a sad and tearful farewell to family and friends, rather than a sober transition to eternal life. The phrase "Memento mori" which encouraged men to think upon death and prepare themselves for the final journey was replaced by the phrase "In Memoria," encouraging survivors to contemplate the life past of the deceased.*
>
> (Snyder 1971, pp. 23–24)

Photographic portraits on tombstones are known from the beginning of the daguerreotype era until the present day and logically extend the idea of mortuary portraiture. The vast majority of these images portray the deceased alone

98
The tombstone of John and Annie Madonia, Santa Clara Mission Cemetery, Calif. Pearl Jones, 1982. Gelatin silver print, 8 × 10 inches. Courtesy, Pearl Jones, Vallejo, Calif.

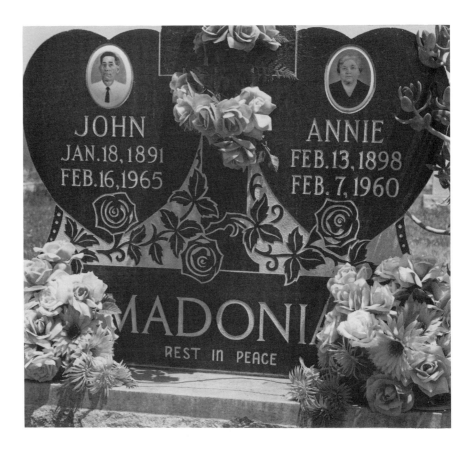

and alive (figure 98). Rarely are postmortem or funeral images used (figures 99 and 100). Their distribution through time and locale is difficult to determine, but, based on news items in nineteenth-century photographic magazines and journals and the number of patents registered for devices for securing photographs to tombstones, it is evident that they existed from the 1840s onward. "Photographs in Cemeteries. . . . Hundreds of them may be seen in our cemeteries" (*The Photographic Times,* April 2, 1869). The *Pittsburgh Morning Post* on November 29, 1853, published the following item: "Beautiful Idea—The *Newark Advertiser* says: 'A grave-stone lately set in that city has at the top a daguerreotype of the deceased person, neatly set into the stone. This is a novel and appropriate method, not only of commemorating friends, but of bringing them, as they appeared in life, to the recollection of acquaintances visiting their graves.'"

99

The tombstone of the Very Rev.
Andrew Karnauch, died June
26, 1963, and Matushka
Tatiana Karnauch, died Janu-
ary 26, 1961, Oakland Ceme-
tery, Philadelphia. Jay Ruby,
1992. Gelatin silver print,
8 × 10 inches. Courtesy, Cen-
ter for Visual Communication,
Mifflintown, Pa.

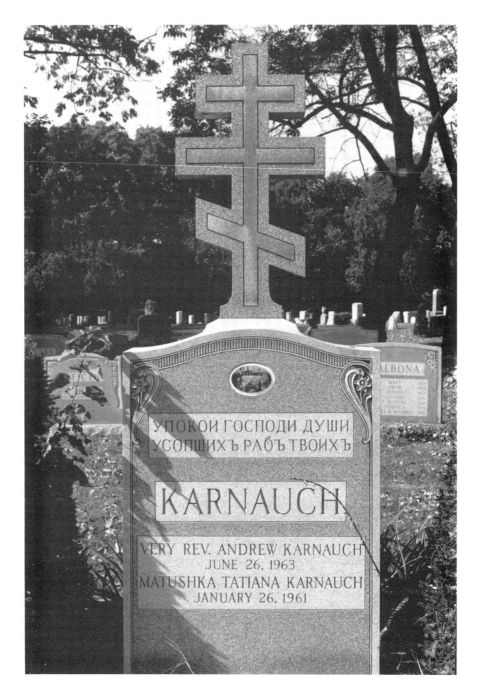

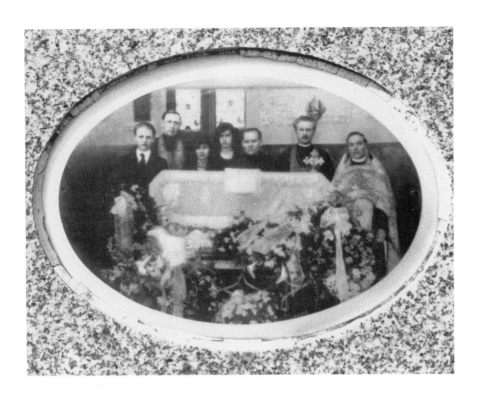

100
*Detail from figure 99: photo-
graph of Matushka Tatiana
Karnauch in her casket. Jay
Ruby, 1992. Gelatin silver
print, 8 × 10 inches. Cour-
tesy, Center for Visual Commu-
nication, Mifflintown, Pa.*

An anonymous article in *Hutching's Illustrated California Magazine* (May 11, 1857) entitled "Daguerreotypes on Tombstones" provides a marvelously flowery justification for the practice.

There is often—indeed, almost always—a feeling of sadness, which falls with gentle stealth upon the heart, when with slow and measured footsteps, we walk among the green hillocks of the dead. The cheerful looking flowers and shrubs, planted and watched by some loving-hearted mourner, may somewhat relieve the intensity and depth of its gloom; but, with this relief, it partakes too much of the "earth, earthy" and of the "cold, dark grave" than of the "mortal" having "put on immortality."

If on every tombstone there could be seen the life-likeness of the sleeper, as with sparkling eye, and noble mien, he walked "a man among men"; or of some gentle lady, whose kindly and generous impulses could be read in every feature of the "face divine"; or of the angel-child, whose joyous laugh, and innocent-smile speaks of the loss to the bereaved and living parents—and of its passage from earth to heaven—to be the guardian-spirit of the wandering

and the disconsolate upon earth—how much more inviting would then be the last resting places of the departed,—could we thus seek the "living" among the "dead" and on every tombstone see the living representative of the sleeper.

Apparently the first daguerreotype produced in Indianapolis was used on a tombstone. Dr. Oliver F. Fitch, an Indianapolis physician, had an image of his love, Phoebe Shirk, taken in 1844.

He still has the picture . . . and it is remarkably clear considering the sixty-three years that have passed since the sunlight brought forth the image from the magic surface of the copper plate. . . . The picture was a success and the romance a success, for the subject of the daguerreotype later became the bride of Dr. Fitch. She lived for five years after the happy marriage. The grief-stricken husband placed a slab of pure Italian marble at her grave and in it he set the girlhood picture of his young wife. Since the death of Mrs. Fitch, in 1853, the picture has faced storm and sunshine unprotected, and yet the hand of love had done its work so well that the picture may be copied today by any ordinary camera.

(*Indianapolis Sunday Star,* November 3, 1907,
cited in Rudisell 1971, p. 217)

While tombstone photographs may be a logical extension of the portrait tombstone, they are not as durable as stone. Perhaps because of the lack of durability, the Roman Catholic Church has a prohibition against memorial portraiture in some of their American dioceses. Since September 1942, the following rule has been in effect for the Philadelphia Catholic cemeteries: "PHOTO-GRAPHS—Photographs of any kind, or other representations of the person interred, are not permitted on cemetery plots or on memorials in the cemeteries."[6] When I inquired about the reasons for the rule the manager of the cemeteries was uncertain about them but assumed that it was based on cosmetic considerations, i.e., the photographs would fade or tarnish, rather than a moral judgment. According to Leo A. Droste, C.A.E., Executive Director, National Catholic Cemetery Conference, "There is no uniformity on whether or not such photographs are permitted in a Catholic cemetery. Cemeterians who do not permit these in their cemeteries inform me that the major reason is vandalism. If the pictures are damaged and destroyed, the remaining monument is unsightly—thus, the prohibiting of permitting such photos. I can inform you that the majority of Catholic cemeteries (both diocesan operated and parish operated) do not permit such photos in their cemeteries" (personal communication, January 5, 1993).[7]

There appear to be no photo tombstones in the Arlington National Cemetery. According to Patrick Garland, Director, Office of Memorial Programs, Department of Veterans Affairs, the national cemetery system of the department permits photographs on government headstones and markers in both private and national cemeteries. However, the Army department, which administers the Arlington National Cemetery, "does not allow photographs on the Government-provided headstones or markers in its cemeteries, considering photographs inappropriate on military headstones or markers" (personal communication, July 12, 1993). When an official from the Army department was asked about this restriction, he stated that the Army had no such restriction.

In Juniata County, Pennsylvania, there are four twentieth-century photographic tombstones—all children and all produced in the last decade. It is interesting to note that of the four stones with photographs one has been deliberately defaced. It is a strange act in a community where vandalism anywhere is rare. If the photographic representation of the dead is regarded by some as being more than slightly morbid and downright offensive, then it is possible that the defacement is not the act of a vandal but of someone displaying moral indignation. Similar defacements have been reported of photographic tombstones of animals in a Long Island, New York, pet cemetery (Aaron Katcher, personal communication, January 17, 1982). This vandalism may be an indication of hostility toward the custom or simply an act of sociopathic youth.

Whatever the cause for the destruction of these particular images, the lack of permanence is a concern for those who manage cemeteries and consequently for whose who manufacture these devices. As a consequence, a number of people sought to alleviate the problem by inventing a "long-lasting" photographic tombstone. At the same time, professional photographers tried to convince their customers of the durability of their product. An anonymous entry in *Wilson's Photographic Magazine* (December 5, 1891, p. 705) reads: "A remarkable example of the durability of the Daguerreotype is to be found in the old graveyard at Waterford, Connecticut. In the headstone that marks the grave of a woman who died more than forty years ago, her portrait is inlaid, covered with a moveable portable shield. The portrait is almost as perfect as when it was taken."

The first known patent for a photographic tombstone was registered to Solon Jenkins, Jr., of West Cambridge, Massachusetts, on March 11, 1851, for "Securing Daguerreotypes on Monumental Stones" (U.S. Patent No. 7,974). Jenkins stated that he had

> invented a new and useful improvement in Monumental Gravestones. . . .
> The nature of my invention consists of a peculiar mode of attaching, permanently and durably, a daguerreotype or photographic portrait to an ordinary

monumental stone. . . . The daguerreotype, coated with a protective varnish, was framed with a metallic border which, in turn, was cemented to a plate of glass. The glass-covered daguerreotype was then placed with a frame or a case of metal or molded plaster. After a cavity was cut into the headstone, plaster was poured into the niche, and when placed in position the front of the shield rested flush upon the stone face of the monument.

(Rinhart and Rinhart 1980, p. 304)

From the tone of the writing one could assume that Jenkins was not the first to make such a device. There is no record whether Mr. Jenkins actually went into business or sold his invention to anyone (figure 101).

In the September 2, 1854, issue of *Scientific American* (p. 410) an item entitled "Daguerreotypes Attached to Monuments" stated that "George R. Willmot of Meriden, Connecticut, has taken measures to secure a patent for an improved method of attaching daguerreotype plates to monuments. The daguerreotype is placed within an air-tight box, having an ornamented front, and the box is then secured in an aperture made for the purpose, in the side of the monument. A convenient slide, upon the exterior, serves as a protection from the weather and also to exclude light, and thus preserves the picture from injury." No patent was located.

In the January 5, 1856, issue of *Scientific American,* G. H. Hubbard, in an article entitled "Securing Daguerreotypes to Monuments," describes his method and suggests that people use "photographs or ambrotypes instead of daguerreotypes as the different temperatures to which they are exposed would be less likely to affect the picture." No patent is known for Hubbard. The *Scientific American* editor comments, "it is our opinion that beautiful monuments of cast-iron will yet come into extensive use, as they can be produced elaborately ornamented, at the mere tithe of the cost of marble monuments. The above plan is well worthy of general adopting."

The next recorded "improvement" in these images was patented by N. W. Langley, Henry Jones, and Aaron S. Drake of Stoughton, Massachusetts, on December 6, 1859 (U.S. Patent No. 26,370) (figure 102). In their patent description the inventors state that "The attempts heretofore made to preserve a likeness of a deceased person on a tombstone by securing thereto a daguerreotype or photograph, has failed from the difficulty of excluding the atmosphere from the picture." According to the Rinharts (1980, p. 304), this device was supposed to be an improvement in that the "likeness was placed in a glass case or a flat bottle which was closed by a tightly fitting glass stopper, placed in the prepared recess, and then cemented to the tombstone." Whether this did indeed solve the problem is unknown.

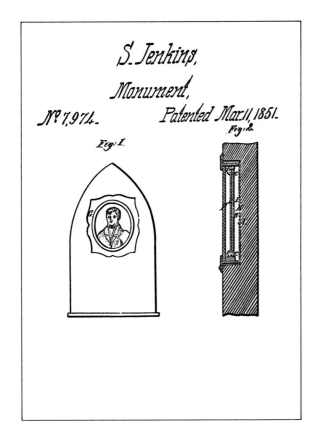

101
U.S. Patent No. 7,974 for a
monument. Patented March
11, 1851 by S. Jenkins. Copy
from United States patent
application.

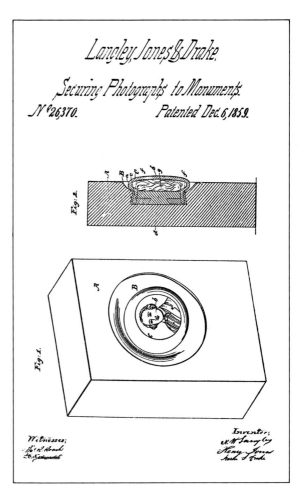

102
U.S. Patent No. 26,370 for
"Securing Photographs to Mon-
uments." Patented December
6, 1859 by Langley, Jones &
Drake. Copy from United
States patent application.

103
U.S. Patent No. 22,850 for a
"Monumental Daguerreotype
Case." Patented February 8,
1859 by Jacob Bergstresser.
Copy from United States
patent application.

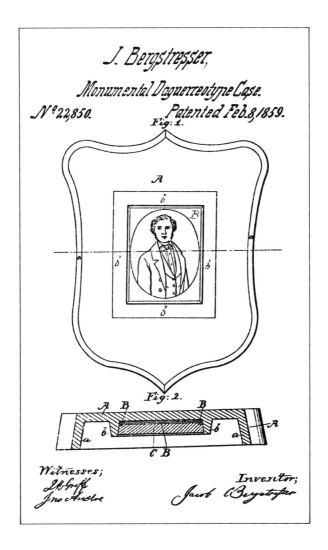

103
U.S. Patent No. 22,850 for a
"Monumental Daguerreotype
Case." Patented February 8,
1859 by Jacob Bergstresser.
Copy from United States
patent application.

On February 8, 1859, Jacob Bergstresser of Berrysburg, Dauphin County, Pennsylvania, applied for a patent (no. 22,850) for a "Glass Monumental Daguerreotype Case." From the patent description it is not clear whether the case was to be attached to a tombstone or hung on the wall, or both. Since the French custom of displaying daguerreotypes on the wall never caught on in the United States, it is more likely that the patent was for attaching photographs to a tombstone. It is possible that Bergstresser sold his idea to the Mausoleum Daguerreotype Company of New York—Mr. A. L. Baldwin, owner (figure 103). According to Spira (1981), Baldwin sold what he called "Monumental Daguerreotype Cases" in 1855 through the Scovill Manufacturing Company of New York (figure 104).

104
*Reproduction of a page from
a catalog of monumental da-
guerreotype cases manufactured
by the Mausoleum Daguerreo-
type Company, New York.
Courtesy, S. F. Spira,
Whitestone, N.Y.*

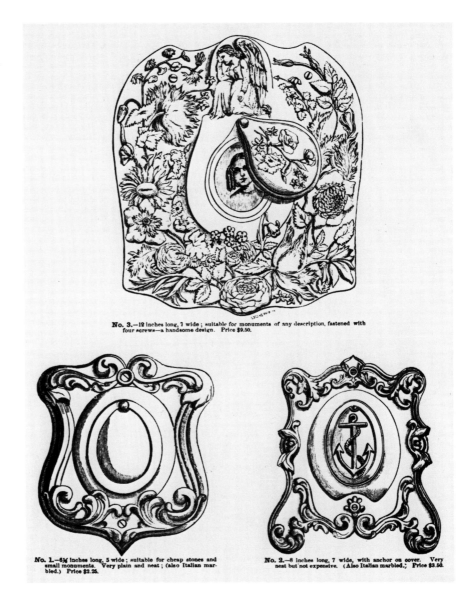

The following ad appeared in the *Daily Pittsburgh Gazette* of April 15, 1856, p. 3.

> *Above is an engraving of a very elegant daguerreotype case, executed in white Parian marble, richly carved, and designed to be attached to monuments and monumental stones, and to contain a daguerreotype or other likeness of the deceased. The likeness is placed in a brass case made perfectly air and water*

tight, and protected from the light and weather by a carved marble covering, which moves upon a pivot, as seen in the cut. This brass case is inserted in an aperture in the back of the marble case, and the whole is fastened to the monument or grave stone, by means of two, and sometimes four, screws. The marble cases are of various sizes and patterns to correspond with the size of the monument and the age of the deceased. The smallest are about one third larger than the cut, and are elegantly carved. The largest are twelve inches long, and nine inches wide or six times the size of the cut, which is a copy of their pattern. The prices vary from $2.25 to $15, according to size. The idea of attaching daguerreotypes or other likenesses of deceased persons to the stones erected to perpetuate their memories, originated with Mr. A. L. Baldwin of Meriden, Conn, who at once got up a variety of elegant designs in marble, and, having secured a patent for his invention, formed a Manufacturing Company, which is now in successful operation at Meriden, Conn. and has agencies established in various parts of the United States. The central office of the Company is at No. 335 BROADWAY, NEW YORK, and Mr. A. L. BALDWIN is its agent. Persons who may wish to obtain further particulars together with engravings showing different designs and patterns of the marble cases manufactured by the MAUSOLEUM DAGUERREOTYPE COMPANY, can do so by addressing Mr. Baldwin as above and enclosing a postage stamp. PATENT RIGHTS for States, counties, and towns are for sale by Mr. Baldwin on reasonable and accommodating terms. Orders for cases should also be addressed to him. A liberal discount to wholesale purchasers. Agents wanted in every town in the United States and the Canadas with whom a liberal arrangement will be made. Applications must be made without delay.

A. L. BALDWIN
Agent of Mausoleum Daguerreotype Company
No. 335 BROADWAY, NEW YORK[8]

Spira (1981) also reports that the World Manufacturing Company of Columbus, Ohio, a manufacturer of electric, aluminum, and other patented specialties, offered the "Indestructible Patented Aluminum Photographic Case." The brochure suggests that "Your duty to your beloved friends or relatives remains unfulfilled without having placed one of these beautiful cases upon their monument, so that you and your friends might often see them as they were known on earth." Spira speculates that the company never produced these monuments.

The following item appeared in the *Juniata Sentinel Republican* (Pennsylvania) on May 21, 1884: "S. R. Miller of Mount Union, has invented a tombstone that has a place for the photograph of the deceased." Miller was a commercial

photographer who alternated between having a studio in several small central Pennsylvania towns and being an itinerant. It seems reasonable to assume that S. R. Miller was not the only professional photographer who attempted to "invent" a process that would attract the buying public's eye. While only a handful of nineteenth-century photographic tombstones are known today, the number of patents and companies offering the service and the amount of discussion in the photographic trade journals certainly supports the notion that the practice was widespread. Where these stones are remains a mystery.

Evidence that the custom also existed in nineteenth-century England is equally perplexing. In 1869 the *Philadelphia Photographer* published the following item: "Photographs in Tombstones—The English correspondent of the *Moniteur* mentions that it is becoming more and more common to enclose photographs of deceased persons in tombstones and vaults, and that when vitrified photographs are more attainable, this custom will be more reasonable." Michael Hallett (1987) described a tombstone in Worcester, England, with a postmortem photograph from 1871 of John Hopkins. According to Hallett, "the use of photographs inset in gravestones or monumental sculpture is rare in England" (p. 119). However, the following item found in the American publication, *The Photographic News* (September 25, 1874), suggests that photographs may have been temporarily affixed to some stones. I have also seen snapshots temporarily attached to tombstones in several Philadelphia cemeteries.

Photographic Galleries in Churchyards

The Shewsbury Burial Board finds itself just now in a curious difficulty. It appears that a practice has grown up in the town of affixing to the tombstones in the cemetery the photographic carte de visite *of the person buried beneath. The exhibition attracts the curious, who in their efforts to get near the illustrated tombstone, walk over the grass, to the detriment of the board's property. "By allowing the grass to grow long, and then cutting it," the board realize as much as from £20 to £30 a year, and consequently view with gravest displeasure this new manifestation of mourning. The deterioration of the graveyard hay crops is, of course, a very serious matter. But there are other considerations that make the threatened new fashion one which it is eminently desirable should be nipped in the early bud. In some minds there is probably a feeling of revolt against the desecration even of an unfamiliar graveyard by turning it into a photographic gallery through which the curious may roam on a fine Sunday afternoon. There is no doubt that, as far as the bereaved relatives, who have thus adorned the borough cemetery, are concerned the exhibition is well meant, and is born of the conviction that a passing stranger would be glad to pause and look for a moment upon the counterfeit presentment of one*

who, perchance, filled a large space in their life. Different persons have diverse ways of expressing an identical sentiment. Some cherish the memory of their dead solitarily in their hearts; others, it appears, take out one from a dozen cartes de visite *of the departed, and paste it over the tombstone. The subject is one which is not to be argued on its merits, and on which hard words may not be said. But we are free to make the observation that it is the duty of a local burial board carefully to guard its sources of revenue and that grass which, allowed to grow long and then cut, brings in from £20 to £30 a year, is worth looking after* (Daily News).

I return to the question of frequency of photographic tombstones in the next chapter.

In the twentieth century, photographic tombstones are being manufactured by several concerns (figure 105). J. A. Dedouch of Oak Park, Illinois, is the largest North American manufacturer. It is a family business started in 1893 by the current president Richard Stannard's grandfather, a portrait painter. In the Upstate New York section of the *Sunday Democrat and Chronicle* (Rochester), in an article dated August 30, 1981, written by Ann Pritchard, Stannard discussed his business. "Even in death people want to be more than just another number, just another stone. What can be a more distinctive memorial than an accurate photographic likeness? . . . A bust or bas relief sculpture is an artist's interpretation of a loved one . . . a photograph is accurate and explicit." Dedouch employs almost 300 people—over 20 as artists, retouchers, and tinters. The range of images they use is large. In addition to the standard bust portrait there are snapshot scenes of people with their cars, boats, homes, or a favorite motorcycle, and tombstone photographs of pets, including hamsters. Often people ask the company to alter the image they send in. For example, Gypsies sometimes want gold teeth or jewelry painted on their images (figure 106).

In Europe, the firm of Giovanni Rossato of Vicenza, Italy, has made porcelain photographs for tombstones since 1936. A small percentage of their customers are from the United States. They also do photoengraving–sand-blasted portraits in black granite. They produce 20,000 photographic tombstone plaques annually (Serge Lasko, personal communication, March 29, 1983).

Because porcelainized photographic plaques may be vulnerable to vandalism, several companies offer an alternative method for placing an image on a tombstone (figure 107). For example, Photoblast Engraving, Ltd., St. Catherines, Ontario, Canada, makes granite photo plaques. Serge Lasko, president, states that "in the past the ceramic portraits have been very popular. . . . However, due to cemetery vandalism many cemeteries are refusing to allow the monument retailers to install them. . . . About 50 percent of our orders seem to be

105
Tombstones of Leonore M. and
Robert G. "Bob" Fowler, Santa
Clara Mission Cemetery,
Calif. Pearl Jones, 1982. Gela-
tin silver print, 8 × 10 inches.
Courtesy, Pearl Jones, Vallejo,
Calif.

106
"No. 5 Dedo Jadcrest." Page 1
from the Dedouch Company
catalog. Offset printed page,
8⅞ × 5⅞ inches. Courtesy,
Richard Stannard, Dedouch
Company, Oak Park, Ill.

107
"Thanks for the Memories," the tombstone of Joseph F. Baldino (1937–1989), Oakland Cemetery, Philadelphia. Jay Ruby, 1992. Gelatin silver print, 8 × 10 inches. Courtesy, Center for Visual Communication, Mifflintown, Pa.

108
"Talking tombstone"—an artist's sketch based on inventor John Dilks's description. Copy rendered by Janis Essner from Clemens and Smith (1982, p. 114).

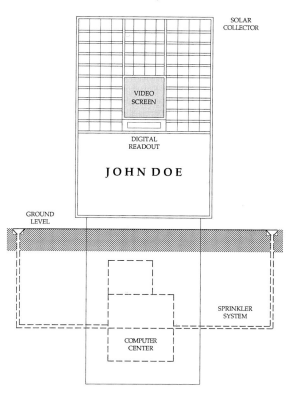

of young people and children. . . . We would like to leave you with this: If the Egyptians had known about Photoblast, we would know a lot more about our past" (personal communication, March 29, 1983).

John Dilks of Creative Tombstones, Pleasantville, N.J., proposed a "talking" tombstone (figure 108) with

a built-in video panel. . . . The screen, to be protected by bulletproof glass, will be activated by a "proximity detector" capable of picking up ultrasonic sound waves produced by the approach of a visitor to the grave. Once activated, the screen will transmit a series of synthesized images: The name of the deceased, his photographic portrait, a family tree listing ancestors and surviving relatives, and a digital clock giving the exact time since the death. At the same time a computerized voice based on that of the deceased will be emitted from the stone. The voice first will "introduce" itself: "Hello, my name is so-and-so and I died on such and such day." It then will launch into the deceased's life story.

(Clemens and Smith 1982, pp. 113–114)

To my knowledge Dilks never produced any tombstones.

In order to accommodate the loss of a loved one, we need to celebrate his or her life. Memorializing the deceased with a photograph seems an altogether reasonable means to accomplish that task. The logic of this argument is sufficient that several industries—from memorial card manufacturers to photographic tombstone plaque makers—have arisen to facilitate these activities.

four

Conclusion: A Social Analysis of Death-Related Photographs

The inevitable fact of death needs to be reckoned with and accounted for; it has to be explained and to be included in a wider scheme of representations.

Jack Goody (1974, p. 448)

Uses of Death-Related Photography

There is no mystery as to why people take pictures of deceased loved ones. They feel the need for a last visual remembrance. If the deceased was a child, particularly a very young child, it may be the only photograph they possess. In the nineteenth century, people used corpse and funeral pictures in the same way they used other photographs—that is, mounted and hung in parlors, bedrooms, and living rooms, glued in albums, mailed to relatives, placed on top of mantels, carried in wallets, and so on. In contrast to the twentieth century, there was no attempt to hide these images. Anyone who was privy to your family photographs could see them. According to Lesy, at the turn of the century in the rural Wisconsin town he researched,

> They put the funeral pictures right alongside the rest in the family album. Everyone had a center table with shelves. They'd put the album on top, and the family Bible on the bottom. When company came, they'd sit them down and open the album. It was the polite thing. They'd turn the album pages and every once in a while the company would say something about how long Arthur's hair had been when he was little, or how they hadn't seen that picture in ages, or how sweet the baby looked, and which one was it, since they knew you'd lost little Robert and Lawrence and Ida.

> (Lesy 1973, n.p.)

Figure 109 illustrates this openness. A dead woman is depicted in a parlor chair in the "live, not dead" pose discussed in chapter two. On top of the piano, a postmortem photograph can be seen. There are two possible explanations for this photograph: we are looking at the parlor as it normally appeared or the photographer or family set the stage for the second postmortem photograph by placing another postmortem image on the mantel. Whether the setting is an

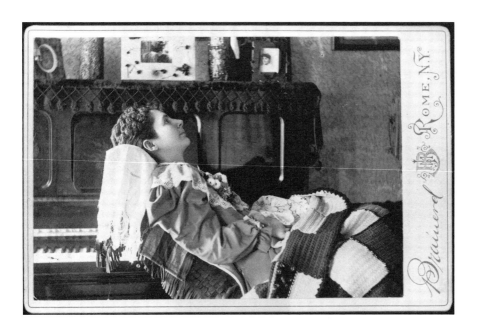

109
Photograph of unidentified deceased woman in parlor chair. J. M. Brainard, Rome, N.Y., ca. 1880–1900s. Gelatin silver print on cardboard mount, cabinet card. (Note: on top of the piano there is a postmortem photograph.) Courtesy, the Strong Museum, Rochester, N.Y., copyright 1992.

idealized one or typical of this household, both the photographer and the family must have thought the placement of this image was appropriate.

Two postcards from the turn of the century also suggest how matter-of-fact death-related images were at that time and the apparent ease with which people used photographs to converse about death. On the back of a photographic snapshot postcard showing a funeral is the following message: "Emma, if you send some one out I will give you some tomatoes as I am going to pick them tomorrow. This card is of that Hornoff boy's funeral last summer that was shot at camp. G. H." Sideways near the top it reads "Can you read this I have Helen on my lap and she won't hold still."[1]

On the back of another postmortem photographic postcard depicting a deceased child on a sheepskin is the following:

> *Dear Sister Ora, I'll send you this picture in Roy's letter. I'll write you a letter soon. This leaves us all about the same except we all have colds. Ora, this looks just as baby did when she died. But not much like she did when she was well for she was the fattest baby I ever had. She had big brown eyes and was always laughing and playing but her jaws locked before she died and she had such spasms that it drew her face until it didn't look natural to me. Well this is all I have time for.*[2]

What is remarkable to us about these two cards is that to the writers death is just another item of news along with their health and the tomatoes.

It is possible that in the nineteenth century death-related images served some formal purpose in the mourning process. As seen earlier, Lloyd argued that posthumous mourning paintings functioned in this manner (1980, p. 105) (see figure 16). Unfortunately, Lloyd offers no other evidence of this custom nor could I locate any mention of it in the nineteenth-century literature on mourning. I find it exceedingly odd that if death-related photographs were as common as they appear to have been and so many people wrote about the etiquette of mourning, that no one thought to mention how photographs fit into these customs.

In the twentieth century, the uses of death-related photographs are more guarded. They are absent from all of the recent family albums I have examined. Those who do possess death-realted family pictures regard them as very private pictures to be shown only to selected people. A rural Pennsylvania funeral director told me that the photograph he took of his young daughter upon her death was only for him and his wife, and that he had not even shown it to his other children. On the other hand, he sometimes notices that when he gives a family member a Polaroid postmortem they requested him to take, the family members pass it among themselves and any friends who happen to be around—much in the manner one passes around any newly acquired Polaroid.

I have interviewed families who keep postmortem pictures in their family Bible or with other important family documents such as birth certificates and property deeds. Based on my ethnographic studies, I conclude that photographs taken since World War II are not likely to be in the family album or deposited in other places where the family keeps their photographs but rather kept in a special place of more limited access and privacy.

The custom of sending a funeral or postmortem photo to someone who could not attend the funeral is a commonly given reason for the practice today. It is thought to be especially prevalent among recent immigrants and others who maintain a close affinity with relatives who remain in the country of origin. For example, Irish, Polish, Russian, Italian, and Asian Americans have engaged in this activity since their arrival in the United States. In times past and during both world wars it was difficult for people to attend the funeral service. The photograph was given as a substitute for the experience—surely one of photography's most basic functions. Among more recent immigrants such as the Tongans in Utah, funerals are videotaped for relatives not able to come from Tonga to the event (Hammond 1988). The camcorder will undoubtedly displace the snapshot camera as the preferred recording device at funerals as it has with many other social events deemed worthy of preserving.

Distribution and Frequency of Occurrence

Only some death-related photographs survive the ravages of time. Given current attitudes toward death evinced by most middle-class Americans, it is safe to assume that many people destroyed their family's postmortem photographs because they were appalled by them. A number of images reproduced in this book and others in my collection were acquired because a family member wished to rid their family photograph collection of these "sick" pictures from the past. Boerdam and Oosterbaan (1980) speculate that a similar attitude is to be found in Europe. "It is remarkable, however, that very few photographs of dead persons have been preserved. These photographs have probably been destroyed or thrown away in the course of time under the influence of a growing resistance to this kind of photograph. The disappearance of photographs of the dead could be an illustration of the theory developed by Elias that more and more aspects of life are put out of sight 'behind the scenes'" (p. 102).

Those images, particularly daguerreotypes, that have survived often are recontextualized in galleries, private collections, and museums where they become transformed into art objects with a market value. Photohistorians generally follow the methods of art historians and therefore search for evidence in these institutional locations where recent postmortem snapshots are not likely to be found. It is one reason why the Rinharts (1967), Taft (1938), Burns (1990), Lesy (1973), and others have erroneously assumed the practice was confined to the nineteenth century. They were looking in the wrong places.

The corpse and funeral photographs produced in the last several decades are more likely to be retained by the family because the photographs are sufficiently recognizable to be considered part of the family's heritage and because they have far less market value. The photographs are therefore only accessible to scholars who employ ethnographic and ethnohistorical methods. It is my experience that families are reluctant to let you see their postmortem images for fear of being ridiculed. Until a rapport has been established, they will deny their existence. When I asked directly, the most frequent response was not to confirm or deny the existence of the images but to ask, "How do you feel about that?" Once assured that they would not be thought of as a ghoul, the pictures emerged. But the conversations were still limited and, by and large, lacking in revelations because I was an outsider to their grief and they know society at large disapproves of the practice. The only people who might have access to in-depth information about how people feel about these images are grief counselors, and as I have pointed out in the Introduction, they have failed to publish their findings.

The helter-skelter fashion in which these pictures appear hardly makes them usable for quantitative analysis. So it is necessary to offer a studied estimate. Based on an examination of several thousand photographs, death-related images are found from the beginning of photography until today in all photographic formats—daguerreotypes, ambrotypes, tintypes, cartes de visite, cabinet cards, stereographs, postcards, snapshots, Polaroids and 35mm color slides as wallet-sized snapshots, life-sized enlargements made to be hung on the wall, cards mounted in albums, attached to memorial cards and tombstones, and placed in jewelry. While the majority of my research was carried out in the northeastern United States, I have informal knowledge that suggests the practice is found over a large geographic, socioeconomic, and regional spread within the United States, Europe, Asia, and South America—in other words, throughout the world.

Two impressions are worth noting for their suggestive qualities about contemporary practice. Dian Rabson, photographic librarian of the Colorado Historical Society in Boulder, states that during a period of two years when she was working in Kodak's processing division, she "inspected a surprisingly great number of photographs of mourners posed around or beside an open casket. This image would sometimes be supplemented by a portrait of the dead person in the casket." It was her impression that "sometimes these images would outnumber wedding photographs!" (personal communication, December 10, 1981).

On two separate visits to the Berkey Labs in Cornwell Heights, Pennsylvania, where a processing machine produces thousands of prints per hour, I observed a number of death-related images. The speed with which the machine operated made systematic counting impractical. My guess is that each time I saw several dozen funeral photos in a sample of several thousand images. The plant operators said that the observation could be repeated at any time with the same results. They also offered the following insight based on their observation of Americans' picture-taking habits. Two photographic practices are common and yet seldom discussed in public—corpse and funeral pictures and amateur erotica, also produced for a very limited audience.

Circumstantial evidence strongly suggests that these anecdotes are merely the tip of the iceberg. There is no doubt that many Americans have made death and funeral photographs for the past 150 years, even though their activities have, until recently, escaped the notice of scholars and even heath-care professionals in the business of counseling mourners about the management of their grief.

It may be that these photographs are more frequently commissioned and produced by women than men. In American society women have been assigned the task of maintaining the identity of the family—symbolic as well as actual.

Keeping the family photo album and other memory objects are two manifestations of this task.

> *Since the early nineteenth century women have taken the active role in creating and preserving "remembrances," artifacts that serve as reminders of people and events. This practice is a legacy of the Victorian Era (1837–1901), during which middle-class women developed a "cult of memory" in which they memorialized the rites of passage in their lives and the personal relationships they enjoyed. . . . The cult of memory found its greatest expression in the memorialization of the dead. Steeped as they were in sentimentality, nineteenth-century women carried the emotional weight of the family's grief and sought to commemorate their relationships with departed friends and relatives. . . . [The Victorian] keepsakes strengthened the bonds of kinship and friendship at a time when the growth of industry and cities caused stressful social changes.*

(Lamoree and Bourcier 1990, n.p.)

The practice of taking postmortem and funeral photographs crosscuts ethnic boundaries. It is not common among the very rich or the very poor, that is to say, it is a middle- and lower-middle-class activity. It is found more frequently among people with a strong ethnic identity, particularly African Americans, Asian Americans, Polish Americans, Russian Americans, and Italian Americans. While it is less common among WASPs who have no particular ethnic identity outside of the United States, it is found among the Scotch-Irish Presbyterians and German Lutherans who live in Juniata County, Pennsylvania.[3] I have not discovered any reason for this cultural distribution except that the practice was brought to the United States when people emigrated. Whatever the distribution, it is certain that the practice of taking death-related photographs was more widespread than the market for posthumous mourning paintings, which was apparently confined to "certain families among the middle and upper-middle-class Protestants" (Lloyd 1980, p. 106).

The account books from the daguerrean studios of Southworth & Hawes represents one of the most comprehensive sources of information about the business of early photography. In the 1940s, the collector Alden Scott Boyer acquired an extensive collection of their daguerreotypes as well as the firm's account books and business records. Shortly before his death, Boyer gave his photographic holdings to the International Museum of Photography in the George Eastman House in Rochester, New York (Anon. 1953). There are six postmortem daguerreotypes in the collection. It is therefore possible to see that Southworth practiced what he preached as regards the composition of a corpse photograph (see figure 17).

The account books of Southworth & Co. are not complete. The entries are often cryptic. However, they do provide us with an indication of the frequency of postmortem photography in the nineteenth century and make it possible to draw some conclusions about this activity as it concerns this prestigious firm.[4] Between 1841 and 1859, 16 "sittings" on 12 separate days are listed in the account books as being of a deceased person. One entry is actually a copy of a receipt.

> *Mr. F. Blak* [sic] *to*
> *A. L. Southworth & Co.*
> *To services taking likeness* [sic] *of deceased*
> *child at house* *12.00*
> *carriage hire* *.63*
> *Boston July 22, 1845* *$12.63*
> *Rec'd payt.*

Photographing the deceased was the only photographic business noted in the account book for 5 of the 12 days. For example, on February 21, 1846, there were three "deceased" sittings listed, one with a fee for a carriage. Other business for that day included copying, a crayon photograph plus duplicates, but no other sittings.[5] For Southworth, postmortem photography was an important source of income.

Eleven entries, the majority of the deceased sittings, contain a fee for a carriage, indicating that the photographers went to the home of the deceased. The location of most nineteenth-century corpse photographs cannot be determined by examining the image. It seems self-evident that the place where the picture was taken was dictated by the funeral customs of the time. When viewings and funerals occurred in the home, so did photographing of the dead. However, there is evidence from Europe which may undermine this apparently self-evident assumption. As noted earlier, the Danish literary critic Georg Brandes took his dead child to the photographer's studio (Brandes 1890, in Kildegaard 1986, p. 77). In 1895 the government of Austria "passed a bill against postmortem photography in studios because of the high risk of spreading mortal diseases" (Brückner and Mass 1975, p. 100, cited in Kildegaard 1986, p. 78). No similar laws have been located in the United States.[6]

The cost of a deceased "sitting" ranged from $10 to $15 with $12 being the most frequent charge—a fee that was sufficient to prevent the working class from availing themselves of Southworth & Hawes's services. The account books do not always mention the size of the daguerrean plate—a major factor in determining cost. The fee for a postmortem image does not seem to be significantly

higher than the cost of a studio photograph of a living person, with a range from $5 to $25 for a mammoth plate. Southworth & Hawes was a pricey studio. One could acquire a daguerrean image in Boston for less than $1. Southworth & Hawes's fees were comparable to having your portrait painted. According to the painter William Sidney Mount's account books, he charged $20 for a posthumous mourning painting in 1846 (Frankenstein 1968, p. 26). The Rinharts (1967, p. 80) claim that a postmortem daguerreotype could cost as much as $75. They offer no evidence for this assertion.[7]

The University of Louisville Photographic Archives has collections from two twentieth-century commercial photographic studios that contain postmortem and funeral photographs. Caufield & Snook, founded in 1904, accepted many commissions until their last owners acquired the firm in the 1960s (see figures 48 and 49). According to Dick Duncan, the company got calls for "this sort of work" with "some frequency in the early sixties and that he at first did the work himself since none of the staff people wanted to do it. He discovered that he strongly disliked the work and so he began to refuse" (James Anderson, personal communications, April 9, and May 26, 1992).

In addition, according to an unpublished manuscript of Stern J. Bramson, owner-operator of the Royal Photo Company from 1912 to 1989,

> In the 1930s we photographed a number of funerals. We would go to the funeral home and photograph the deceased in the casket showing the open section. We would always get one of the funeral directors from the home to take off the lace covering over the open section of the casket, so we could get a good view of the face. This type photo was best illuminated by flood light to take out the shadows. It seemed like we were shooting about one funeral every week for about 7 or 10 years and then it slowed down. Some families told me that some member lived out of town and couldn't come for the funeral so they would mail the photos to that person.
>
> (From an unpublished manuscript by Stern J. Bramson, Photographic Archives, University of Louisville, pt. 2, p. 25)

As for contempory practice, in 1982 a questionnaire was distributed to a Pennsylvania association of professional photographers. The majority of the membership in this organization are studio photographers living in rural communities, small towns and suburbs. Sixty percent of the photographers cater to people with a strong ethnic identity (e.g., 24% said that Italian Americans constituted the majority of their customers). They specialize in wedding, graduation, and baby portraits. Of 193 questionnaires that were sent out, responses

were received from 142 photographers (74%). Sixty-three percent of the photographers who responded had been commissioned to take a photograph of a deceased person, mainly at the funeral home (80%). The commissions were not common—18% said only once; 13% twice; only 4% said it was a frequent commission. Family members usually commissioned the photograph (90%), but only 40% asked for a particular view. Of those who requested a specific view, a close-up of the deceased and an overall view of the casket with the flowers were the most common requests (see figures 29 and 30 for examples of the poses). One commission was for a close-up so that the eyes could be retouched to appear to be open (as in figure 28). The most common explanation the photographers recall their clients using was that they wanted it as a remembrance for absent relatives or children too young to attend the funeral. When asked their personal reaction to the practice, 43% were negative or strongly negative; 10% were positive or strongly positive; and 27% were neutral; the remainder had a mixed response to the idea.

A questionnaire was also mailed to members of the Philadelphia Area Funeral Directors Association in 1982. There were 22 responses out of 46 questionnaires sent. Their businesses were mainly located in urban communities (76%) with a strong ethnic identity (57%). More than 95% of the directors knew photographs were being taken in association with a funeral, even though 48% of them never actually witnessed the act. Eighty-five percent of the respondents stated that their establishments had no regulations about the activity. Approximately half (48%) of the photographers were family members who took pictures of the deceased in the casket (38%) as well as the floral arrangements and the activities surrounding the funeral. Those directors who knew how the pictures were used (more than 56%) said that they were for relatives who could not attend the service. Only 23% of the directors had ever taken pictures of their own family members. When asked for their personal reaction to the practice, 25% were negative or strongly negative; 19% were positive or strongly positive; 24% were neutral; and the remainder had a mixed reaction. I can think of no reason to assume that the results of these two surveys would not be replicated in the rest of the country.

The syndicated newspaper advice column of Ann Landers is designed to appeal to the widest possible audience. It is difficult to imagine Ms. Landers going very far out on a limb in discussing anything that would be considered abhorrent to the majority of her readers. The following column appeared in the *Philadelphia Inquirer* on February 25, 1991. It offers the strongest evidence of how widespread and commonplace the custom is.[8]

Advocates for photographing the deceased

Dear Readers: One thing I have learned from writing this column is that no matter how weird something may seem to me, there are others who hold a totally different point of view. For example—photographing deceased family members in the casket.

"Upset in Michigan" wrote to say that she was appalled when her cousin sent several pictures of a deceased relative lying in a satin-lined casket with funeral wreaths all around. I said I shared her sentiments and suggested she put the pictures away and forget about them.

Since that column appeared I have received nearly a thousand letters in support of taking such pictures [*emphasis added*]. *If you'd like to look over my shoulder, be my guest.*

From Evansville, Ind.: "When my mother passed away from lung cancer five years ago, I was shocked and appalled to see my niece taking pictures of her in the casket. I thought it was insensitive and disrespectful, but I said nothing.

"The following week, my niece brought the pictures to my home. I thanked her politely and put them away without opening the envelope. Several months later, I ran across the envelope stuck between two books in the library and decided to open it. I had forgotten how beautiful my mother was. Those months in the hospital were so filled with pain and suffering that my last memories of the dear woman tore at my soul. Those pictures were a great comfort, Ann. I am so happy I have them."

Wayne, Nebraska: "We lost our baby daughter at birth. She was full-term, perfectly formed and very beautiful. My mother asked me if I wanted her to take a picture of the baby before they lowered the lid of the casket. I said, 'No, please, don't.' My mother respected my wishes but now I regret terribly that I didn't give her permission to do it. Photographs are a wonderful way to keep beautiful memories alive forever. If you print my letter, just sign it— Cheryl."

White Plains, New York: "My wife and I were married nearly 50 years when she passed away. Mary was a pretty woman but for some reason she did not photograph well. Consequently she avoided the camera and hid whenever family photos were taken. When Mary passed away the mortician did such a wonderful job that I asked my son to take a picture of his dear mother as she lay in the casket with a red rose in her hand. That photo turned out to be the best one ever taken of my wife and I wouldn't trade it for a million dollars."

Modesto, California: "I didn't take pictures of my mother just before the funeral services and now I'm sorry. My last memories of her were agonizing.

She was a living skeleton and weighed less than 70 pounds when she died. I wanted a closed casket but the mortician assured me he could make her look beautiful and he did. How I wish I had taken a picture of her as she looked then."

Biloxi, Mississippi: "In the deep South, people save for their funerals nearly all their lives, even if it's a dollar or two out of every paycheck. My kinfolk were all buried in outfits that were much fancier than what they could afford when they were living. We make it a practice to take pictures of all our relatives in their coffins. They looked better dead and dressed up than they ever looked when they were alive and in their work clothes. Praise the Lord."[9]

The evidence for the distribution and frequency of photographic tombstones is more publicly available and more likely to be preserved through time than is corpse photography. Dethlefsen (1981), an archaeologist specializing in the social history of cemeteries, believes their distribution may be linked to religious beliefs and other cultural factors. "I have wondered why photographic reproductions of the deceased are so uncommon on the gravestones of one part of the country and of the world, and not of another, and what their connection with particular religious preferences has to do with some aspects of world view shared across many, but not all, communities" (p. 158).

For the nineteenth century, there is a perplexing lack of fit among the data. On the one hand, there are a number of patents and companies offering devices to secure photographs to tombstones (see chapter 3 for details). However, there is no evidence that any of the entrepreneurs mentioned ever manufactured or sold any of these advices. Only a very few daguerreotype tombstones have survived. It would seem logical to assume that if all of the inventors described in the previous chapter saw photographic tombstones as potential moneymakers, then there must have been a considerable market.

James Anderson, a Utah photographer chronicled by Rell Francis, took a photograph of Wheeler & Childs, Undertakters, Marble Workers & Etc [*sic*] in Springville, Utah, in the 1880s, probably for advertising purposes (figure 110). A detail of that image reveals a stone containing a postmortem photograph of a child (figure 111). Among the few surviving daguerrean tombstones is one located in Oak Hill Cemetery in Georgetown, Washington, D.C. The inscription reads "Sacred to the memory of Nephi Bell, who died November 22nd, 1862, aged 19 years, 2 months, 17 days. The photograph is a studio shot of the young man standing with his hat held near his knee.[10]

My examination of cemeteries in the Philadelphia area revealed a perplexing distribution of photographic tombstones. I systematically explored two famous nineteenth-century rural cemeteries, Laurel Hill and Woodlands, and

110
"Wheeler & Childs, Undertak-
ers, Marble Workers & Etc,"
Springville, Utah. George E.
Anderson, 1888. Modern gela-
tin silver print from glass plate
negative, 8 × 10 inches. Cour-
tesy, Rell Francis, Springville,
Utah.

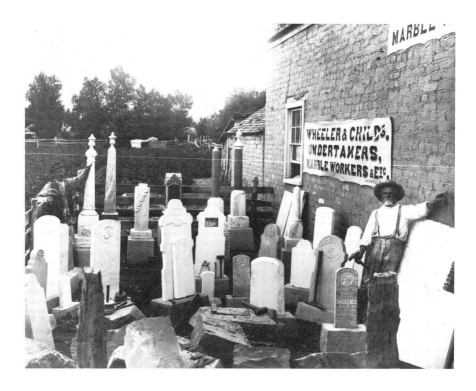

111
Detail from figure 110. Mod-
ern gelatin silver print from
glass plate negative, 8 × 10
inches. Courtesy, Rell Francis
Springville, Utah.

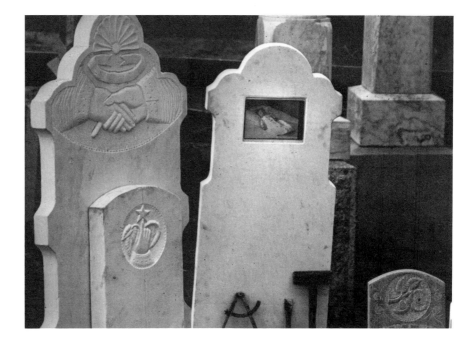

found no nineteenth-century tombstones with photographs. A complete survey of two additional Philadelphia cemeteries, Oakland (founded in 1891) and Northwood (founded in 1878), revealed many twentieth-century photo tombstones.

Northwood is located in the northwest corner of Philadelphia in a neighborhood that was originally German American. Since that time the area has become more ethnically diverse. There are approximately one hundred thousand graves in Northwood. One hundred twenty-nine have photographs. While the ethnicity of these 129 could not always be determined with certainty, the following distribution was noted: 74 were African Americans; 21 were European Americans; 17 were Asian Americans; and 17 appear to be Gypsies. While the cemetery was founded in 1878, only four photographs were located with dates prior to the 1970s and the number of photo tombstones in the 1980s was double that of the 1970s.

Oakland is predominantly a cemetery for people from the Ukraine and Russia. Out of approximately 38,000 graves, 248 had photographs on the tombstones. While determining the ethnicity of the people portrayed is not always possible, it appears that 71% were Slavic (mostly Ukrainian or Russian), 3% were Italian, and the rest (26%) are unknown. The earliest images were from the 1920s (four). There is a gradual increase in each decade—22 in the 1930s, 41 during the 1940s and again in the 1950s. The largest number found, 63, were from the 1960s. The number declined to 39 during the 1970s and to 34 in the 1980s. Thus far, four photo tombstones are known in the 1990s.

A casual inspection of several other cemeteries in the Philadelphia area confirmed these findings. There are no nineteenth-century photo tombstones. Twentieth-century photo tombstones are rare until after World War II. The vast majority display people with some obvious ethnic identity. The absence of photos on tombstones prior to World War II remains unexplained.

Among Jewish Americans, the problems created by death-related photos are revealing of the American dilemma about acknowledging death. According to Maurice Lamm's interpretation of Jewish law and custom, "viewing the corpse is objectionable, both theologically and psychologically. It shows no respect for the deceased, and provides questionable therapy for the bereaved. Religiously, it expresses disregard for the rights of the dead and a perversion of the religious significance of life and death" (1969, p. 27). Lamm goes on to argue that it is not therapeutic for mourners to see the body. The argument that a religious prohibition can be supported with psychological evidence is not supported by many non-Jewish grief counselors. "Some authorities believe that being allowed to view the body of the deceased confirms the reality of the loss, prevents denial, and ultimately facilitates the grieving process" (Brown and Stoudemire 1983,

p. 381). Whether it is only a religious prohibition or sound psychological practice, corpse and funeral photography are generally not practiced by Jews.[11]

Given a general prohibition against graven images, designed in part to prevent the worship of ancestors, it would be logical to assume photographs would be absent from tombstones in Jewish cemeteries. Not so. In the Oak Woods Cemetery on the south side of Chicago there are several Jewish cemeteries within the larger cemetery. From 1900 to the present, photographic tombstones abound (figure 112). James Tibensky of Berwyn, Illinois, surveyed two additional cemeteries in the Chicago area—Bohemian National and Waldheim in Forest Park, where a number of his relatives are buried (figure 113). In both cemeteries, photographs are to be found. When Tibensky asked the Eisenstein family historian (his wife's family) about the large number of photographic tombstones for the Eisensteins, the historian "had no idea as to the 'real' explanation, but guessed it was a 'compromise' made to accommodate the Eastern European tradition of pictures on graves" (personal communication, 1983).

According to the research that anthropologist David Gradwohl has conducted in Jewish cemeteries in the United States, photographic tombstones are more common in Conservative and Orthodox than in Reform cemeteries. He supports Tibensky's notion that the custom is common in the country of origin of the Jews who practice it in the United States.[12] "Photographs of the deceased are attached to several other monuments in the Mount Carmel Cemetery [Lincoln, Nebraska]. While we initially thought this practice would be contrary to the Orthodox tradition which abhors graven images, we have observed the use of photographs on gravestones in a number of Orthodox and Conservative cemeteries throughout the central and eastern United States. Further research, we suspect, will show the derivation of this practice from Eastern Europe where it occurs in both Jewish and Christian cemeteries" (Gradwohl and Rosenberg 1988, p. 244).

Two respected scholars of Jewish law and custom argue that the practice is in "bad taste." "There is no legal objection to having a photograph of the deceased on the tombstone but it should be discouraged as being in poor taste and out of place in a cemetery (for a discussion of the subject see *Kol Bo'al Aveilut* p. 380)" (Klein 1979, p. 296). Lamm (1969) concurs: "Good taste, quiet dignity, and the avoidance of ostentation are the only guidelines for selecting the monument. . . . Photographs mounted on monuments are not in good taste. Some authorities maintain that they are prohibited. It does seem that a person should be remembered without having his portrait to stare at. If already erected, however, these tombstones should cause no disputes, and are better left to stand as they are" (p. 191).

112
View of Jewish section of Oak Woods Cemetery, Chicago. Jay Ruby, 1992. Gelatin silver print, 8 × 10 inches. Courtesy, Center for Visual Communication, Mifflintown, Pa.

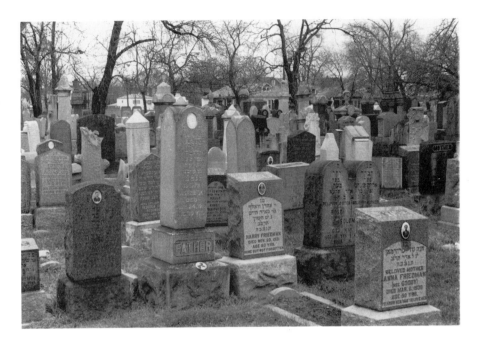

113
Photographic tombstone of Liby Heiga Banchefsky, died September 30, 1928. James Tibensky, 1983. Gelatin silver print, 8 × 10 inches. Courtesy, Center for Visual Communication, Mifflintown, Pa.

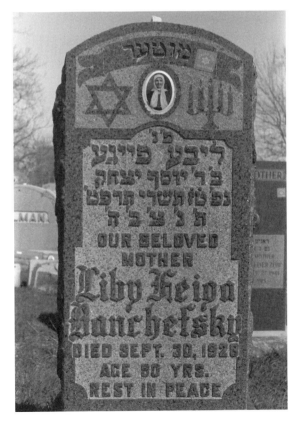

Gradwohl suggests that employing the notion of taste has more to do with ethnic and possibly class differences among Jews than actual religious law—a conflict between the customs of the eastern Ashkenazim (mostly Orthodox and Conservative from Russia, Poland, and the Baltic states) and the western Ashkenazim (largely Reform from Germany).

"Officially this practice is strongly discouraged by most Orthodox rabbis in terms of the avoidance of the use of graven human images. In this instance, however, folk tradition often wins over rabbinic proscription" (Gradwohl, unpublished paper). Whatever the explanation this is yet another example of "official" culture attempting to prevent the use of death-related photographs, and failing because the desire to remember with a photograph is so strong that it overcomes any sanctions that would be associated with a practice that is in "bad taste."

Motivation

Why do some people take photographs of their dead loved ones and their funerals and affix their images on tombstones? Is there some overriding purpose and motivation that can account for all photographs of death? It may be no more complex than the fact that photographs that memorialize a life or commemorate a death provide us with a means to remember so we can forget. There is a commonsense link between grieving and photographic images. Preserving memories was unquestionably a basic motivation for the creation of photography. According to people in the profession of grief management, memories of the deceased are essential for the normal mourning processes to work (Lewis 1979, p. 304). An object that reminds the mourners of the cause of their sadness may serve to make the work of grief more tangible. Photographs of the deceased provide significant assistance in getting survivors to accept the finality of the loss and begin the essential reintegration of the mourner into society (Brown and Stoudemire 1983, p. 378). Mourners are always confronted with two seemingly contradictory needs: to keep the memory of the deceased alive and at the same time, accept the reality of death and loss. Photographs of the deceased serve as a means to address this contradiction. Pictures of death are inescapable reminders of the loss, while memorial images of a life that is no more help us to symbolically keep the dead alive.

Having a photograph of a deceased relative is a logical extension of the desire to have images to preserve family ties and one's heritage. This need is an especially important part of American family life because of the disruptions caused by the nineteenth-century expansion to the West after the Civil War, by

the initial migrations from Europe and other countries of origin, and by World War II and its economic aftermath. When families are geographically dispersed, any photograph of a loved one who died can become an important object for the survivors, even a death picture. Funeral photographs may be the only way in which family members separated by great distances can participate in these important rites of passage.

Once families could symbolically preserve themselves with pictures, the importance of these photos became immediately clear. In 1864, only 25 years after the invention of photography, studios were copying already existing but fading images of people who had died. An item in *Humphrey's Journal* states: "In many galleries they are making copies from the likenesses of deceased persons into photographs, as the times have not yet had any tendency to take away that deep affection which holds the memory of one friend to another" (1864, vol. 12, p. 324). On the back of a carte de visite tintype (ca. 1860s) produced in L. Horning's City Photograph Rooms in Philadelphia, customers are enjoined to "Preserve the Pictures of Your Deceased Friends." [13]

In his 1872 autobiographical reminiscences of his life as a photographer, H. J. Rogers expresses the sentiment in flowery Victorian style. "What happy consolation! What emotions of gladness spring up from our hearts as we gaze upon the life-like presentations of the familiar faces, in life's journey no longer with us. We are not aware of the immeasurable extent and degree to which our domestic and social affections, and sentiments, are perpetuated and purified as we solitarily look upon the shadows of departed absent friends. Their pictures meet our eyes, reflecting the brightness of life into our souls" (pp. 42–43).

The sentiment of keeping someone alive with a picture is a theme found in popular literature and song, from the Judds' 1989 hit "Guardian Angel" (*River of Time* album) to the Carter Family, a pioneer country and western music group, who recorded the following song in Atlanta in 1932[14]:

Picture on the Wall

There's an old and faded picture on the wall,
That has been a'hanging there for many a year.
'Tis a picture of my mother, for I know there is no other
That can take the place of Mother on the wall.
(Chorus)
On the wall, on the wall,
How I love that dear old picture on the wall.
Time is swiftly passing by and I bow my head and cry
'Cause I know I'll meet my mother after all.
Yes, the children all have scattered, all have gone.

And I have a little family all my own.
And I know I love them well, more than anyone can tell,
But I'll hold that dear old picture on the wall.
Since I lost that dear old mother years ago,
There is none to whom with troubles I can go.
As my guitar makes its chords, I am praying to the Lord
Let me hold that dear old picture on the wall.[15]

While there might be some disagreement about how long one is to keep alive a memory of someone dead, memorializing with an image of the person still alive seemingly was never considered problematic. In this case, the private needs of the mourner have always been socially acceptable. The creation of photographic memorial cards, prayer cards, photographic tombstones, and video "living wills" by the terminally ill do not seem to carry a connotation of morbidity or pathological behavior. As I suggested in the Introduction, the pictorial acknowledgment of a "newsworthy" death or the casualties of war are common, even normal. Artists have painted and photographed death with seeming impunity. Yet, the private use of a photograph of a corpse or a funeral to commemorate a death in one's family is a practice unfamiliar and even abhorrent to many twentieth-century Americans. Individuals who feel the need for a funeral portrait suffer the possibility of condemnation from family and friends and, in some cases, even their funeral director and bereavement counselor. As noted earlier, if you are Jewish, you are told that images of the dead violate Jewish custom and law and that photographs on tombstones are "in bad taste."

Americans who wish to take postmortem or funeral photos find themselves trapped between conflicting twentieth-century cultural expectations—using the camera to memorialize important experiences and people and the belief that material remembrances of someone who is dead prolongs grief and are therefore morbid and unhealthy. The mourner who wants a picture must, somehow, discover a means to resolve

the contradiction between society's need to push the dead away and its need "to keep the dead alive." The social distance between the living and the dead must be increased after death, so that the group first, and the most affected grievers later, can re-estabish their normal activity without a paralyzing attachment to the corpse. Yet the deceased cannot simply be buried as a dead body; the prospect of total exclusion from the social world would be too anxiety-laden for the living, aware of their own eventual fate. The need to

114
Unmailed commercial post-card with printed inscription "Hindu Funeral Pile." No publisher, ca. early 1900s. Courtesy, Center for Visual Communication, Mifflin-town, Pa.

Hindu Funeral Pile.

keep the dead alive directs societies to construct rituals that celebrate and insure a transition to a new social status, that of spirit, a being now believed to participate in a different realm.

(Blauner 1977, p. 187)

Even the idea of collecting nineteenth-century examples of these images upsets some people and causes them to assume the collector has a morbid, unhealthy fascination with death. Lou McCulloch, a collector, in *Card Photographs: A Guide to Their History and Value* (1981), a book designed to promote and assist photograph collecting, states that "today many people are appalled by such photographs [i.e., postmortems] but one must remember that the practice was based upon an accepted social custom" (p. 55). While gathering information for this study, I placed advertisements in periodicals that deal with collecting and antiques. Some of the responses led me to a semiunderground group of collectors who specialize in macabre and grotesque photographs—postcards of beheadings in China, piles of corpses (figure 114), dead soldiers from the Spanish-American War (figure 115), torture victims, and other esoteric images of the exotic other. The assumption made on the part of those answering my advertisement was that if I was interested in postmortem images, I must be interested in other "macabre" subjects.[16]

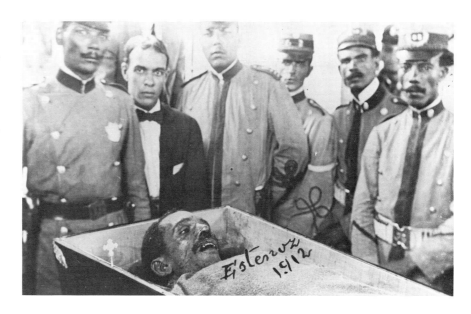

This contemporary ambivalence is further reflected in the results obtained from the 1982 survey of attitudes toward death-related photography among professional photographers and funeral directors in Pennsylvania discussed earlier. When asked about their personal reaction to these photographs, funeral directors were about equally divided—25% were strongly opposed and the same number strongly positive, while 24% were neutral. Among professional photographers the responses was more one-sided—43% were negative, 27% were neutral, and only 10% were positive. When asked whether they had ever taken funeral photographs for their families, over three-quarters of both groups answered no. As we saw earlier, Howard Raether, Executive Director of the National Funeral Directors Association, believes that "In the minds of many . . . photography of the deceased, regardless of where it is done, is abhorred" (personal communication, December 9, 1981). On the other hand, Ann Landers has suggested on a number of occasions that within reason and "good taste," [17] the practice is perfectly acceptable. The lack of a cultural norm is abundantly clear. Publicly, Americans think the idea of taking corpse photos is unhealthy, while privately many practice it.

Evidence from the nineteenth century suggests a relatively straightforward motivation for many, perhaps most, postmortem photographs that was unique to the time. Photographic portraiture was a popular and widespread practice in America. By the 1860s, everybody wanted their likeness preserved. However, not all people had easy access to a photographer. So when a person died without

116
Florence May Laser. E. P. Tompkins, Photographer, Holden, Mo. Albumen print, carte de visite. (Note: the inscription on the back reads: "Taken when dying. Died Aug-17, 1874.") Courtesy, Pennsylvania State University, William Darrah Collection, University Park.

117
Detail from figure 116. Courtesy, Pennsylvania State University, William Darrah Collection, University Park.

ever having had his or her picture taken, particularly a child, a postmortem photograph seemed a logical thing to do. At least there could be one photograph to preserve the memory of a life cut short. Since the likelihood of someone dying before that person had a photograph taken was higher in the 1800s than it is today, high infant mortality may account for the popularity of postmortem photos of infants in the nineteenth century. Darrah (1981) states that, "Portraits of dead persons, especially of young children, were often the only pictures of the individual the family could possess. Child mortality until 1885 carried off one child out of five during the first year of life and two out of five by the fifth year" (p. 39). The carte de visite of Florence May Laser certainly supports the notion that parents were often desperate to have one picture of their dying child. An adult hand supports the child while on the back of the image someone has written "Taken while dying" (figures 116 and 117).[18]

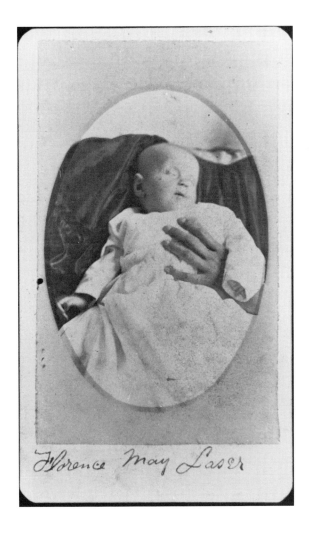

With the lowering of infant mortality rates in the United States during the twentieth century and the increased availability of amateur photo equipment, far fewer people went to their grave without having at least one photo taken. Still, some children do die without the parents having a reasonable opportunity to take their picture. During the 1980s, health care officials who encountered infant mortality on a regular basis "reinvented" postmortem photography without realizing they were emulating an already existing practice. The current widespread use of postmortem photography for stillborn children and following neonatal fatalities provides us with an unequaled opportunity to explore the social and psychological functions of these images. The remainder of this chapter concentrates on images taken of babies, citing the most conclusive evidence yet uncovered about the motivations for taking these pictures and the apparent utility of the images for mourners. It is altogether reasonable to suggest that the conclusions drawn from these activities also apply to adults.

According to the directors of the Neonatal Hospice of Children's Hospital of Denver, since 1983 they have been taking photographs of deceased babies and offering them to the parents. Dr. Jonathan Whitfield, a neonatologist at Children's Hospital who helped organize the hospice program, discovered that "families who initially turn down the pictures often come back later and ask for them." Whitfield makes a practice of photographing all infants admitted to the hospice. If the infant dies before a photograph can be taken, a postmortem image is made. He says that no hospice staff member was aware of the history of the custom. They simply decided to offer the photographs to the parents since many had none (personal communication, November 21, 1983).

The practice can be found throughout the United States. For example,

> *for those babies who die at Sparrow Hospital [in Lansing, Michigan] . . . a photograph is taken upon the death of an infant. An attempt is made to make the appearance of the infant as natural as possible; for example, my baby was photographed in a receiving blanket. The parents are informed of the photograph's existence which will be provided to them, at no charge, upon their request. The majority of the parents elect to have the picture. I'm sure you can appreciate that with the death of a newborn this photograph is the only tangible item the parents have of the child.*
>
> (Paul Greathouse, Secretary, Helping Other
> Parents in Normal Grieving, a national volun-
> teers group, personal communication, Decem-
> ber 2, 1988)

Emanuel Lewis (1983), a British psychiatrist who speciaizes in counseling the bereaved parents of stillborn children, has also employed postmortem photo-

graphs in his practice for over 10 years. "Another vital element in facilitating mourning is a photograph of the stillborn baby. This is, of course, especially useful if either parent has not seen the dead baby. Many bereaved parents frequently look at the photograph during the mourning period. It helps them keep alive their fading memory of their baby. The parents and staff understandably find it easier to show a photograph of the dead baby to siblings rather than the dead baby itself" (p. 220). Lewis offers the following explanation as to why photographs are so important when dealing with grief about stillborn children.

> *The process of mourning involves thinking and feeling about the dead person. This is difficult without any knowledge of the body of the dead person. The awareness of the body aids the necessary identification with the dead person and the "digestive" process which gradually frees us from this identification. The difficulty of grieving for someone reported "missing, believe killed" or "lost at sea" is well known; a death without a body seen by anyone seems unreal. The existence of the Tomb of the Unknown Warrior recognizes the need of the bereaved to have a sense of a grave with a body that just might be their dead relative or friend. Mourning a stillbirth is an even more complicated and difficult task. To facilitate mourning, I recommend that a stillbirth be managed by making the most of what is available and can be remembered. The aim is to make history, to make memories that can be thought about and talked about, which will then fill the emptiness that impedes the mourning of a stillborn.*

(Lewis 1983, p. 218)

Lewis suggests postmortem photographs ought to become a normal part of the process of mourning the stillborn.

The National Stillbirth Research Project of the University of Nebraska published a study (DeFrain 1986) based on a survey of 350 mothers of stillborn children, including in-depth interviews with 22 families as case studies. The results tend to support Lewis's contention that photographs have a positive therapeutic value. Many of the parents thought that seeing the baby in a photograph was an important part of their recovery from the loss. According to DeFrain, all the parents who saw their child (roughly 50%), "were pleased that they had seen the baby, though some regretted they had not held the baby or had not taken pictures" (p. 49).

The testimonies of these parents provides eloquent evidence of the therapeutic value of postmortem images.

We both saw the baby. It was difficult and painful. I'd never seen anyone dead before, but I really needed to see him and to confirm with my eyes what I knew with my intellect. To have a picture in my memory of my baby, it's all I'll ever have of him. It is important. He was real. He lived in me and died in me—a part of me.

I know that seeing her was a very necessary part of the grieving process. . . . We did not see her. The one big regret I have is that we did not see her or get a picture of her.

(DeFrain 1986, pp. 51–54)

In discussing the funeral of their stillborn, the parents were more ambivalent about their participation and about sharing the image of their child with others.

(Case No. 1) No open casket. Just my husband and I saw Lance. No pictures were taken of the casket or anything. I did not want pictures of that. . . . I was not allowed to attend. It was done two days after she was born. I felt the funeral home rushed it before I could get out of the hospital. They commented how it was time to get on with living. No open casket. No pictures. Several close friends and family attended.

(Case No. 2) The casket was open. It broke our hearts when they closed it and her father carried her to the hearse. We took a picture, which is now on top of our TV. Many people commented on how beautiful a baby she was.

(DeFrain 1986, pp. 77–82)

Sonograms provide parents whose children die prior to the last trimester a chance to have a pictorial remembrance. In an unpublished paper, Linda Layne explores the role of "technologically-produced representations of fetuses in narratives of loss." She argues that "these images perform a basically indexical function and that in the search for meaning bereaved parents draw on other discourses, frequently religious ones. As a result, medico-technological and eschatological images of a miscarried or stillborn fetus are frequently interwoven in such narratives; sonogram photos were guarded as precious keepsakes in a 'memory book' and poems written describing the child as an angel in heaven." She suggests that "these seemingly divergent sets of images both form a part of a 'moral imagination', i.e., 'a culturally endowed world-picture, . . . that both shapes people's view of themselves and their surrounding and presents a picture in which they measure, assess, and reflect upon the reality of their experience'"

(Layne 1990, pp. 2–3). Layne also feels that "Sonogram images and fetal monitors play another very important role in narratives of loss. Sonogram images and scraps from fetal monitors are frequently saved by bereaved parents and utilized as evidence to prove to others that a 'baby' existed" (1992, p. 23).

The concern for the grief felt by the parents of stillborn children has certainly taken an about-face in the last 20 years. Until recently, stillborn children were treated as if they were aborted fetuses. "A stillbirth is a nonevent in which there is intense anxiety, guilt, shame, yet with no tangible person to mourn" (Lewis 1979, p. 208). Lewis makes the following analogy regarding the medical profession's attitude:

> *The astronomers tell us that a black hole is a star with an extraordinary dense mass whose gravitational pull is so powerful that no energy can escape from it, so that it appears to us as a nothing, a black hole in space. Our image of a stillborn seems like a black hole in the mind, full of invisible things and difficult to recall and, therefore, hard to think about. An obstetric resident, asked to photograph a stillborn baby said, "What is the point? It will come out fuzzy!" To many a stillborn is a sort of ghost baby.*
>
> (Lewis 1983, p. 209)

Three pamphlets designed for laypersons clearly illustrate the shift in thinking about the needs of the parents of stillborn children to mourn their loss. *When Hello Means Goodbye: A Guide for Parents Whose Child Dies Before Birth, at Birth or Shortly After Birth* was written in 1981 by Pat Schwiebert, a nurse, and Paul Kirk, a physician, both affiliated with Perinatal Loss, a Portland, Oregon, organization designed to assist parents with the work of grief. Among the things discussed is "Taking a picture of your baby." Schwiebert and Kirk suggest that the practice become normal hospital procedure.

> *Though the intense pain which you feel will be lessened with the passing of time, you will find that you won't ever want to forget this little person who was so dear to you. A picture can provide tangible evidence that this was your child—that he or she was indeed a part of your life and equal to your other children in the love you gave, if only while inside you. A single picture of this child will be something you can value as much as dozens of pictures of this child's brothers and sisters who survive. . . . We can arrange for a picture of your baby to be taken in the nursery in the same way as with living babies after they are cleaned and dressed. Even if you decide now that you don't want to see or keep the picture, it can be placed with the baby's hospital record, and*

you may request a copy at a later time if you change your mind. Or you may
want to take your own pictures.

(Schwiebert and Kirk 1981, p. 17)

In an appendix the authors acknowledge the reluctance some parents have about photographing their dead child. They provide a list of things that parents have told them they wished they had done before it was too late. Among them is "To arrange for a picture to be taken of the child after embalming and before the burial" (p. 37).

Undoubtedly the strongest evidence for the postmortem photograph as a normative part of grief management for parents of stillborn children is to be found in a 1985 pamphlet, *A Most Important Picture: A Very Tender Manual for Taking Pictures of Stillborn Babies and Infants Who Die* (figure 118) written by a neonatologist, chaplain, and the directors of the Centering Corp. of Omaha, Nebraska—an organization that conducts workshops on death and children for "perinatal care givers." The pamphlet is a how-to workbook with a variety of pictures designed to illustrate poses. It provides historical perspective on the practice by printing postmortem photos from the turn of the century as well as a James Van Der Zee image. The authors explain their intent:

118
Unidentified parents with
their stillborn child. Unidenti-
fied, 1980s. Polaroid. Cour-
tesy, Irwin J. Weinfeld, The
Reuben Center for Women and
Children, Toledo, Ohio.

These photographs are intended to illustrate various ways of taking pictures which will be supportive and affirming to the grieving family. Although the pictures are not professional . . . all of them are very important. While taking pictures of stillborn babies and infants who die has become very wide-spread and is deeply appreciated by most parents, there is still some resistance surrounding the practice. Working through staff feelings and respecting individual differences will help you as you do the best to serve the needs of your families.

<div align="center">(Johnson et al. 1985, p. 1)</div>

Later on they explain

The Importance of Pictures. There are four basic reasons for taking pictures of infants who have died:

A picture helps the family confirm the reality of their baby's life and death.

A picture shows them exactly how the baby looked so they do not have to rely on memory or fantasy.

A picture gives them one way to share their baby with other people.

A picture may be the only tangible memory of their baby [figure 119].

<div align="center">(Johnson et al. 1985, p. 12)</div>

According to a *New York Times* article by Sandra Blakeslee, "New Groups Aim to Help Parents Face Grief When a Newborn Dies" (September 8, 1988, p. B1), "at least five groups with hundreds of chapters all over the country now offer counseling to parents who have lost infants." Rana Limbo is a La Crosse, Wisconsin, nurse who has conducted programs in over 500 hospitals training more than 2,000 bereavement counselors through an organization called Resolve Through Sharing. In addition to the workshops the organization offers a range of self-help publications, funeral cards, and a book, *When a Baby Dies: A Handbook for Healing and Helping.* The book contains advice about photographing deceased children.

Taking Photographs. Photographs should be routinely taken and kept on file even if parents say they do not want them. Often, parents decide later that they do want them. The opportunity to take pictures will never come again. When photographs are taken, a ribbon or hat can be strategically placed to cover defects. Different views should be taken, including closeups of special features (e.g., hands). At least one photograph should be taken of the baby nude

119
Unidentified stillborn child.
Unidentified, 1980s. Polaroid.
Courtesy, Irwin J. Weinfeld,
The Reuben Center for Women
and Children, Toledo, Ohio.

so that parents have a chance to see the baby that way, should they wish to do
so. Pictures that include a pretty blanket, baby toy, or fresh or silk flowers pro-
vide better photographic memories. Parents also may appreciate a family photo
which includes surviving siblings.

(Limbo and Wheeler 1986, p. 96)

Limbo also provides a time during the workshops in which a "Protocol for Pho-
tography" is discussed and participants are given instructions in posing and
framing the images.

Lewis argues that in the case of the stillborn "most people know little of
the natural history of the normal reactions of parents handling their dead ba-
bies. . . . The detailed study of the natural history of bereavement has shown
that many seemingly crazy ideas and actions are within the normal range of
responses to loss" (Lewis 1979, p. 304). He cites work which suggests that no

matter how painful the image may be for the parents to see, the alternative can be worse. A study by Shoekir (1979) suggests that if mothers of malformed stillborn babies are not shown their children, they imagine much worse malformations. Shoekir had mothers draw pictures of what they imagined their babies looked like. Lewis writes, "I have stressed the need for a bereaved mother to have an experience of her stillborn baby as a person with a body to enable her to successfully mourn her loss." He calls the technique "bring the baby back to death. . . . By going over the birth, we can enable her to build up a mental picture of the baby, to create her baby in her mind" (Lewis 1983, pp. 224–225).

A case study provided by a psychiatric colleague suggests that Lewis's notions can apply to a variety of situations and are not necessarily confined to grief for stillborn children. A middle-aged African-American woman was dealing with the fact that her son was shot and killed in a pool hall fight. After the funeral the deceased's girlfriend called his mother explaining that she, the girlfriend, had taken a picture of the dead son at the funeral home. She wanted to know whether the mother wanted a copy of the funeral photograph. The mother was uncertain and asked the advice of her sisters. One told her not to accept the picture because it would only cause her pain to see him in the coffin. It would stir up bad memories. The other told her that it was good to have the picture because she would be able to see him at rest. She was advised that if she got the picture, that it belonged in the family Bible. The woman told the therapist she was trying to dream of her dead son to remember him during happier times.

None of the specialists who use postmortem images in their therapy with parents of dead infants have remarked in a general way about the role of photographs in the management of grief. As commented on in the Introduction, there is no significant literature that discusses the role of *any* photographs, postmortem or other, in the management of grief. It seems only reasonable to suggest that if postmortem, funeral, and family mourning photographs have a positive therapeutic value for the parents of stillborn children, they have a similar effect on people mourning anyone who died.

Do these images prolong or resolve grief? Some laypersons and professionals maintain the notion that having *any* postmortem image is "dwelling on death," and therefore unhealthy. Three examples serve to illustrate the complexity of the problem.

I was told by a Philadelphia area funeral director about an elderly Italian-American woman who carries in her wallet along with photos of her children and grandchildren a postmortem portrait of her husband. She shows the image to her friends and relatives much in the same way one would show other snapshots. The response to the image by her friends, especially women her own age,

is to comment on how peaceful he looks, how nice the flowers are, and so on. In other words, they respond to the photograph in ways that are similar to how they would talk to the widow during the actual viewing of the body. One has to ask whether the photograph is assisting this woman in working out her grief or in becoming a lifelong widow, someone in a pathological state of grief.

In describing case studies of delayed pathological grief, Brown and Stoudemire (1983) discuss a case study of a mother of a 12-month-old who could not get over her child's death. As a symptom of pathological grief, the authors cite the fact that "the patient showed a photograph of the dead infant in the funeral coffin; she had carried the picture in her wallet for 30 years" (p. 31).

The West Indian-born British writer V. S. Naipaul vividly recalls his experience with grief and photographs:

> Three days after her death, at the time she was being cremated in Trinidad, I spread her photographs in front of me on the low coffee table in the sitting room of my new house in Wiltshire. I had been intending for years to sort out these family pictures, put them in albums. There had always seemed to be time. In these photographs, while she had lived, I had not noticed her age. Now I saw that many of the photographs—her little honeymoon snapshots especially—were of a young girl with slender arms. That girl was now someone whose life had been lived; death had, painfully, touched these snapshots with youth. I looked at the pictures I had laid out and thought about Sati harder than I had ever thought about her. After thirty-five or forty minutes—the cremation going on in Trinidad, as I thought—I felt purged. I had had no rules to follow; but I felt I had done the right thing. I had concentrated on that person, that life, that unique character; I had honored the person who had lived.
>
> (Naipaul 1987, pp. 345–346)

Perhaps it is not the photographs in and of themselves that are a sign of pathology or health but rather how they are used by the mourner. We are only now coming to terms with the notion that normal grief is a long process with discernable stages—shock, preoccupation with the deceased, and resolution. How long each stage lasts varies from individual to individual as well as from culture to culture (Brown and Stoudemire 1983). Once our society accepts the fact that mourners have to work through these stages at their own pace, the use of photographs as an aide-mémoire may become more publicly accepted.

In the nineteenth century, the personal desire for a corpse or funeral photograph was socially appropriate and the behavior was supported by the culture. One could publicly display the photographs without fear of being regarded as pathological. Personal needs and society's expectation of what constitutes a nor-

mal response to loss were not in conflict. This is not true in the twentieth century. Yet in spite of the social disapprobation, many, many people continue the practice. Americans have spent most of this century adoring youth and denying death. We have removed death, along with birth, from the everyday reality of our lives to institutions where strangers take charge of these crucial moments. We have sheielded ourselves as much as possible from our species' beginnings and endings. We are slowly beginning to realize that pretending that death doesn't exist will not prevent it from intruding into our lives. As difficult as it has been, we are beginning to accept sadness and grief as a normal, even healthy, part of living. We cannot prevent the loss of those we love but we do sometimes mitigate the loss with a photograph. As the oldest photographic advertising slogan suggests—Secure the Shadow, Ere the Substance Fade.

Albumen photographs were produced from the 1850s to the 1890s. Paper was coated with egg white infused with salt and sensitized with silver nitrate. Contact prints were made by exposing a glass plate negative and paper to the sunlight. The print was usually toned with gold chloride; the result was a purplish-brown color. The finished print was affixed to a cardboard mount.

Ambrotypes somewhat resemble daguerreotypes in size and the manner in which they were cased. A glass plate negative is produced by a wet collodion process and backed by black paper, cloth, or black paint. The backing causes the negative to appear to be positive. Ambrotypes were produced from the mid-1850s until 1880.

Cabinet card photographs were invented when the popularity of the carte de visite waned in the 1880s. They lasted until the 1900s. They were photographs, some albumen, and others produced with a gelatin silver process, affixed to a 4½ × 6½ inch cardboard mount. Albums were designed to house both cabinet cards and cartes de visite.

Carte de visite photographs were the first photo album images. Most often they consisted of an albumen print affixed to a standardized 4¼ × 2½ inch cardboard mount designed to be used in a standard album. Cartomania swept the United States in the 1860s and continued into the 1890s.

Daguerreotypes are silver mercury images produced on a thin sheet of silver-plated copper. In order to see a positive image the viewer must turn the daguerreotype in such a manner as to reflect the light. In the United States, daguerreotypes were enclosed in leather or gutta-percha cases similar to those used for miniature paintings. They were popular from 1840 to 1860. The sizes of daguerreotype plates as well as ambrotypes and tintypes were standardized.

Full plate	6½ × 8½ inches
½ plate	4¼ × 5½ inches
¼ plate	3¼ × 4¼ inches
⅙ plate	2¾ × 3¼ inches
⅑ plate	2 × 2½ inches
⅟₁₆ plate	1⅜ × 1⅝ inches

Stereographs are paired photographs mounted on a 3½ × 7 inch card, designed to produce a three-dimensional image when seen through a viewer (stereoscope). They were made as early as 1850 and continued to be produced into the 1940s.

Tintypes resemble both daguerreotypes and ambrotypes. The image is produced by coating a black japanned sheet of metal with collodion and exposing it in the camera. Tintypes were first produced in 1856 and were continued to be found into the 1940s. Early tintypes were encased like daguerreotypes. Later they were placed in slip-sheets and cut to fit into a carte de visite album. Full-plate tintypes were sometimes overpainted to resemble an oil painting and mounted in a wall frame.

Introduction: Seeing Death

1

Alison Nordstrom, director of the Southeast Museum of Photography in Daytona Beach, Florida, was brave enough to allow an exhibit. "Something To Remember You By: Death and Photography in America," which opened in May 1994.

2

Readers wishing a more in-depth discussion of the "ethnography of visual communication" model that underlies this study are directed to Ruby and Worth (1981).

3

The expectation most readers have is that a book on photography will contain certain kinds of images. A reader of this book in manuscript commented that the book moved from "interesting pictures to needlessly boring ones" and that I could correct the "visual weakness" of the study by adding some of Richard Avedon's photographs of his dead father. While Avedon's photographs as well as those of other photographic artists who have dealt with death are compelling, these images are exceptional and therefore of little use in understanding the commonplace in our culture.

4

The pioneering work of Heinz Henisch and his journal *History of Photography* should be acknowledged here. *History of Photography* was the first journal to regularly publish articles about the everyday photographic activities of ordinary photographers and to expand the concept of what constitutes the history of the medium.

5

Newhall simply states that "almost every daguerreotypist announced his readiness to take posthumous portraits" (1982, p. 32).

6

Since the end of the 1980s, three exhibitions of postmortem and death-related photographs with catalogs have appeared (Tartt 1989; Meinwald 1990; Norfleet 1993) and two unpublished masters' theses (Bowser 1983; Snyder 1971). All of these works assume an art-historical approach and tend to concentrate on the nineteenth century.

7

I have written a detailed critique of Burns and Lesy elsewhere (Ruby 1991a).

8

There is no evidence, pro or con, to suggest that the images are constructed or interpreted based on cultural variables such as class, ethnic, or regional identity.

9

The American Psychological Association's study of television estimates that the average American child sees over 8,000 murders by the age of 7 years (*Philadelphia Inquirer*, February 26, 1992).

10

Prior to the advent of the halftone when newspapers could print photographs, photographers would take pictures of newsworthy events and sell them as souvenirs. Disdéri's carte de visite of the executed Communards of the 1871 Paris Commune uprising is perhaps the most famous. Every public execution in the United States seems to have been similarly memorialized and commodified.

11

In the April 1872 edition of *Anthony's Photographic Bulletin* (vol. 3, no. 4, p. 509), in an article "Transalpine Photography" written originally for the *British Journal of Photography*, an unidentified author claims that "there were to be bought a great variety [of photographs] purporting to be faithful representations of the events of the siege (that is, the Paris uprising of 1871), such as barricades, executions, streets with dead bodies lying in them and so forth. They . . . were fictitious, carefully-arranged tableaux, but terribly natural, and greedily bought by tourists, the greater portion of who never . . . questioned the reality of the representation."

12

It is unclear how many people actually saw the Antietam photographs. "In spite of the fact that the exhibition of the Antietam pictures at Brady's gallery attracted large crowds and the attention of the press, and that similar pictures continued to be taken, printed, and sold throughout the war and immediately afterward, it is difficult to establish that they actually found a popular audience" (Stapp 1988, p. 20).

13

While the writer of the editorial evinces a strong response to the photographs, we have no real evidence as to the general response of the other gallery visitors or the public in general. "How the American public actually responded to the images, whether a sizable contemporary market for them even developed after 1862, however, is very uncertain" (Stapp 1988, p. 31).

14

Rewarding photojournalists for capturing the decisive moment of death extends beyond the Pulitzer. The 1990 World Press Award was given to Georges Merillon of Amsterdam for *Mourning in Kosovo,* which shows Elshani Nasim, a gravely wounded demonstrator shot by Yugoslav soldiers during ethnic clashes in Kosovo, lying in his bed surrounded by weeping village women.

15

Journalists are not the only ones who lie with the camera. A recent study by Marling and Wetenhall (1991) documents the deliberate faking of Rosenthal's flag-raising over Iwo Jima. This World War II icon of American bravery was nothing more than a publicity stunt staged for the War department.

16

Documentary photography is a poorly defined genre occupying a place permanently liminal to both photojournalism and artistically intended work. The masterfully composed, dramatically attesting scenes of death during wartime produced by people like Eugene Smith, Philip Jones Griffith, and Susan Meiselas present us with the same problems created by Alexander Gardner and Robert Capa. Are viewers supposed to understand them as ideologically intended art or simply as reportage?

17

With the advent of so-called reality shows like *Cops* and *I Witness Video,* the blurring of theatre and actuality has increased. As Van Gordon Sauter suggested in his *Variety* (February 24, 1992) review of *I Witness Video:* "But for all the immediacy, there is a certain unreality about all this reality. Television has become so adept at re-creating reality that reality has about it a certain cheapness, a lack of enough camera angles, if you will. We are used to having our reality constructed by art directors and professional performers and production designers and stuntmen and imaginative directors. . . . So stay tuned for further installments in the unreality of reality."

one

Precursors: Mortuary and Posthumous Paintings

1

The place of death masks in the pictorial representation of the dead is unclear. Ernst Benkard's 1927 *Undying Faces* is one of the few studies of the custom. It seems to parallel mortuary paintings in that in the beginning death masks were confined to the rich and powerful. Gradually the practice was democratized. Several central Pennsylvania funeral directors, currently in business, have told me that they were taught to produce a mask in mortician's school. None of the directors ever recall being asked to produce a mask for a client.

2

Like all important moments of our lives, death has been the subject of artistic representation in many cultures and throughout most periods of history. It is simply not feasible to adequately explore the topic of death as an artistic subject in this study. Readers are referred, with some reservations, to Ariès (1985) for a more general discussion.

In addition, art photographers from H. Bayard to Andres Serrano have produced photographs of the dead as artistic statements. While art photographs of death are arresting, their purpose is not immediately related to the subject of this study—the social and private uses of photographs of deceased family members and acquaintances in dealing with loss.

In photography there are only rare examples of well-known photographic artists taking funeral portraits. Perhaps the most famous is Man Ray's 1922 deathbed image of Marcel Proust. According to Merry Foresta, curator of a recent Man Ray exhibition, Jean Cocteau asked Man Ray to take the photograph. Cocteau reportedly had the image published in French newspapers along with the announcement of Proust's death without giving Man Ray credit for the picture. Man Ray was furious. Apparently Cocteau simply called Man Ray and told him to bring his camera to Proust's home because something important had happened and Cocteau wanted Man Ray to take a picture. He did not tell Man Ray that Proust was dead. Foresta assumes that Man Ray took the picture because he liked photographing famous people and this was another feather in the young artist's cap (Merry Foresta, personal communication, March 3, 1990). In preparing a multimedia book, Ben David (1991) had the following response to the photograph: "As we pored through the reproductions, I saw Marcel Proust. Man Ray had been summoned to photograph Proust on his death bed. The man who had written *A la recherche du temps perdu* was himself a dead photo memory—the ultimate surrealist/dada image" (p. 380).

There is a postmortem photograph attributed to Julia Margaret Cameron. While it slightly resembles her portrait of her sleeping grandson, *Archie, 1865,* Mike Weaver, a scholar of Cameron's work, believes it to be falsely attributed to her (personal communication, October 26, 1989).

Mortuary photographs produced today of newsworthy subjects are "news" items designed to inform, not to be regarded primarily as artistic achievements. While images of accidents, war, and other forms of mayhem are commonly rewarded, no mortuary photograph, even of a head of state, has ever won a Pulitzer Prize.

3

Ariès (1985) offhandedly contradicts Pigler (1956). "Similar paintings [i.e., secular mortuary paintings] are attributed to Rembrandt and Rubens" (p. 199). He offers no more precise information. My attempts to locate mortuary paintings by either Rubens or Rembrandt were unsuccessful. I find many of Ariès's assertions lacking in supporting evidence. In general, Ariès's work on death is filled with many examples of shoddy scholarship and served little use in my work.

4

Also see Lloyd (1978/80, p. 109) for another example.

5

They were present in the nineteenth century in Denmark. "Later on the private portrait painted by local painters represents needs to immortalize the dead infant" (Poulsen 1892, quoted in Kildegaard 1986, p. 84).

6

"Vasari tells us that after Luca Signorelli's beautiful young son was killed at Cortona, his father drew the body 'so that he might always behold in the work of his hands what nature had given him and cruel fortune taken away'" (cited in Lloyd 1982, p. 3). There is also Léon Cogniet's painting of Tintoretto painting his dead daughter at the Bordeaux Museum, reproduced in P. Galibert, *Chefs d'oeuvre du Musée de Bordeaux*, 1906 pl. 2, and Alexandre Robert's 1846 painting of Signorelli painting his dead son, reproduced in H. Hymans, *Berlinische Kunst des 19. Jahrhunderts* (Leipzig, 1906, p. 57).

7

Apparently, Bernhardt used the coffin on a regular basis as a piece of bedroom furniture. "My bedroom was very tiny. The big bamboo bed took up all the room. In front of the window was my coffin, where I frequently installed myself to learn my lines" (Bernhardt 1907, p. 269).

Hippolyte Bayard (inventor of the positive-negative process), on October 18, 1940, posed himself as a drowned man in a daguerreotype. The following note accompanied the image: "The corpse of the gentleman you see above is that of Monsieur Bayard, inventor of the process. The Government which has been only too generous to Monsieur Daguerre, has said it can do nothing for Monsieur Bayard, and the poor wretch has drowned himself. Oh! the vagaries of human life" (Jammes 1975, p. 21).

8

At first the gallery was available only to Mrs. Stanford and her friends. Today the gallery is open to the public. While the Stanfords sought comfort for their loss with spiritualists, the rumors that Leland, Jr.'s, spirit visited and thereby motivated them to found Stanford University are apparently incorrect.

9

I did not make an exhaustive examination of consolation literature. I based this statement on an examination of one of the most popular works of this genre, Elizabeth Stuart Phelps's 1868 *The Gates Ajar* and the absence of a discussion of images in Ann Douglas's (1974) definitive exploration of the genre.

10

The similarity in this case is no coincidence. North was also a portrait painter.

two

One Last Image: Postmortem and Funeral Photography

1

The distinction between likeness and portrait in photography was first made by William Stapp in his discussion about whether the famous Robert Cornelius self-portrait daguerreotype was indeed the first photographic rendering of the human face. "While Cornelius may not have been 'the first to obtain a likeness of the human face,' he certainly was the first to obtain one that was natural in pose, conveying a sense of vitality and personality. Because of this, Cornelius's self-portrait represents the first true photographic portrait produced in America, and perhaps in the world" (Stapp 1983, p. 35). Stapp's argument is a temporal one, but the idea can also be used conceptually to discuss photographic renderings of the human form from any time.

2

There are marvelous and unfortunately all-too-rare exceptions to this statement.

3

While conducting ethnographic research into photographic social practices in the early 1980s in central Pennsylvania, I observed and acted as a "gofer" for several rural professional photographers at weddings, high school graduation portrait sittings, and so forth. The conventions and intentions described in the body of the text were derived from that experience. It has been cross-checked with a number of other photographers as well as several vocational-technical schools teaching commercial and professional photography.

4

An exception to this argument is to be found in the highly stylized wedding portraits in which the bride is superimposed on a wine glass or church.

5

Cited in Smith 1987, p. 99.

6

In Weidner's catalog essay on Lambdin, she suggests that "deaths or anticipated deaths were a favorite theme in American art, literature, and music in the Victorian era and especially in the 1860's" (1986, p. 22). Indeed, Lambdin painted at least one additional painting on this theme— *Woman on Her Deathbed*. Weidner goes on to cite a number of Victorian paintings that may have influenced Lambdin—Henry Wallis's 1856 *The Death of Chatterton*, Millais's *Ophelia* (1852), and the composite photograph by Henry Peach Robinson, *Fading Away*.

7

Additional examples of postmortem photographs in which the deceased is placed in a chair are to be found in the Strong Museum collection (88.1675 and 88.1192).

8

Additional examples are to be found in the Strong Museum collection (88.1084 and 88.1147, daguerreotypes of unidentified adult males; and 88.1675, a daguerreotype of a child).

9

According to Fritz Kempe, in Austria

photos of corpses were the rage in the 1850s and 60s (there were even photographers who specialized in this practice). In this way, Albin Mutterer of Vienna became prominent because of his offer to produce "life-like" photography of the deceased. He brought the corpse to his studio and sat it in a chair; the rendering of the eyes and other shading was done by a skilled retoucher. Heinz Gebhardt also describes in his Königlich-Bayerische Photographie *(Royal Bavarian Photography) several producers of "corpse portraits." One of them, Adolph Scherer of Munich, notes that he finishes "corpse portraits with great care in order to produce a friendly appearance."*
(Kempe 1980, pp. 4–5, my translation)

10

In the Strong Museum collection (88.1391) there is a carte de visite of twins in a single casket. They are posed in an embrace and there are flowers around them. According to Deborah Smith, the Kentucky Museum in Bowling Green also has a ca. 1900 photograph of twins.

11

University of Rochester Manuscripts Collection A.M81.

12

A photographer named Waldo E. Price advertised in the *Rochester Business Directory* from 1897 to 1917. From 1897 to 1902 he was situated in Rochester; from 1902 to 1905 in Canandaigua; and from 1905 to 1917 back in Rochester. No additional information is available on his work.

13

There is a Strong Museum (88.1345) carte de visite of a dead dog with this inscription on the back: "Jack Clement, Age 16, Died Apr 16/68."

14

I am greatly indebted to Rell Francis for permission to use this photo as well as the information concerning its meaning and creation.

15

The widow or grief-stricken parent clutching the photograph of the dead loved one at a funeral is a common news photograph during a war.

16

These family death tableaux are widely known from both Lesy's *Wisconsin Death Trip* (1973) and Van Der Zee's Harlem photographs (1978).

17

The Strong Museum has a number of similar images: mothers with their children (daguerreotypes 88.1056, 88.1106, 88.1115, and 88.1131; carte de visite 88.1372); fathers with their children (daguerreotypes 80.5681, 80.5682, 88.1111, 88.1112, 88.1142, and 88.1149; carte de visite 88.1393); and both parents with the child (daguerreotypes 88.1103 and 88.1149; cabinet card 88.1234).

18

Other examples exist in the Strong Museum collection (88.1141).

19

In addition, British genre painters such as Richard Redgrave and C. R. Leslie painted staged domestic scenes of a sleeping child in the mother's arms. Photographer Roger Fenton's 1850s photograph, *Hush, Lightly Tread* is clearly derived from the convention. Paintings and photographs of children asleep in their parents' arms and images of deceased children in their parents' arms are too similar in composition to be accidental. Mike Weaver suggests that all of these images ultimately derived from Madonna and Child paintings (personal correspondence, October 26, 1991).

20

Burns's book (1990) contains several examples of dramatically posed family photographs (figures 3, 5, 17, 25, 29, 45, and 72).

21

Dian Rabson (personal communication, December 10, 1982) suggests that the coffin or graveside family portrait is still rather common.

22

Similar poses can be seen in a stereograph of two women in mourning clothes sitting by a grave in the Spring Grove Cemetery (J. W. Winder, Cincinnati, Ohio, photographer) in the Dexter Collection of the University of Vermont, Burlington; a snapshot of a young boy and several women by a graveside (Strong Museum); and a snapshot of a woman placing flowers on a grave with a man watching (Strong Museum).

23

I am told by Aaron Katcher that Paris still has mourning stores.

24

James was fond of combining portraits with memorials. In *The Fondey Family,* painted in 1803, James portrayed the entire family. In the background one can see a tombstone for Cornelia, their baby daughter, who died 6 years before.

25

Burns (1990) incorrectly assumes that photographs of people in mourning are rare. His caption for figure 10 states: "This is the only known daguerreotype of people in mourning clothes posed to document their grief." In addition to Snyder's state-

197 **Notes**

ment of their commonness, the Strong Museum has six widow photographs (86.2.4, 88.1060, 88.1071, 88.1074, 88.1148, and 88.1191). I have several in my private collection and have seen dozens more.

three
Memorial Photography

1
"The mourning picture, a style one might call a *melancholia artificialis,* has never been the subject of a comprehensive monograph, nor has it been identified as an American art genre, although it was just as popular in the New Republic as abstract medieval tombstone iconography had been in Puritan America" (Schorsch 1979, p. 41).

2
Darrah (1981) cites a carte de visite photograph from the Nicholas Graver collection that shows "Miss Catherine Ditmars (1879) at various ages. The photographer, G. A. Flagg of Ovid, New York, copied the portraits which were distributed by members of the family" (p. 145).

3
In Germany, *Haarbilder* ("hair pictures") were common homemade memorials at the turn of the century. They consist of a shadow frame with hair weavings and waxen flowers designed around a photograph of the deceased. According to Deborah Smith, they are also found in the United States. I have never seen one.

4
It is my hunch that memorial cards were produced and used all over America, but because I have not systematically explored the entire country, I am being conservative about the geographic distribution of this practice.

5
In the Prado in Madrid, there are several paintings of flower wreaths around the Virgin. One is by Rubens. They are called *guirnaldas* and resemble funeral floral memorial photographs.

6
Rules and Regulations of Philadelphia Diocesan Cemeteries (Philadelphia: Catholic Cemeteries Office, n.d.).

7
Laurel Gabel informs me that the New London Cemetery (Connecticut) and the Cedar Grove Cemetery (Iowa) both have regulations: "Photographic reproductions of the deceased on gravestones are forbidden." I'm certain that a systematic search of other cemeteries in the United States would reveal similar prohibitions.

8
Tom Weprich in his research into photography in Pittsburgh located this item and kindly passed it on to me.

four
Conclusion: A Social Analysis of Death-Related Photographs

1
Collection of the author.

2
Strong Museum (88.1543).

3
In Muncie, Indiana, or *Middletown,* the setting for Robert and Helen Lynd's study of the American middle class (1929), the collection of negatives of a professional photographer who functioned in the 1920s and 1930s revealed eight casket photos. According to Dwight Hoover (1986), editor of a book based on the photographs, the settings were all private homes of the lower middle class (p. 109).

4
Unfortunately, it would be unwise to generalize too much from these account books. Southworth & Hawes are, in many ways, unrepresentative of other daguerreotypists. Southworth was a trained painter and the firm had an urban-based business with many prestigious clients. Numerically, most daguerrean "artists" were itinerant or occupants of low-rent studios. They had little formal aesthetic or even much technical training.

5
In Aldon Scott Boyer's notebook no. 3, contained in the International Museum of Photography's collection, he comments about that day that "there is no end to photographing dead people."

6
My attempts to search for nineteenth-century municipal ordinances prohibiting transporting corpses to photographers' studios was met by disbelief from the law school librarians I contacted. So the laws may exist, but I cannot discover a method of finding them.

7
"Charges ran as high as $75—a large sum compared with the $1 or $5 fee [depending on the skill and reputation of the artist] that was usually charged for portraits from life, taken in a studio" (Rinhart and Rinhart 1967, p. 80).

8
Ann Landers's ethnic background is Jewish. It may be that her statement that corpse photography is "weird" is merely a reflection of the absence of the custom among Jews.

9
Permission to reprint this column was granted by Ann Landers.

10
According to Deborah Smith (personal communication, September 10, 1982) there is a postmortem photographic tombstone in a Port Penn, Delaware, cemetery of a child named Willie H. Mirch, who died March 20, 1865.

11
In discussing the idea of Jews taking corpse or funeral photographs, I consulted one of the oldest and largest Jewish funeral parlors in Philadelphia. The supervisor I spoke to said that she has worked on about 200 funerals a year for the last 11 years and never saw anyone ever take a photograph. However, she did acknowledge that she has a postmortem photograph of her grandfather. It was taken because they didn't have any photographs of him.

12
I have been told that photographs can be found on Jewish tombstones in Russia, Poland, all of the Baltic republics, and Israel.

13
Collection of the author.

14
RCA Victor recording LPM-2772: "Mid the Green Fields of Virginia."

15
Sara, Maybelle, and A. P. Carter, recorded February 25, 1932, in Atlanta, Georgia.

16
A. D. Coleman includes postmortem photographs in his *The Macabre in Photography* (1977).

17
Landers is also clear as to when picture taking is out of bounds (*Detroit Free Press,* February 25, 1991, p. 2E):

> *Dear Ann Landers: Our once-beautiful (and vain) mother died a few days ago. She went from 145 pounds to 78 and requested a closed casket.*
>
> *Her sister went to the funeral home early and took several Polaroid pictures of Mom and passed them around at the funeral. Of course, Mom looked like a skeleton. I know she would have hated for people to see how emaciated she had become.*
>
> *When I got the pictures, I tore them up. My aunt is furious. I feel I did my mother a favor. What is your opinion?—Respect for the Dead.*
>
> *Dear Respect: I'm with you.*

18
There are a number of invalid and deathbed photographs of adults. There are two from the Strong Museum (88.1684): a silver print in bordered mat, ca. 1910, of a sick woman in bed looking at the camera, and the "invalid" series—cabinet cards of an ill woman in bed. One has the inscription on the back, "I have been on this bed of affliction in the ninth year when this was taken. Dec 1897 Lucy Mackey," and another is of the same woman (88.1343) 1 year later.

Bibliography

Akeret, Robert
 1973. *Photoanalysis.* New York: Peter H. Wyden.
Ames, Kenneth
 1981. Ideologies in Stone: Meanings in Victorian Gravestones. *Journal of Popular Culture* 14:650–661.
Anony.
 1953. The Boyer Collection. *Image* 2:41–48.
Ariès, Philippe
 1974a. *Western Attitudes Toward Death: From the Middle Ages to the Present.* Baltimore: Johns Hopkins University Press.
 1974b. *Death in America.* Philadelphia: University of Pennsylvania Press.
 1976. The Reversal of Death: Changes in Attitudes Toward Death in Western Societies. *American Quarterly* 26:536–560.
 1981. *The Hour of Our Death.* New York: Knopf.
 1985. *Images of Man and Death.* Janet Lloyd, translator. Cambridge, Mass.: Harvard University Press.
Bazin, André
 1967. *What Is Cinema?* Hugh Gray, editor and translator. Berkeley: University of California Press.
Beecher, Lyman
 1961. *The Autobiography of Lyman Beecher.* Barbara M. Cross, editor. Cambridge, Mass.: Belknap Press of Harvard University Press.
Benkard, Ernest
 1927. *Undying Faces: A Collection of Death Masks.* New York: Norton.
Benson, Eugene
 1870. American Art in the Yale Art Gallery. *The Palladium,* June 16, p. 4.
Berger, John
 1980. *About Looking.* New York: Pantheon Books.
Bernhardt, Sarah
 1907. *Memories of My Life, Being My Personal, Professional, and Social Recollections as Woman and Artist.* New York: D. Appleton.
Blauner, Richard
 1977. Death and Social Structure. In *Passing: The Vision of Death in America.* Westport, Conn.: Greenwood Press.
Boerdam, Jaap, and Warna Oosterbaan
 1980. Family Photographs—A Sociological Approach. *The Netherlands Journal of Sociology* 16:2.
Bowser, Kent
 1983. An Examination of Nineteenth Century American Post-Mortem Photography. Unpublished M.A. thesis, Ohio State University, Columbus.

Brandes, Georg
 1890. *Snevringer og Horizonter.* Copenhagen: Levved III.
Brown, J. Trig, and G. Alan Stoudemire
 1983. Normal and Pathological Grief. *Journal of the American Medical Association* 1250:378–382.
Broyard, Anatole
 1981. Literature on Death. *New York Times,* October 25, Section 7, p. 55.
Brückner, W., and E. Mass
 1975. *Das Fotoalbum 1858–1918.* Munich.
Burgess, N. G.
 1855. Taking Portraits After Death. *The Photographic and Fine Art Journal* 8:80.
Burns, Stanley
 1990. *Sleeping Beauties: Memorial Photography in America.* New York: Twelve Trees Press.
Clemens, Christopher, and Mark Smith
 1982. *Death: Grim Realities and Comic Relief.* New York: Delacorte Press.
Coleman, A. D.
 1977. *The Grotesque in Photography.* New York: Summit Books.
Curl, James S.
 1972. *The Victorian Celebration of Death.* Detroit: Partridge Press.
Darrah, William C.
 1977. *The World of Stereographs.* Gettysburg, Pa.: Darrah.
 1981. *Cartes de Visite in Nineteenth Century Photography.* Gettysburg, Pa.: Darrah.
David, Ben
 1991. Infra-thin Multimedia. *Visual Resources* 7:379–393.
DeFrain, John
 1986. *Stillborn: The Invisible Death.* Lexington, Mass.: Lexington Books.
Dethlefsen, Edwin S.
 1981. The Cemetery and Culture Change: Archaeological Focus and Ethnographic Practice. In *Modern Material Culture: The Archaeology of Us.* Richard A. Gould and Michael B. Schiffer, editors. New York: Academic Press, pp. 137–160.
Dijkstra, Bram
 1986. *Idols of Perversity: Fantasies of Feminine Evil in Fin-de-Siècle Culture.* New York: Oxford University Press.
Douglas, Ann
 1974. Heaven Our Home: Consolation Literature in the Northern United States, 1830–1880. *American Quarterly* 26:496–515.

Eco, Umberto
1986. A Photograph. In *Travels in Hyper Reality: Essays.* William Weaver, translator. New York: Harcourt Brace Jovanovich.

Farrell, James
1980. *Inventing the American Way of Death: 1830–1920.* Philadelphia: Temple University Press.

Fralin, Frances, editor
1985. *The Indelible Images: Photographs of War—1846 to Present. With an Essay by Jane Livingstone.* New York: Abrams.

Frankenstein, Alfred
1968. *Painter of Rural America: William Sidney Mount: 1807–1868.* Washington, D.C.: H. K. Press.

Frassanito, William A.
1975. *Gettysburg: A Journey in Time.* New York: Scribners.

Gass, William
1973. Review of *Wisconsin Death Trip. New York Times Book Review,* June 24, pp. 7, 18.

Gernsheim, Helmut, and Alison Gernsheim
1965. *A Concise History of Photography.* New York: Grosset & Dunlap.

Goldman, Judith
1976. The Camera Confronts Death. *Village Voice,* June 28, p. 129.

Goody, Jack
1974. Death and the Interpretation of Culture: A Bibliographic Overview. *American Quarterly* 26:448–455.

Gorer, Geoffrey
1965. *Death, Grief and Mourning.* New York: Doubleday.

Gradwohl, David Mayer, and Hanna Rosenberg
1988. This is the Pillar of Rachel's Grave unto This Day: Cemeteries in Lincoln, Nebraska. In *Persistence and Flexibility: Anthropological Perspectives on the American Jewish Experience.* Walter P. Zenner, editor. Albany: State University of New York Press, pp. 223–259.

Gress, E.
1975. *Mine Mange Hjem,* 3rd edition. Copenhagen: Gyldendal.

Guttman, Judith
1973. Review of *Wisconsin Death Trip. Reviews in American History,* 1:488–492.

Hales, Peter
1984. *Silver Cities: The Photographs of American Urbanization, 1839–1915.* Philadelphia: Temple University Press.

Hallett, Michael
1987. The Hopkins Memorial Stone. *History of Photography* 11:119–122.

Hammond, Joyce
1988. Visualizing Themselves: Tongan Videography in Utah. *Visual Anthropology* 1:379–400.

Harris, Liz
1987. Review of *The Forbidden Zone. New York Times Book Review,* June 19, p. 10.

Harrison, Gabriel
1851. Lights and Shadows of Daguerrean Life. *The Photographic Art-Journal,* 1:179–181.

Henisch, Heinz K., and Bridget A. Henisch
1994. *The Photographic Experience 1839–1914. Images and Attitudes.* University Park: Pennsylvania State University Press.

Herbert, Robert
1991. *Georges Seurat, 1859–1891.* New York: Abrams.

Hoover, Dwight
1986. *Magic Middletown.* Bloomington: Indiana University Press.

Humphreys, S. C.
1981. Death and Time. In *Mortality and Immortality: The Anthropology and Archaeology of Death.* S. C. Humphreys and H. King, editors. New York: Academic Press.

Jacobson, David
1992. The Dear Departed in Everlasting VHS. *San Francisco Chronicle,* December 6, p. 13.

Jammes, André
1975. *Hippolyte Bayard.* Lucerne, Switzerland: Verlag C. J. Bucher.

Johnson, Deborah J.
1989. *Shepard Alonzo Mount: His Life and Art.* Stony Brook, N.Y.: Museums at Stony Brook.

Johnson, Joy, S. Marvin Johnson, James H. Cunningham, and Irwin J. Weinfeld
1985. *A Most Important Picture.* Omaha: Centering Corporation.

Katcher, Aaron Honori, and Alan M. Beck
1991. Animal Companions: More Companion than Animal. In *Man and Beast Revisited.* Michael H. Robinson and Lionel Tiger, editors. Washington, D.C.: Smithsonian Institution Press.

Kempe, Fritz
1980. Introduction to *In Memoriam.* Robert Lebeck. Dortmund, Germany: Die Bibliophilen Taschenbücher. Harenberg Kommunikation.

Kildegaard, Bjarne
1986. Unlimited Memory: Photography and the Differentiation of Familial Intimacy. In *Man and Picture: Papers from the First International Symposium for Ethnological Picture Research in Lund* [Sweden], *1984.* Stockholm: Almqvist & Wiksell International.

Klein, Isaac
1979. *A Guide to Jewish Religious Practice.* New York: Jewish Theological Seminary of America.

Knightly, Philip
1975. *The First Casualty.* New York: Harcourt Brace Jovanovich.

Kübler-Ross, Elisabeth
1969. *On Death and Dying.* New York: Macmillan.

Lamm, Maurice
1969. *The Jewish Way in Death and Mourning.* New York: Jonathan David.

Lamoree, Karen, and Paul Bourcier
 1990. Exhibition brochure from "Forget Me Not: Ritual and Remembrance in the Lives of Rhode Island Women." Providence: Museum of Rhode Island History.
Layne, Linda L.
 1990. Imaging the Fetus: Technological and Eschatological Representations. Unpublished paper.
 1992. Of Fetuses and Angels: Returning to the Whole in Narratives of Pregnancy Loss. In *Knowledge and Society*. David J. Hess and Linda L. Layne, editors. New York: JAL Press.
Leekley, Sheryle, and John Leekley
 1982. *Moments: The Pulitzer Prize Photographs*. New York: Crown Publishers.
Lesy, Michael
 1973. *Wisconsin Death Trip*. New York: Panethon.
 1987. *The Forbidden Zone*. New York: Farrar, Straus, Giroux.
Lewis, Emanuel
 1979. Mourning by the Family After a Stillbirth or Neonatal Death. *Archives of Disease in Childhood* 54:303–306.
 1983. Stillbirth: Psychological Consequences and Strategies of Management. In *Advances in Prenatal Medicine*, volume 3. A Miunsko, E. Friedman and L. Gluck, editors. New York: Plenum, pp. 205–245.
Limbo, Rana K., and Sara Rich Wheeler
 1986. *When a Baby Dies: A Handbook for Healing and Helping*. La Crosse, Wisc.: Resolve Through Sharing.
Llewellyn, Nigel
 1991. *The Art of Death: Visual Culture in the English Death Ritual*. London: Reaktion Books.
Lloyd, Phoebe
 1978/80. A Young Boy in His First and Last Suit. *Minneapolis Institute of Arts Bulletin* 64:105–111.
 1980. Posthumous Mourning Portraiture. In *A Time to Mourn: Expressions of Grief in 19th Century America*. M. Pike and J. Armstrong, editors. Stony Brook, N.Y.: Museums of Stony Brook, pp. 71–87.
 1982. A Death in the Family. *Bulletin, Philadelphia Museum of Art* 78:3–13.
 1983. Posthumous Mourning Portraits. Presented at the American Studies Association Meetings, Philadelphia, October 5.
Ludwig, Allan I.
 1966. *Graven Images: New England Stone Carving and Its Symbols 1650–1815*. Middletown, Conn.: Wesleyan University Press.
Marling, Karal Ann, and John Wetenhall
 1991. *Iwo Jima: Monuments and the American Hero*. Cambridge, Mass.: Harvard University Press.
McCulloch, Lou
 1977. The Art of Mourning. *The Antiques Journal*, October, pp. 19–21,51.
 1981. *Card Photographs: A Guide to Their History and Value*. Exton, Pa.: Schiffer.

Meinwald, Dan
 1990. *Memento Mori: Death in Nineteenth Century Photography*, an exhibition catalog. Riverside: California Museum of Photography.
Mitford, Jessica
 1963. *The American Way of Death*. New York: Simon & Schuster.
Moeller, Susan D.
 1989. *Shooting War: Photography and the American Experience of Combat*. New York: Basic Books.
Naipaul, V. S.
 1987. *The Enigma of Arrival*. New York: Knopf.
Nelson, Malcolm A., and Diana Hume George
 1982. Grinning Skulls, Smiling Cherubs, Bitter Words. *Journal of Popular Culture* 15:163–174.
Newhall, Beaumont
 1982. *The History of Photography from 1839 to the Present*. Boston: Little, Brown.
Norfleet, Barbara
 1993. *Looking at Death*. Boston: Godine.
Osborne, Carol M.
 1982. Stanford Family Portraits by Bonnat, Carolus-Durn, Meissonier, and Other French Artists. *The Stanford Museum Bulletin* 10–11:3–12.
Phelps, Elizabeth Stuart
 1868. *The Gates Ajar*. New York: Houghton Mifflin.
Pigler, Anton
 1956. Portraying the Dead. *Acta Historiae Artium Academiae Scientiarum Hungaricae* 4:1–74.
Ploog, Randolph J.
 1990. The Account Books of Isaac Augustus Wetherby: Portrait Painter/Photographer. *History of Photography* 14:77–85.
Ragon, Michel
 1983. *The Space of Death: A Study of Funerary Architecture, Decoration, and Urbanism*. Charlottesville: University Press of Virginia.
Ring, Betty
 1971. Embroideries by American Schoolgirls. *Antiques* 100:570–575.
Rinhart, Floyd, and Marion Rinhart
 1967. Rediscovery: An American Way of Death. *Art in America* 55:78–81.
 1971. *America's Affluent Age*. South Brunswick, N.J.: A. S. Barnes.
 1980. *The American Daguerreotype*. Athens: University of Georgia Press.
Rogers, H. J.
 1872. *23 Years Under a Sky-Light or Life and Experiences of a Photographer*. Hartford, Conn.: Privately printed.
Root, Marcus Aurelius
 1971. *The Camera and the Pencil, or, The Heliographic Art* [Reprint, original 1864.] *With an Introduction by Beaumont Newhall*. Pawlet, Vt: Helios.
Rosenblum, Naomi
 1989 4 *World History of Photography*. New York: Abbeville Press.

Ruby, Jay
 1981. Seeing Through Pictures: The Anthropology of Photography. *Camera Lucida* 3:20–33.
 1982. *A Crack in the Mirror: Reflexive Perspectives in Anthropology.* Philadelphia: University of Pennsylvania Press.
 1983a. The United States View Company of Richfield, Pa. *Studies in Visual Communication* 9:45–64.
 1983b. Images of the Family: The Symbolic Implications of Animal Photography. In *New Perspectives on Our Lives with Companion Animals.* Aaron Katcher and Alan Beck, editors. Philadelphia: University of Pennsylvania Press, pp. 135–147.
 1984. Post-Mortem Portraiture in America. *History of Photography.* 8:201–222.
 1985. Francis Cooper, Spruce Hill Photographer. *Studies in Visual Communication.* 11:12–29.
 1987/8. Portraying The Dead. *Omega* 19:1–20.
 1988. Images of Rural America. *History of Photography* 12:327–343.
 1991a. Review of *Sleeping Beauties: Memorial Photography in America,* by S. Burns. *History of Photography* 15:328–329.
 1991b. Photographs, Memory, and Grief. *Illness, Crises and Loss* 1:1–5.
Ruby, Jay, and Sol Worth
 1981. An American Community's Socialization to Pictures: An Ethnography of Visual Communication. In *Studying Visual Communication.* Larry Gross, editor. Philadelphia: University of Pennsylvania Press, pp. 200–203.
Rudisell, Richard
 1971. *The Mirror Image: The Influence of the Daguerreotype on American Society.* Albuquerque: University of New Mexico Press.
Ryder, James
 1873. Recollections. *American Annual of Photography,* pp. 144–146.
Scharf, Aaron
 1968. *Art and Photography.* London: Allan Lane.
Schiller, Dan
 1981. *Objectivity and the News, the Public and the Rise of Commercial Journalism.* Philadelphia: University of Pennsylvania Press.
Schorsch, Anita
 1976. *Mourning Becomes America: Mourning Art in the New Nation.* Exhibition catalog. Harrisburg: Pennsylvania Historical and Museum Commission.
 1979. A Key to the Kingdom: The Iconography of a Mourning Picture. *Winterthur Portfolio* 14:41–72.
Schwiebert, Pat, and Paul Kirk
 1981. *When Hello Means Goodbye.* Portland, Oreg.: Perinatal Loss.
Shoekir, M.
 1979. Managing the family of the abnormal newborn. In *Proceedings of the 1978 Birth Defects Conference.* B. D. Hall, editor. New York: National Foundation–March of Dimes.

Simon, Donald
 1980. Green-Wood Cemetery. In *A Time to Mourn: Expressions of Grief in Nineteenth Century America.* Martha Pike and Janice Gray Armstrong, editors. Stony Brook, N.Y.: Museums of Stony Brook, pp. 51–66.
Smith, Deborah
 1987. Safe in the Arms of Jesus: Consolation on Delaware Children's Gravestones 1840–1899. *Markers* 11:3–9.
Snyder, Daniel Gyger
 1971. American Family Memorial Imagery, the Photograph and the Search for Immortality. Unpublished M.A. thesis. Albuquerque: University of New Mexico.
Sobieszek, Robert A.
 1976. *The Spirit of Fact, the Daguerreotypes of Southworth & Hawes, 1843–1862.* Boston: Godine.
Southworth, Josiah
 1873. A Panel Discussion on Technique. *Philadelphia Photographer* 10:279–280.
Spira, S. F.
 1981. Graves and Graven Images. *History of Photography* 5:325–328.
Stannard, David E.
 1974. Editor's Introduction. *American Quarterly,* Special Issue: Death in America 26:443–447.
Stapp, William
 1983. Robert Cornelius and the Dawn of Photography. In *Robert Cornelius: Portraits from the Dawn of Photography.* William Stapp, editor. Washington, D.C.: Smithsonian Institution Press, pp. 25–44.
 1988. Subjects of Strange . . . and Fearful Interest: Photojournalism from Its Beginnings in 1839. In *Eyes of Time: Photojournalism in America.* Marianne Fulton, editor. New York: New York Graphic Society Book.
Steinbeck, John
 1958. *Once There Was a War.* New York: Viking Press.
Stitt, Susan
 1980. Forward to *A Time to Mourn.* Martha V. Pike and H. Janice Gray Armstrong, editors. Stony Brook, N.Y.: Museums at Stony Brook, pp. 7–8.
Sudnow, David
 1967. *Passing On.* Englewood Cliffs, N.J.: Prentice-Hall.
Swaab, Shirley
 1981. Death as a Way of Life: Mourning Art and Customs. *National Association of Dealers in Antiques Bulletin,* July, pp. 2–5.
Taft, Robert
 1938. *Photography and the American Scene.* New York: Dover Books.
Tartt
 1989. *Taken: Photography and Death.* Exhibition catalog. Washington, D.C.: Tartt Gallery.
Twain, Mark
 1965 [1884]. *The Adventures of Huckleberry Finn.* New York: Bantam.

Vanderhaeghe, Guy
 1985. *Man Descending.* New York: Ticknor & Fields.
Van Der Zee, James
 1978. *Harlem Book of the Dead.* New York: Morgan & Morgan.
Volkan, Vamik
 1970. Typical Findings in Pathological Grief. *The Psychiatric Quarterly* 44:231–250.
 1971. A Study of a Patient's "Re-Grief Work." *The Psychiatric Quarterly* 45:255–273.
 1972. The Linking Objects of Pathological Mourners. *The Archives of General Psychiatry* 27:215–221.
 1975. Re-Grief Therapy and the Function of the Linking Object as a Key to Stimulate Emotionality. In *Emotional Flooding.* Paul Olson, editor. New York: Behavioral Publications, pp. 179–224.
Weidner, Ruth Irwin
 1986. *George Cochran Lambdin, 1830–1896.* Chadds Ford, Pa.: Brandywine River Museum.
Weiser, Judy
 1993. *PhotoTherapy Techniques: Exploring the Secrets of Personal Snapshots and Family Albums.* San Francisco: Jossey-Bass.
Welling, William B.
 1978. *Photography in America, the Formative Years, 1839–1900.* New York: Crowell.
Whelen, Richard
 1985. *Robert Capa.* London: Faber.
Wikler, Marvin
 1977. Using Photographs in the Termination Phase. *Social Work* 21:318–319.
Winerip, Michael
 1990. A Dog's Portrait: Make Him Young and Full of Spots. *New York Times,* March 23, p. B4.
Wood, Dave
 1976. *Wisconsin Life Trip.* Dan Camp Press.
Woolson, Atta Gold
 1873. *Woman in American Society.* Boston: Roberts Brothers.
Worth, Sol, and Larry Gross
 1981. Symbolic Strategies. In *Studying Visual Communication.* Larry Gross, editor. Philadelphia: University of Pennsylvania Press.

List of Figures

Index